HOLT SCIENCE & TECHNOLOGY

Weather and Climate

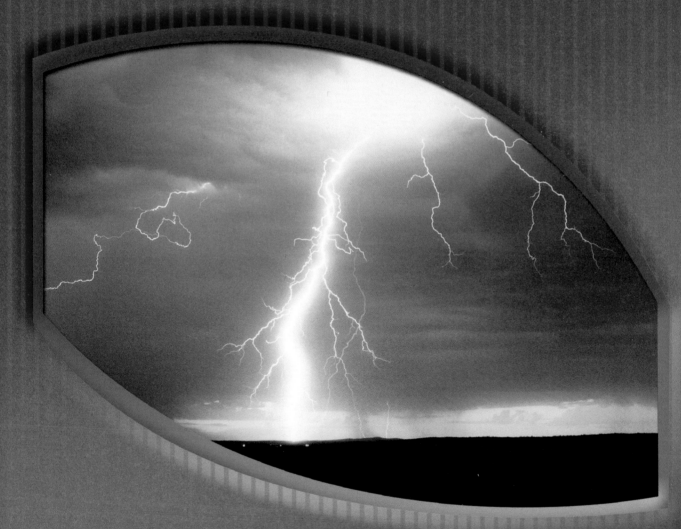

HOLT, RINEHART AND WINSTON

A Harcourt Education Company

Orlando • **Austin** • New York • San Diego • Toronto • London

Acknowledgments

Contributing Authors

Kathleen Kaska
Former Life and Earth Science Teacher and Science Department Chair

Robert J. Sager, M.S., J.D., L.G.
Coordinator and Professor of Earth Science
Pierce College
Lakewood, Washington

Inclusion Specialist

Karen Clay
Inclusion Specialist Consultant
Boston, Massachusetts

Safety Reviewer

Jack Gerlovich, Ph.D.
Associate Professor
School of Education
Drake University
Des Moines, Iowa

Academic Reviewers

David M. Armstrong, Ph.D.
Professor
Ecology and Evolutionary Biology
University of Colorado
Boulder, Colorado Institution

John Brockhaus, Ph.D.
Professor of Geospatial Information Science and Director of Geospatial Information Science Program
Department of Geography and Environmental Engineering
United States Military Academy
West Point, New York

Deborah Hanley, Ph.D.
Meteorologist
State of Florida
Department of Agriculture and Consumer Services
Division of Forestry
Tallahassee, Florida

Madeline Micceri Mignone, Ph.D.
Assistant Professor
Natural Science
Dominican College
Orangeburg, New York

Dork Sahagian, Ph.D.
Research Professor
Department of Earth Sciences
Institute for the Study of Earth, Oceans, and Space
University of New Hampshire
Durham, New Hampshire

Teacher Reviewers

Diedre S. Adams
Physical Science Instructor
Science Department
West Vigo Middle School
West Terre Haute, Indiana

Laura Buchanan
Science Teacher and Department Chairperson
Corkran Middle School
Glen Burnie, Maryland

Robin K. Clanton
Science Department Head
Berrien Middle School
Nashville, Georgia

Meredith Hanson
Science Teacher
Westside Middle School
Rocky Face, Georgia

Jennifer L. Lamkie
Science Teacher
Thomas Jefferson Middle School
Edison, New Jersey

Susan H. Robinson
Science Teacher
Oglethorpe County Middle School
Lexington, Georgia

Lab Development

Kenneth E. Creese
Science Teacher
White Mountain Junior High School
Rock Spring, Wyoming

Weather and Climate

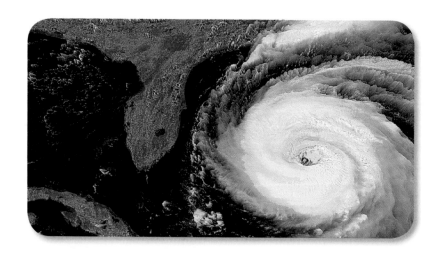

Labs and Activities

PRE-READING ACTIVITY

FOLDNOTES

START-UP ACTIVITY

Quick Lab

Labs

INTERNET ACTIVITY

Go to go.hrw.com and type in the red keyword.

SCHOOL to HOME

READING STRATEGY

CONNECTION TO ...

MATH PRACTICE

Science in Action

How to Use Your Textbook

Your Roadmap for Success with Holt Science and Technology

Reading Warm-Up

A Reading Warm-Up at the beginning of every section provides you with the section's objectives and key terms. The objectives tell you what you'll need to know after you finish reading the section.

Key terms are listed for each section. Learn the definitions of these terms because you will most likely be tested on them. Each key term is highlighted in the text and is defined at point of use and in the margin. You can also use the glossary to locate definitions quickly.

STUDY TIP Reread the objectives and the definitions to the key terms when studying for a test to be sure you know the material.

Get Organized

A Reading Strategy at the beginning of every section provides tips to help you organize and remember the information covered in the section. Keep a science notebook so that you are ready to take notes when your teacher reviews the material in class. Keep your assignments in this notebook so that you can review them when studying for the chapter test.

SECTION 3

Global Winds and Local Winds

If you open the valve on a bicycle tube, the air rushes out. Why? The air inside the tube is at a higher pressure than the air is outside the tube. In effect, letting air out of the tube created a wind.

READING WARM-UP

Objectives
- Explain the relationship between air pressure and wind direction.
- Describe global wind patterns.
- Explain the causes of local wind patterns.

Terms to Learn

wind
Coriolis effect
polar easterlies
westerlies
trade winds
jet stream

READING STRATEGY

Prediction Guide Before reading this section, write the title of each heading in this section. Next, under each heading, write what you think you will learn.

wind the movement of air caused by differences in air pressure

Why Air Moves

The movement of air caused by differences in air pressure is called **wind**. The greater the pressure difference, the faster the wind moves. The devastation shown in **Figure 1** was caused by winds that resulted from extreme differences in air pressure.

Air Rises at the Equator and Sinks at the Poles

Differences in air pressure are generally caused by the unequal heating of the Earth. The equator receives more direct solar energy than other latitudes, so air at the equator is warmer and less dense than the surrounding air. Warm, less dense air rises and creates an area of low pressure. This warm, rising air flows toward the poles. At the poles, the air is colder and denser than the surrounding air, so it sinks. As the cold air sinks, it creates areas of high pressure around the poles. This cold polar air then flows toward the equator.

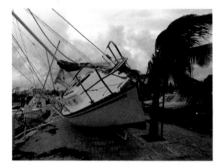

Figure 1 *In 1992, Hurricane Andrew became the most destructive hurricane in U.S. history. The winds from the hurricane reached 264 km/h.*

458 Chapter 15 The Atmosphere

Be Resourceful—Use the Web

SCiLINKS.

Internet Connect boxes in your textbook take you to resources that you can use for science projects, reports, and research papers. Go to scilinks.org, and type in the SciLinks code to get information on a topic.

go.hrw.com

Visit go.hrw.com Find worksheets, **Current Science**® magazine articles online, and other materials that go with your textbook at **go.hrw.com**. Click on the textbook icon and the table of contents to see all of the resources for each chapter.

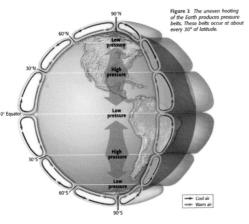

Figure 2 *The uneven heating of the Earth produces pressure belts. These belts occur at about every 30° of latitude.*

90°N
60°N
30°N — Low pressure
— High pressure
0° Equator
— Low pressure
30°S — High pressure
60°S — Low pressure
90°S

→ Cool air
→ Warm air

Pressure Belts Are Found Every 30°
You may imagine that wind moves in one huge, circular pattern from the poles to the equator. In fact, air travels in many large, circular patterns called *convection cells*. Convection cells are separated by *pressure belts*, bands of high pressure and low pressure found about every 30° of latitude, as shown in **Figure 2**.
As warm ai[r] ...
poles, the ai...
latitude, son...
causes high [p]...
This cool ai...
rises again. ...
equator. Air...
60° north ar...
creates a lov...
☑ *Reading C*...
pressure? *(Se*...

Mountain Breezes and Valley Breezes
Mountain and valley breezes are other examples of local winds caused by an area's geography. Campers in mountainous areas may feel a warm afternoon quickly change into a cold night soon after the sun sets. Differences in temperature and elevation cause this effect. The sun warms the valley and the air above it during the day. Then, the warm air rises and blows up the mountain, creating a valley breeze. At night, the mountains cool faster than the valleys. So, the cold air sinks and flows down from the mountains, creating a mountain breeze.
☑ *Reading Check* Why does the wind tend to blow down from mountains at night?

CONNECTION TO Social Studies
Local Breezes The chinook, the shamal, the sirocco, and the Santa Ana are all local winds. Find out about an interesting local wind, and create a poster-board display that shows how the wind forms and how it affects human cultures.
ACTIVITY

SECTION Review

Summary
- Winds blow from areas of high pressure to areas of low pressure.
- Pressure belts are found approximately every 30° of latitude.
- The Coriolis effect causes wind to appear to curve as it moves across the Earth's surface.
- Global winds include the polar easterlies, the westerlies, and the trade winds.
- Local winds include sea and land breezes and mountain and valley breezes.

Using Key Terms
1. In your own words, write a definition for each of the following terms: *wind*, *Coriolis effect*, *jet stream*, *polar easterlies*, *westerlies*, and *trade winds*.

Understanding Key Ideas
2. Why does warm air rise and cold air sink?
 a. because warm air is less dense than cold air
 b. because warm air is denser than cold air
 c. because cold air is less dense than warm air
 d. because warm air has less pressure than cold air does
3. What are pressure belts?
4. What causes winds?
5. How does the Coriolis effect affect wind movement?
6. How are sea and land breezes similar to mountain and valley breezes?
7. Would there be winds if the Earth's surface were the same temperature everywhere? Explain your answer.

Math Skills
8. Flying an airplane at 500 km/h, a pilot plans to reach her destination in 5 h. But she finds a jet stream moving 250 km/h in the direction she is traveling. If she gets a boost from the jet stream for 2 h, how long will the flight last?

Critical Thinking
9. **Making Inferences** In the Northern Hemisphere, why do westerlies flow from the west but trade winds flow from the east?
10. **Applying Concepts** Imagine you are near an ocean in the daytime. You want to go to the ocean, but you don't know how to get there. How might a local wind help you find the ocean?

SCLINKS.
Developed and maintained by the National Science Teachers Association
For a variety of links related to this chapter, go to www.scilinks.org
Topic: Atmospheric Pressure and Winds
SciLinks code: HSM0115

463

Use the Illustrations and Photos

Art shows complex ideas and processes. Learn to analyze the art so that you better understand the material you read in the text.

Tables and graphs display important information in an organized way to help you see relationships.

A picture is worth a thousand words. Look at the photographs to see relevant examples of science concepts that you are reading about.

Answer the Section Reviews

Section Reviews test your knowledge of the main points of the section. Critical Thinking items challenge you to think about the material in greater depth and to find connections that you infer from the text.

STUDY TIP When you can't answer a question, reread the section. The answer is usually there.

Do Your Homework

Your teacher may assign worksheets to help you understand and remember the material in the chapter.

STUDY TIP Don't try to answer the questions without reading the text and reviewing your class notes. A little preparation up front will make your homework assignments a lot easier. Answering the items in the Chapter Review will help prepare you for the chapter test.

Holt Online Learning

Visit Holt Online Learning
If your teacher gives you a special password to log onto the Holt Online Learning site, you'll find your complete textbook on the Web. In addition, you'll find some great learning tools and practice quizzes. You'll be able to see how well you know the material from your textbook.

CNN student News

Visit CNN Student News
You'll find up-to-date events in science at **cnnstudentnews.com**.

SAFETY FIRST!

Exploring, inventing, and investigating are essential to the study of science. However, these activities can also be dangerous. To make sure that your experiments and explorations are safe, you must be aware of a variety of safety guidelines. You have probably heard of the saying, "It is better to be safe than sorry." This is particularly true in a science classroom where experiments and explorations are being performed. Being uninformed and careless can result in serious injuries. Don't take chances with your own safety or with anyone else's.

The following pages describe important guidelines for staying safe in the science classroom. Your teacher may also have safety guidelines and tips that are specific to your classroom and laboratory. Take the time to be safe.

Safety Rules!

Start Out Right

Always get your teacher's permission before attempting any laboratory exploration. Read the procedures carefully, and pay particular attention to safety information and caution statements. If you are unsure about what a safety symbol means, look it up or ask your teacher. You cannot be too careful when it comes to safety. If an accident does occur, inform your teacher immediately regardless of how minor you think the accident is.

If you are instructed to note the odor of a substance, wave the fumes toward your nose with your hand. Never put your nose close to the source.

Safety Symbols

All of the experiments and investigations in this book and their related worksheets include important safety symbols to alert you to particular safety concerns. Become familiar with these symbols so that when you see them, you will know what they mean and what to do. It is important that you read this entire safety section to learn about specific dangers in the laboratory.

Eye protection	Clothing protection	Hand safety
Heating safety	Electric safety	Chemical safety
Animal safety	Sharp object	Plant safety

Eye Safety

Wear safety goggles when working around chemicals, acids, bases, or any type of flame or heating device. Wear safety goggles any time there is even the slightest chance that harm could come to your eyes. If any substance gets into your eyes, notify your teacher immediately and flush your eyes with running water for at least 15 minutes. Treat any unknown chemical as if it were a dangerous chemical. Never look directly into the sun. Doing so could cause permanent blindness.

Avoid wearing contact lenses in a laboratory situation. Even if you are wearing safety goggles, chemicals can get between the contact lenses and your eyes. If your doctor requires that you wear contact lenses instead of glasses, wear eye-cup safety goggles in the lab.

Safety Equipment

Know the locations of the nearest fire alarms and any other safety equipment, such as fire blankets and eyewash fountains, as identified by your teacher, and know the procedures for using the equipment.

Neatness

Keep your work area free of all unnecessary books and papers. Tie back long hair, and secure loose sleeves or other loose articles of clothing, such as ties and bows. Remove dangling jewelry. Don't wear open-toed shoes or sandals in the laboratory. Never eat, drink, or apply cosmetics in a laboratory setting. Food, drink, and cosmetics can easily become contaminated with dangerous materials.

Certain hair products (such as aerosol hair spray) are flammable and should not be worn while working near an open flame. Avoid wearing hair spray or hair gel on lab days.

Sharp/Pointed Objects

Use knives and other sharp instruments with extreme care. Never cut objects while holding them in your hands. Place objects on a suitable work surface for cutting.

Be extra careful when using any glassware. When adding a heavy object to a graduated cylinder, tilt the cylinder so that the object slides slowly to the bottom.

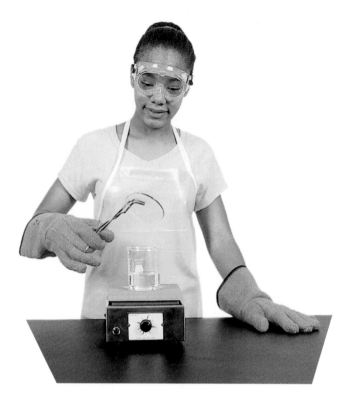

Heat

Wear safety goggles when using a heating device or a flame. Whenever possible, use an electric hot plate as a heat source instead of using an open flame. When heating materials in a test tube, always angle the test tube away from yourself and others. To avoid burns, wear heat-resistant gloves whenever instructed to do so.

Electricity

Be careful with electrical cords. When using a microscope with a lamp, do not place the cord where it could trip someone. Do not let cords hang over a table edge in a way that could cause equipment to fall if the cord is accidentally pulled. Do not use equipment with damaged cords. Be sure that your hands are dry and that the electrical equipment is in the "off" position before plugging it in. Turn off and unplug electrical equipment when you are finished.

Chemicals

Wear safety goggles when handling any potentially dangerous chemicals, acids, or bases. If a chemical is unknown, handle it as you would a dangerous chemical. Wear an apron and protective gloves when you work with acids or bases or whenever you are told to do so. If a spill gets on your skin or clothing, rinse it off immediately with water for at least 5 minutes while calling to your teacher.

Never mix chemicals unless your teacher tells you to do so. Never taste, touch, or smell chemicals unless you are specifically directed to do so. Before working with a flammable liquid or gas, check for the presence of any source of flame, spark, or heat.

Animal Safety

Always obtain your teacher's permission before bringing any animal into the school building. Handle animals only as your teacher directs. Always treat animals carefully and respectfully. Wash your hands thoroughly after handling any animal.

Plant Safety

Do not eat any part of a plant or plant seed used in the laboratory. Wash your hands thoroughly after handling any part of a plant. When in nature, do not pick any wild plants unless your teacher instructs you to do so.

Glassware

Examine all glassware before use. Be sure that glassware is clean and free of chips and cracks. Report damaged glassware to your teacher. Glass containers used for heating should be made of heat-resistant glass.

The Atmosphere

About the PHOTO

Imagine climbing a mountain and taking only one out of three breaths! As altitude increases, the density of the atmosphere decreases. At the heights shown in this picture, the atmosphere is so thin that it contains only 30% of the amount of oxygen found in the atmosphere at sea level. So, most mountaineers carry part of their atmosphere with them—in the form of oxygen tanks.

PRE-READING ACTIVITY

FOLDNOTES **Booklet** Before you read the chapter, create the FoldNote entitled "Booklet" described in the **Study Skills** section of the Appendix. Label each page of the booklet with a main idea from the chapter. As you read the chapter, write what you learn about each main idea on the appropriate page of the booklet.

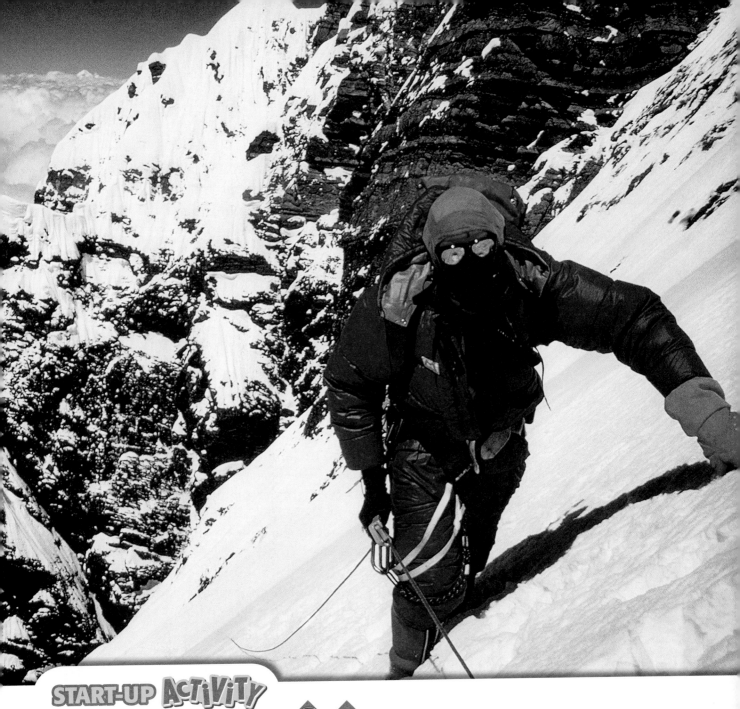

START-UP ACTIVITY

Does Air Have Mass?

In this activity, you will compare an inflated balloon with a deflated balloon to find out if air has mass.

Procedure

1. In a **notebook,** answer the following questions: Does air have mass? Will an inflated balloon weigh more than a deflated balloon?

2. Inflate **two large balloons,** and tie the balloons closed. Attach each balloon to opposite ends of a **meterstick** using identical **pushpins.** Balance the meterstick on a **pencil** held by a volunteer. Check that the meterstick is perfectly balanced.

3. Predict what will happen when you pop one balloon. Record your predictions.

4. Put on **safety goggles,** and carefully pop one of the balloons with a **pushpin.**

5. Record your observations.

Analysis

1. Explain your observations. Was your prediction correct?

2. Based on your results, does air have mass? If air has mass, is the atmosphere affected by Earth's gravity? Explain your answers.

The Atmosphere **3**

Characteristics of the Atmosphere

If you were lost in the desert, you could survive for a few days without food and water. But you wouldn't last more than five minutes without the atmosphere.

The **atmosphere** is a mixture of gases that surrounds Earth. In addition to containing the oxygen you need to breathe, the atmosphere protects you from the sun's damaging rays. The atmosphere is always changing. Every breath you take, every tree that is planted, and every vehicle you ride in affects the atmosphere's composition.

The Composition of the Atmosphere

As you can see in **Figure 1,** the atmosphere is made up mostly of nitrogen gas. The oxygen you breathe makes up a little more than 20% of the atmosphere. In addition to containing nitrogen and oxygen, the atmosphere contains small particles, such as dust, volcanic ash, sea salt, dirt, and smoke. The next time you turn off the lights at night, shine a flashlight, and you will see some of these tiny particles floating in the air.

Water is also found in the atmosphere. Liquid water (water droplets) and solid water (snow and ice crystals) are found in clouds. But most water in the atmosphere exists as an invisible gas called *water vapor.* When atmospheric conditions change, water vapor can change into solid or liquid water, and rain or snow might fall from the sky.

✓ Reading Check Describe the three physical states of water in the atmosphere. (*See the Appendix for answers to Reading Checks.*)

READING WARM-UP

Objectives

- Describe the composition of Earth's atmosphere.
- Explain why air pressure changes with altitude.
- Explain how air temperature changes with atmospheric composition.
- Describe the layers of the atmosphere.

Terms to Learn

atmosphere stratosphere
air pressure mesosphere
troposphere thermosphere

READING STRATEGY

Mnemonics As you read this section, create a mnemonic device to help you remember the layers of the Earth's atmosphere.

Figure 1 Composition of the Atmosphere

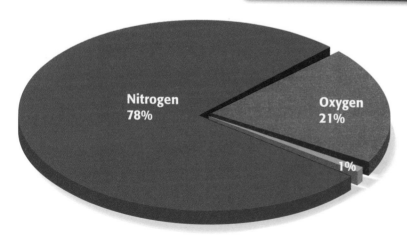

Nitrogen, the most common atmospheric gas, is released when dead plants and dead animals break down and when volcanoes erupt.

Oxygen, the second most common atmospheric gas, is made by phytoplankton and plants.

The **remaining 1%** of the atmosphere is made up of argon, carbon dioxide, water vapor, and other gases.

Atmospheric Pressure and Temperature

What would carrying a column of air that is 700 km high feel like? You may be surprised to learn that you carry this load every day. While air is not very heavy, its weight adds up. At sea level, a square inch of surface area is under almost 15 lb of air. Carrying that much air on such a small surface area is like carrying a large bowling ball on the tip of your finger!

As Altitude Increases, Air Pressure Decreases

The atmosphere is held around the Earth by gravity. Gravity pulls gas molecules in the atmosphere toward the Earth's surface, causing air pressure. **Air pressure** is the measure of the force with which air molecules push on a surface. Air pressure is strongest at the Earth's surface because more air is above you. As you move farther away from the Earth's surface, fewer gas molecules are above you. So, as altitude (distance from sea level) increases, air pressure decreases. Think of air pressure as a human pyramid, as shown in **Figure 2.** The people at the bottom of the pyramid can feel all the weight and pressure of the people on top. Air pressure works in a similar way.

Atmospheric Composition Affects Air Temperature

Air temperature also changes as altitude increases. The temperature differences result mainly from the way solar energy is absorbed as it moves through the atmosphere. Some parts of the atmosphere are warmer because they contain a high percentage of gases that absorb solar energy. Other parts of the atmosphere contain less of these gases and are cooler.

atmosphere a mixture of gases that surrounds a planet or moon

air pressure the measure of the force with which air molecules push on a surface

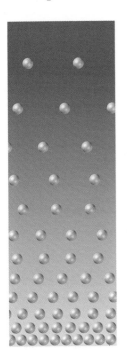
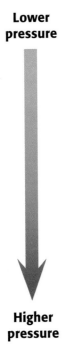

Lower pressure

Higher pressure

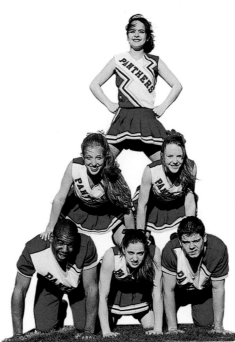

Figure 2 *As in a human pyramid, air pressure increases closer to the Earth's surface.*

Layers of the Atmosphere

Based on temperature changes, the Earth's atmosphere is divided into four layers, as shown in **Figure 3.** These layers are the *troposphere, stratosphere, mesosphere,* and *thermosphere.* Although these words might sound complicated, the name of each layer gives you clues about its features.

For example, *-sphere* means "ball," which suggests that each layer of the atmosphere surrounds the Earth like a hollow ball. *Tropo-* means "turning" or "change," and the troposphere is the layer where gases turn and mix. *Strato-* means "layer," and the stratosphere is the sphere where gases are layered and do not mix very much. *Meso-* means "middle," and the mesosphere is the middle layer. Finally, *thermo-* means "heat," and the thermosphere is the sphere where temperatures are highest.

✔ *Reading Check* What does the name of each atmospheric layer mean?

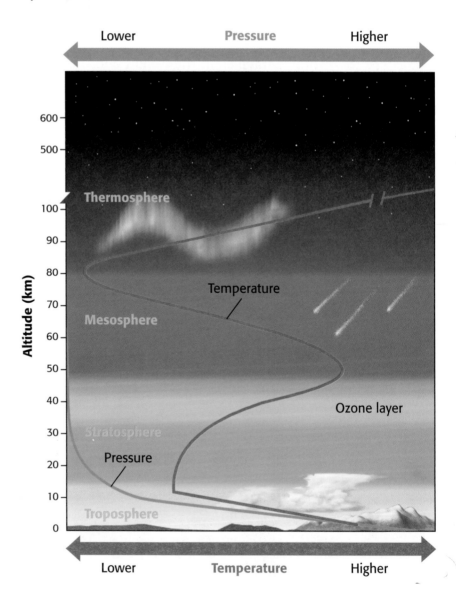

Figure 3 *The layers of the atmosphere are defined by changes in temperature.*

The Troposphere: The Layer in Which We Live

The lowest layer of the atmosphere, which lies next to the Earth's surface, is called the **troposphere.** The troposphere is also the densest atmospheric layer. It contains almost 90% of the atmosphere's total mass! Almost all of the Earth's carbon dioxide, water vapor, clouds, air pollution, weather, and life-forms are in the troposphere. As shown in **Figure 4,** temperatures vary greatly in the troposphere. Differences in air temperature and density cause gases in the troposphere to mix continuously.

The Stratosphere: Home of the Ozone Layer

The atmospheric layer above the troposphere is called the **stratosphere. Figure 5** shows the boundary between the stratosphere and the troposphere. Gases in the stratosphere are layered and do not mix as much as gases in the troposphere. The air is also very thin in the stratosphere and contains little moisture. The lower stratosphere is extremely cold. Its temperature averages –60°C. But temperature rises as altitude increases in the stratosphere. This rise happens because ozone in the stratosphere absorbs ultraviolet radiation from the sun, which warms the air. Almost all of the ozone in the stratosphere is contained in the ozone layer. The *ozone layer* protects life on Earth by absorbing harmful ultraviolet radiation.

The Mesosphere: The Middle Layer

Above the stratosphere is the mesosphere. The **mesosphere** is the middle layer of the atmosphere. It is also the coldest layer. As in the troposphere, the temperature decreases as altitude increases in the mesosphere. Temperatures can be as low as –93°C at the top of the mesosphere.

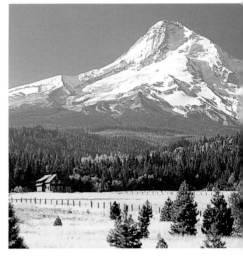

Figure 4 *As altitude increases in the troposphere, temperature decreases. Snow remains all year on this mountaintop.*

troposphere the lowest layer of the atmosphere, in which temperature decreases at a constant rate as altitude increases

stratosphere the layer of the atmosphere that is above the troposphere and in which temperature increases as altitude increases

mesosphere the layer of the atmosphere between the stratosphere and the thermosphere and in which temperature decreases as altitude increases

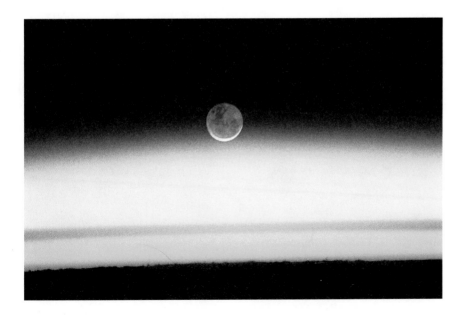

Figure 5 *This photograph of Earth's atmosphere was taken from space. The troposphere is the yellow layer; the stratosphere is the white layer.*

The Thermosphere: The Edge of the Atmosphere

The uppermost atmospheric layer is called the **thermosphere.** In the thermosphere, temperature again increases with altitude. Atoms of nitrogen and oxygen absorb high-energy solar radiation and release thermal energy, which causes temperatures in the thermosphere to be 1,000°C or higher.

When you think of an area that has high temperatures, you probably think of a place that is very hot. Although the thermosphere has very high temperatures, it does not feel hot. Temperature is different from heat. Temperature is a measure of the average energy of particles in motion. The high temperature of the thermosphere means that particles in that layer are moving very fast. Heat, however, is the transfer of thermal energy between objects of different temperatures. Particles must touch one another to transfer thermal energy. The space between particles in the thermosphere is so great that particles do not transfer much energy. In other words, the density of the thermosphere is so low that particles do not often collide and transfer energy. **Figure 6** shows how air density affects the heating of the troposphere and the thermosphere.

Reading Check Why doesn't the thermosphere feel hot?

thermosphere the uppermost layer of the atmosphere, in which temperature increases as altitude increases

Figure 6 Temperature in the Troposphere and the Thermosphere

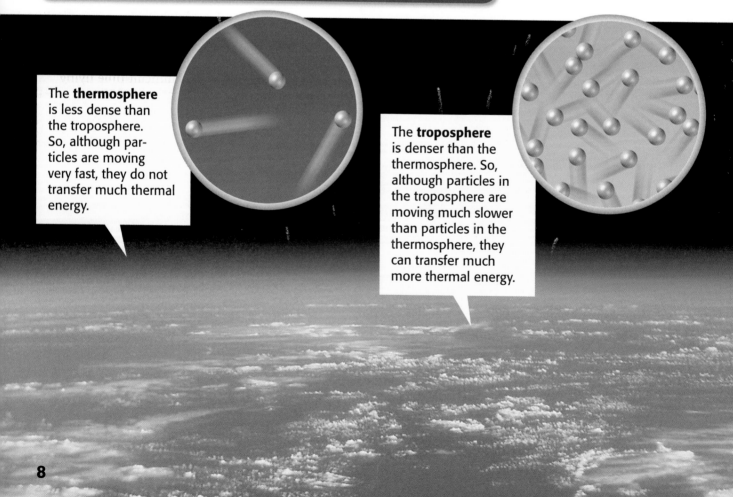

The **thermosphere** is less dense than the troposphere. So, although particles are moving very fast, they do not transfer much thermal energy.

The **troposphere** is denser than the thermosphere. So, although particles in the troposphere are moving much slower than particles in the thermosphere, they can transfer much more thermal energy.

The Ionosphere: Home of the Auroras

In the upper mesosphere and the lower thermosphere, nitrogen and oxygen atoms absorb harmful solar energy. As a result, the thermosphere's temperature rises, and gas particles become electrically charged. Electrically charged particles are called *ions*. Therefore, this part of the thermosphere is called the *ionosphere*. As shown in **Figure 7,** in polar regions these ions radiate energy as shimmering lights called *auroras*. The ionosphere also reflects AM radio waves. When conditions are right, an AM radio wave can travel around the world by reflecting off the ionosphere. These radio signals bounce off the ionosphere and are sent back to Earth.

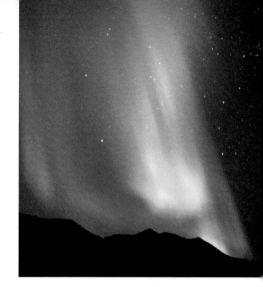

Figure 7 *Charged particles in the ionosphere cause auroras, or northern and southern lights.*

SECTION Review

Summary

- Nitrogen and oxygen make up most of Earth's atmosphere.
- Air pressure decreases as altitude increases.
- The composition of atmospheric layers affects their temperature.
- The troposphere is the lowest atmospheric layer. It is the layer in which we live.
- The stratosphere contains the ozone layer, which protects us from harmful UV radiation.
- The mesosphere is the coldest atmospheric layer.
- The thermosphere is the uppermost layer of the atmosphere.

Using Key Terms

1. Use each of the following terms in a separate sentence: *air pressure, atmosphere, troposphere, stratosphere, mesosphere,* and *thermosphere.*

Understanding Key Ideas

2. Why does the temperature of different layers of the atmosphere vary?
 a. because air temperature increases as altitude increases
 b. because the amount of energy radiated from the sun varies
 c. because of interference by humans
 d. because of the composition of gases in each layer

3. Why does air pressure decrease as altitude increases?

4. How can the thermosphere have high temperatures but not feel hot?

5. What determines the temperature of atmospheric layers?

6. What two gases make up most of the atmosphere?

Math Skills

7. If an average cloud has a density of 0.5 g/m^3 and has a volume of 1,000,000,000 m^3, what is the weight of an average cloud?

Critical Thinking

8. **Applying Concepts** Apply what you know about the relationship between altitude and air pressure to explain why rescue helicopters have a difficult time flying at altitudes above 6,000 m.

9. **Making Inferences** If the upper atmosphere is very thin, why do space vehicles heat up as they enter the atmosphere?

10. **Making Inferences** Explain why gases such as helium can escape Earth's atmosphere.

SC*L*INKS®

NSTA
Developed and maintained by the National Science Teachers Association

For a variety of links related to this chapter, go to www.scilinks.org

Topic: Composition of the Atmosphere
SciLinks code: HSM0328

Atmospheric Heating

You are lying in a park. Your eyes are closed, and you feel the warmth of the sun on your face. You may have done this before, but have you ever stopped to think that it takes a little more than eight minutes for the energy that warms your face to travel from a star that is 149,000,000 km away?

READING WARM-UP

Objectives

- Describe what happens to solar energy that reaches Earth.
- Summarize the processes of radiation, conduction, and convection.
- Explain the relationship between the greenhouse effect and global warming.

Terms to Learn

radiation
thermal conduction
convection
global warming
greenhouse effect

READING STRATEGY

Reading Organizer As you read this section, make a table comparing radiation, conduction, and convection.

Energy in the Atmosphere

In the scenario above, your face was warmed by energy from the sun. Earth and its atmosphere are also warmed by energy from the sun. In this section, you will find out what happens to solar energy as it enters the atmosphere.

Radiation: Energy Transfer by Waves

The Earth receives energy from the sun by radiation. **Radiation** is the transfer of energy as electromagnetic waves. Although the sun radiates a huge amount of energy, Earth receives only about two-billionths of this energy. But this small fraction of energy is enough to drive the weather cycle and make Earth habitable. **Figure 1** shows what happens to solar energy once it enters the atmosphere.

Figure 1 *Energy from the sun is absorbed by the atmosphere, land, and water and is changed into thermal energy.*

About **25%** is scattered and reflected by clouds and air.

About **20%** is absorbed by ozone, clouds, and atmospheric gases.

About **50%** is absorbed by Earth's surface.

About **5%** is reflected by Earth's surface.

Conduction: Energy Transfer by Contact

If you have ever touched something hot, you have experienced the process of conduction. **Thermal conduction** is the transfer of thermal energy through a material. Thermal energy is always transferred from warm to cold areas. When air molecules come into direct contact with the warm surface of Earth, thermal energy is transferred to the atmosphere.

Convection: Energy Transfer by Circulation

If you have ever watched a pot of water boil, you have observed convection. **Convection** is the transfer of thermal energy by the circulation or movement of a liquid or gas. Most thermal energy in the atmosphere is transferred by convection. For example, as air is heated, it becomes less dense and rises. Cool air is denser, so it sinks. As the cool air sinks, it pushes the warm air up. The cool air is eventually heated by the Earth's surface and begins to rise again. This cycle of warm air rising and cool air sinking causes a circular movement of air, called a *convection current,* as shown in **Figure 2.**

✓ Reading Check How do differences in air density cause convection currents? (*See the Appendix for answers to Reading Checks.*)

radiation the transfer of energy as electromagnetic waves

thermal conduction the transfer of energy as heat through a material

convection the transfer of thermal energy by the circulation or movement of a liquid or gas

Figure 2 *The processes of radiation, thermal conduction, and convection heat Earth and its atmosphere.*

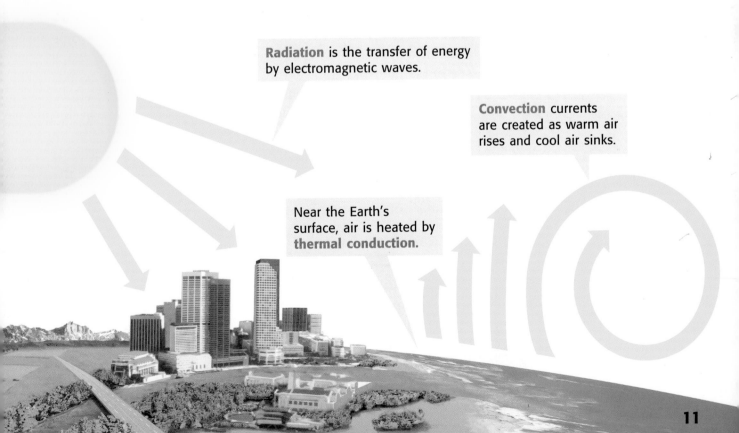

Radiation is the transfer of energy by electromagnetic waves.

Convection currents are created as warm air rises and cool air sinks.

Near the Earth's surface, air is heated by thermal conduction.

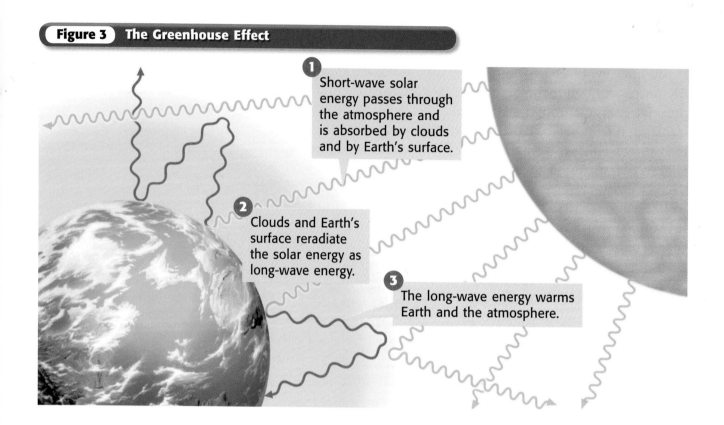

Figure 3 The Greenhouse Effect

1 Short-wave solar energy passes through the atmosphere and is absorbed by clouds and by Earth's surface.

2 Clouds and Earth's surface reradiate the solar energy as long-wave energy.

3 The long-wave energy warms Earth and the atmosphere.

The Greenhouse Effect and Life on Earth

As you have learned, about 70% of the radiation that enters Earth's atmosphere is absorbed by clouds and by the Earth's surface. This energy is converted into thermal energy that warms the planet. In other words, short-wave visible light is absorbed and reradiated into the atmosphere as long-wave thermal energy. So, why doesn't this thermal energy escape back into space? Most of it does, but the atmosphere is like a warm blanket that traps enough energy to make Earth livable. This process, shown in **Figure 3,** is called the greenhouse effect. The **greenhouse effect** is the process by which gases in the atmosphere, such as water vapor and carbon dioxide, absorb thermal energy and radiate it back to Earth. This process is called the greenhouse effect because the gases function like the glass walls and roof of a greenhouse, which allow solar energy to enter but prevent thermal energy from escaping.

greenhouse effect the warming of the surface and lower atmosphere of Earth that occurs when water vapor, carbon dioxide, and other gases absorb and reradiate thermal energy

The Radiation Balance: Energy In, Energy Out

For Earth to remain livable, the amount of energy received from the sun and the amount of energy returned to space must be approximately equal. Solar energy that is absorbed by the Earth and its atmosphere is eventually reradiated into space as thermal energy. Every day, the Earth receives more energy from the sun. The balance between incoming energy and outgoing energy is known as the *radiation balance*.

Greenhouse Gases and Global Warming

Many scientists have become concerned about data that show that average global temperatures have increased in the past 100 years. Such an increase in average global temperatures is called **global warming.** Some scientists have hypothesized that an increase of greenhouse gases in the atmosphere may be the cause of this warming trend. Greenhouse gases are gases that absorb thermal energy in the atmosphere.

Human activity, such as the burning of fossil fuels and deforestation, may be increasing levels of greenhouse gases, such as carbon dioxide, in the atmosphere. If this hypothesis is correct, increasing levels of greenhouse gases may cause average global temperatures to continue to rise. If global warming continues, global climate patterns could be disrupted. Plants and animals that are adapted to live in specific climates would be affected. However, climate models are extremely complex, and scientists continue to debate whether the global warming trend is the result of an increase in greenhouse gases.

✓ **Reading Check** What is a greenhouse gas?

global warming a gradual increase in average global temperature

SECTION Review

Summary

- Energy from the sun is transferred through the atmosphere by radiation, thermal conduction, and convection.

- Radiation is energy transfer by electromagnetic waves. Thermal conduction is energy transfer by direct contact. Convection is energy transfer by circulation.

- The greenhouse effect is Earth's natural heating process. Increasing levels of greenhouse gases could cause global warming.

Using Key Terms

1. Use each of the following terms in a separate sentence: *thermal conduction, radiation, convection, greenhouse effect,* and *global warming.*

Understanding Key Ideas

2. Which of the following is the best example of thermal conduction?
 a. a light bulb warming a lampshade
 b. an egg cooking in a frying pan
 c. water boiling in a pot
 d. gases circulating in the atmosphere

3. Describe three ways that energy is transferred in the atmosphere.

4. What is the difference between the greenhouse effect and global warming?

5. What is the radiation balance?

Math Skills

6. Find the average of the following temperatures: 73.2°F, 71.1°F, 54.6°F, 65.5°F, 78.2°F, 81.9°F, and 82.1°F.

Critical Thinking

7. **Identifying Relationships** How does the process of convection rely on radiation?

8. **Applying Concepts** Describe global warming in terms of the radiation balance.

SCiLINKS®

NSTA
Developed and maintained by the National Science Teachers Association

For a variety of links related to this chapter, go to www.scilinks.org

Topic: Energy in the Atmosphere
SciLinks code: HSM0512

Global Winds and Local Winds

If you open the valve on a bicycle tube, the air rushes out. Why? The air inside the tube is at a higher pressure than the air is outside the tube. In effect, letting air out of the tube created a wind.

READING WARM-UP

Objectives

- Explain the relationship between air pressure and wind direction.
- Describe global wind patterns.
- Explain the causes of local wind patterns.

Terms to Learn

wind	westerlies
Coriolis effect	trade winds
polar easterlies	jet stream

READING STRATEGY

Prediction Guide Before reading this section, write the title of each heading in this section. Next, under each heading, write what you think you will learn.

wind the movement of air caused by differences in air pressure

Why Air Moves

The movement of air caused by differences in air pressure is called **wind.** The greater the pressure difference, the faster the wind moves. The devastation shown in **Figure 1** was caused by winds that resulted from extreme differences in air pressure.

Air Rises at the Equator and Sinks at the Poles

Differences in air pressure are generally caused by the unequal heating of the Earth. The equator receives more direct solar energy than other latitudes, so air at the equator is warmer and less dense than the surrounding air. Warm, less dense air rises and creates an area of low pressure. This warm, rising air flows toward the poles. At the poles, the air is colder and denser than the surrounding air, so it sinks. As the cold air sinks, it creates areas of high pressure around the poles. This cold polar air then flows toward the equator.

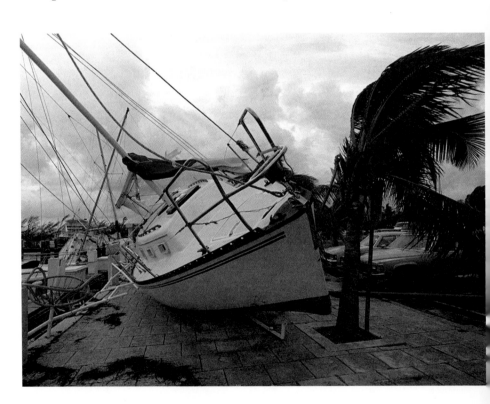

Figure 1 *In 1992, Hurricane Andrew became the most destructive hurricane in U.S. history. The winds from the hurricane reached 264 km/h.*

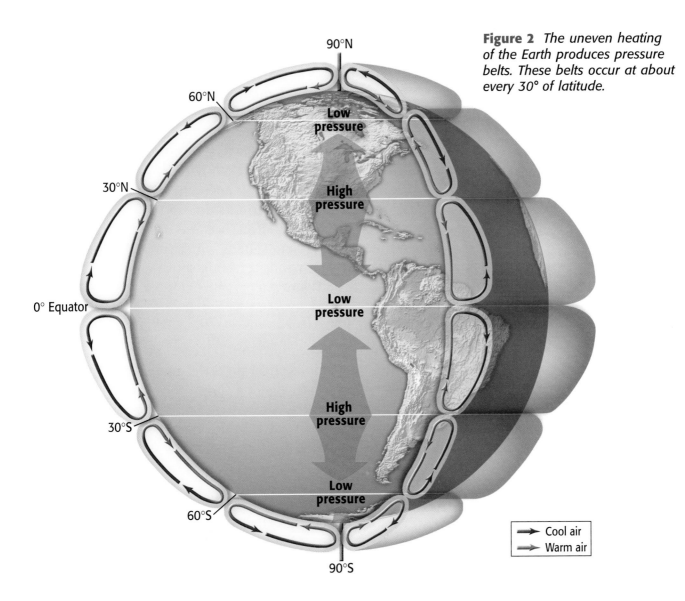

Figure 2 *The uneven heating of the Earth produces pressure belts. These belts occur at about every 30° of latitude.*

90°N

60°N

Low pressure

30°N

High pressure

0° Equator

Low pressure

30°S

High pressure

60°S

Low pressure

90°S

→ Cool air
→ Warm air

Pressure Belts Are Found Every 30°

You may imagine that wind moves in one huge, circular pattern from the poles to the equator. In fact, air travels in many large, circular patterns called *convection cells*. Convection cells are separated by *pressure belts,* bands of high pressure and low pressure found about every 30° of latitude, as shown in **Figure 2.** As warm air rises over the equator and moves toward the poles, the air begins to cool. At about 30° north and 30° south latitude, some of the cool air begins to sink. Cool, sinking air causes high pressure belts near 30° north and 30° south latitude. This cool air flows back to the equator, where it warms and rises again. At the poles, cold air sinks and moves toward the equator. Air warms as it moves away from the poles. Around 60° north and 60° south latitude, the warmer air rises, which creates a low pressure belt. This air flows back to the poles.

✓ Reading Check Why does sinking air cause areas of high pressure? (*See the Appendix for answers to Reading Checks.*)

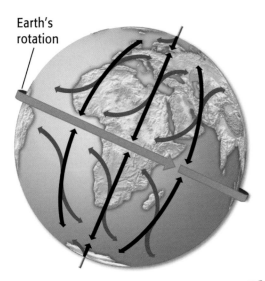

Earth's rotation

Path of wind without Coriolis effect
Approximate path of wind

Figure 3 *The Coriolis effect in the Northern Hemisphere causes winds traveling north to appear to curve to the east and winds traveling south to appear to curve to the west.*

Coriolis effect the apparent curving of the path of a moving object from an otherwise straight path due to the Earth's rotation

polar easterlies prevailing winds that blow from east to west between 60° and 90° latitude in both hemispheres

westerlies prevailing winds that blow from west to east between 30° and 60° latitude in both hemispheres

trade winds prevailing winds that blow northeast from 30° north latitude to the equator and that blow southeast from 30° south latitude to the equator

The Coriolis Effect

As you have learned, pressure differences cause air to move between the equator and the poles. But try spinning a globe and using a piece of chalk to trace a straight line from the equator to the North Pole. The chalk line curves because the globe was spinning. Like the chalk line, winds do not travel directly north or south, because the Earth is rotating. The apparent curving of the path of winds and ocean currents due to the Earth's rotation is called the **Coriolis effect.** Because of the Coriolis effect in the Northern Hemisphere, winds traveling north curve to the east, and winds traveling south curve to the west, as shown in **Figure 3.**

Global Winds

The combination of convection cells found at every 30° of latitude and the Coriolis effect produces patterns of air circulation called *global winds.* **Figure 4** shows the major global wind systems: polar easterlies, westerlies, and trade winds. Winds such as easterlies and westerlies are named for the direction from which they blow.

Polar Easterlies

The wind belts that extend from the poles to 60° latitude in both hemispheres are called the **polar easterlies.** The polar easterlies are formed as cold, sinking air moves from the poles toward 60° north and 60° south latitude. In the Northern Hemisphere, polar easterlies can carry cold arctic air over the United States, producing snow and freezing weather.

Westerlies

The wind belts found between 30° and 60° latitude in both hemispheres are called the **westerlies.** The westerlies flow toward the poles from west to east. The westerlies can carry moist air over the United States, producing rain and snow.

Trade Winds

In both hemispheres, the winds that blow from 30° latitude almost to the equator are called **trade winds.** The Coriolis effect causes the trade winds to curve to the west in the Northern Hemisphere and to the east in the Southern Hemisphere. Early traders used the trade winds to sail from Europe to the Americas. As a result, the winds became known as "trade winds."

✓ **Reading Check** If the trade winds carried traders from Europe to the Americas, what wind system carried traders back to Europe?

The Doldrums

The trade winds of the Northern and Southern Hemispheres meet in an area around the equator called the *doldrums*. In the doldrums, there is very little wind because the warm, rising air creates an area of low pressure. The name *doldrums* means "dull" or "sluggish."

The Horse Latitudes

At about 30° north and 30° south latitude, sinking air creates an area of high pressure. The winds at these locations are weak. These areas are called the *horse latitudes*. According to legend, this name was given to these areas when sailing ships carried horses from Europe to the Americas. When the ships were stuck in this windless area, horses were sometimes thrown overboard to save drinking water for the sailors. Most of the world's deserts are located in the horse latitudes because the sinking air is very dry.

For another activity related to this chapter, go to **go.hrw.com** and type in the keyword **HZ5ATMW**.

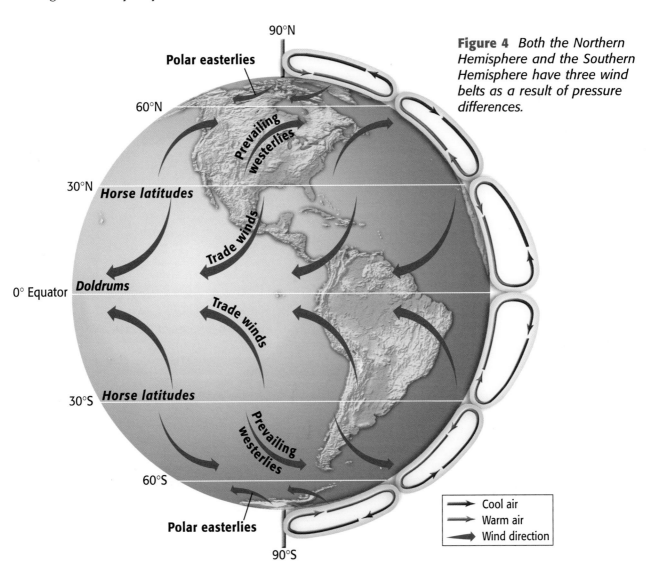

Figure 4 *Both the Northern Hemisphere and the Southern Hemisphere have three wind belts as a result of pressure differences.*

Jet Streams: Atmospheric Conveyor Belts

The flight from Seattle to Boston can be 30 minutes faster than the flight from Boston to Seattle. Why? Pilots take advantage of a jet stream similar to the one shown in **Figure 5.** The **jet streams** are narrow belts of high-speed winds that blow in the upper troposphere and lower stratosphere. These winds can reach maximum speeds of 400 km/h. Unlike other global winds, the jet streams do not follow regular paths around the Earth. Knowing the path of a jet stream is important not only to pilots but also to meteorologists. Because jet streams affect the movement of storms, meteorologists can track a storm if they know the location of a jet stream.

Local Winds

Local winds generally move short distances and can blow from any direction. Local geographic features, such as a shoreline or a mountain, can produce temperature differences that cause local winds. For example, the formation of sea and land breezes is shown in **Figure 6.** During the day, the land heats up faster than the water, so the air above the land becomes warmer than the air above the ocean. The warm land air rises, and the cold ocean air flows in to replace it. At night, the land cools faster than water, so the wind blows toward the ocean.

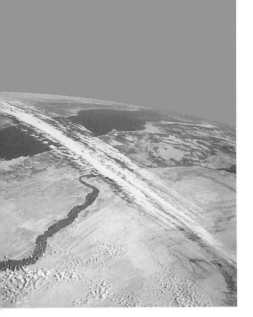

Figure 5 *The jet stream forms this band of clouds as it flows above the Earth.*

jet stream a narrow belt of strong winds that blow in the upper troposphere

Figure 6 **Sea and Land Breezes**

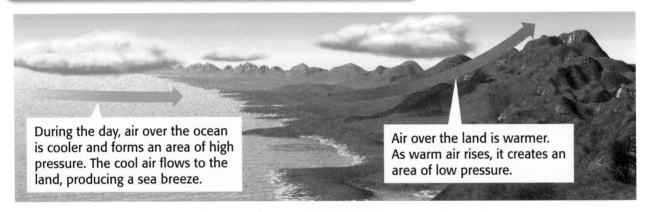

During the day, air over the ocean is cooler and forms an area of high pressure. The cool air flows to the land, producing a sea breeze.

Air over the land is warmer. As warm air rises, it creates an area of low pressure.

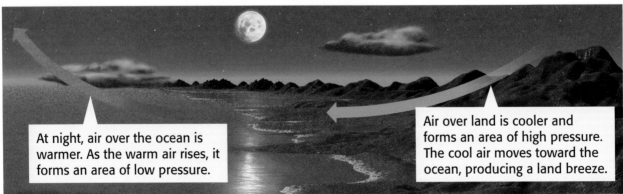

At night, air over the ocean is warmer. As the warm air rises, it forms an area of low pressure.

Air over land is cooler and forms an area of high pressure. The cool air moves toward the ocean, producing a land breeze.

Mountain Breezes and Valley Breezes

Mountain and valley breezes are other examples of local winds caused by an area's geography. Campers in mountainous areas may feel a warm afternoon quickly change into a cold night soon after the sun sets. During the day, the sun warms the air along the mountain slopes. This warm air rises up the mountain slopes, creating a valley breeze. At nightfall, the air along the mountain slopes cools. This cool air moves down the slopes into the valley, producing a mountain breeze.

✓ **Reading Check** Why does the wind tend to blow down from mountains at night?

SECTION Review

Summary

- Winds blow from areas of high pressure to areas of low pressure.
- Pressure belts are found approximately every 30° of latitude.
- The Coriolis effect causes wind to appear to curve as it moves across the Earth's surface.
- Global winds include the polar easterlies, the westerlies, and the trade winds.
- Local winds include sea and land breezes and mountain and valley breezes.

Using Key Terms

1. In your own words, write a definition for each of the following terms: *wind, Coriolis effect, jet stream, polar easterlies, westerlies,* and *trade winds*.

Understanding Key Ideas

2. Why does warm air rise and cold air sink?
 a. because warm air is less dense than cold air
 b. because warm air is denser than cold air
 c. because cold air is less dense than warm air
 d. because warm air has less pressure than cold air does

3. What are pressure belts?

4. What causes winds?

5. How does the Coriolis effect affect wind movement?

6. How are sea and land breezes similar to mountain and valley breezes?

7. Would there be winds if the Earth's surface were the same temperature everywhere? Explain your answer.

Math Skills

8. Flying an airplane at 500 km/h, a pilot plans to reach her destination in 5 h. But she finds a jet stream moving 250 km/h in the direction she is traveling. If she gets a boost from the jet stream for 2 h, how long will the flight last?

Critical Thinking

9. **Making Inferences** In the Northern Hemisphere, why do westerlies flow from the west but trade winds flow from the east?

10. **Applying Concepts** Imagine you are near an ocean in the daytime. You want to go to the ocean, but you don't know how to get there. How might a local wind help you find the ocean?

READING WARM-UP

Objectives

● Compare primary and secondary air pollutants.

● Identify the major sources of air pollution.

● Explain the effects of an ozone hole.

● List five effects of air pollution on the human body.

● Identify ways to reduce air pollution.

Terms to Learn

air pollution
acid precipitation

READING STRATEGY

Reading Organizer As you read this section, make a table that identifies major sources of air pollution and that suggests ways to reduce pollution from each source.

air pollution the contamination of the atmosphere by the introduction of pollutants from human and natural sources

Air Pollution

In December 1952, one of London's dreaded "pea souper" fogs settled on the city. But this was no ordinary fog—it was thick with coal smoke and air pollution. It burned people's lungs, and the sky grew so dark that people could not see their hands in front of their faces. When the fog lifted four days later, thousands of people were dead!

London's killer fog shocked the world and caused major changes in England's air-pollution laws. People began to think that air pollution was not simply a part of urban life that had to be endured. Air pollution had to be reduced. Although this event is an extreme example, air pollution is common in many parts of the world. However, nations are taking major steps to reduce air pollution. But what is air pollution? **Air pollution** is the contamination of the atmosphere by the introduction of pollutants from human and natural sources. Air pollutants are classified according to their source as either primary pollutants or secondary pollutants.

Primary Pollutants

Pollutants that are put directly into the air by human or natural activity are *primary pollutants*. Primary pollutants from natural sources include dust, sea salt, volcanic gases and ash, smoke from forest fires, and pollen. Primary pollutants from human sources include carbon monoxide, dust, smoke, and chemicals from paint and other substances. In urban areas, vehicle exhaust is a common source of primary pollutants. Examples of primary pollutants are shown in **Figure 1.**

✓ **Reading Check** List three primary pollutants from natural sources. (*See the Appendix for answers to Reading Checks.*)

Figure 1 **Examples of Primary Pollutants**

| Industrial emissions | Vehicle exhaust | Volcanic ash |

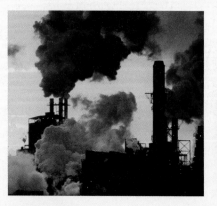 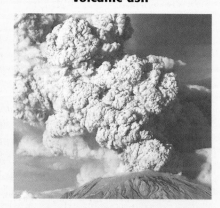

Secondary Pollutants

Pollutants that form when primary pollutants react with other primary pollutants or with naturally occurring substances, such as water vapor, are *secondary pollutants*. Ozone and smog are examples of secondary pollutants. Ozone is produced when sunlight reacts with vehicle exhaust and air. You may have heard of "Ozone Action Day" warnings in your community. When such a warning is issued, people are discouraged from outdoor physical activity because ozone can damage their lungs. In the stratosphere, ozone forms a protective layer that absorbs harmful radiation from the sun. Near the Earth's surface, however, ozone is a dangerous pollutant that negatively affects the health of organisms.

The Formation of Smog

Smog forms when ozone and vehicle exhaust react with sunlight, as shown in **Figure 2.** Local geography and weather patterns can also contribute to smog formation. Los Angeles, shown in **Figure 3,** is almost completely surrounded by mountains that trap pollutants and contribute to smog formation. Although pollution controls have reduced levels of smog in Los Angeles, smog remains a problem for Los Angeles and many other large cities.

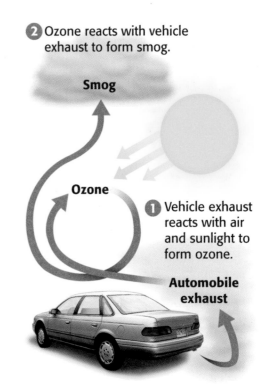

2 Ozone reacts with vehicle exhaust to form smog.

Smog

Ozone

1 Vehicle exhaust reacts with air and sunlight to form ozone.

Automobile exhaust

Figure 2 *Smog forms when sunlight reacts with ozone and vehicle exhaust.*

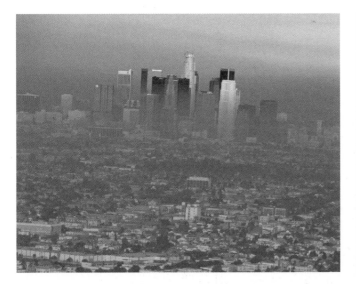

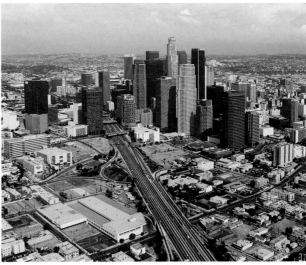

Figure 3 *Smog levels in Los Angeles can vary dramatically. During summer, a layer of warm air can trap smog near the ground. However, in the winter, a storm can quickly clear the air.*

Sources of Human-Caused Air Pollution

Human-caused air pollution comes from a variety of sources. A major source of air pollution today is transportation. Cars contribute about 10% to 20% of the human-caused air pollution in the United States. Vehicle exhaust contains nitrogen oxide, which contributes to smog formation and acid precipitation. However, pollution controls and cleaner gasoline have greatly reduced air pollution from vehicles.

Industrial Air Pollution

Many industrial plants and electric power plants burn fossil fuels, such as coal, to produce energy. Burning some types of coal without pollution controls can release large amounts of air pollutants. Some industries also produce chemicals that can pollute the air. Oil refineries, chemical manufacturing plants, dry-cleaning businesses, furniture refinishers, and auto body shops are all potential sources of air pollution.

Indoor Air Pollution

Sometimes, the air inside a building can be more polluted than the air outside. Some sources of indoor air pollution are shown in **Figure 4.** *Ventilation,* or the mixing of indoor air with outdoor air, can reduce indoor air pollution. Another way to reduce indoor air pollution is to limit the use of chemical solvents and cleaners.

Figure 4 *There are many sources of indoor air pollution. Indoor air pollution can be difficult to detect because it is often invisible.*

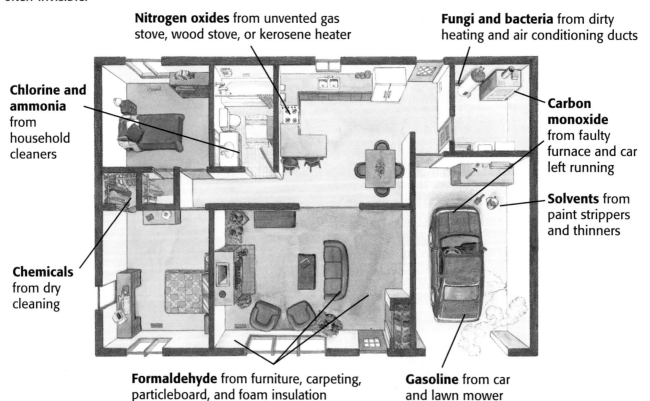

Nitrogen oxides from unvented gas stove, wood stove, or kerosene heater

Fungi and bacteria from dirty heating and air conditioning ducts

Chlorine and ammonia from household cleaners

Carbon monoxide from faulty furnace and car left running

Solvents from paint strippers and thinners

Chemicals from dry cleaning

Formaldehyde from furniture, carpeting, particleboard, and foam insulation

Gasoline from car and lawn mower

Acid Precipitation

Precipitation such as rain, sleet, or snow that contains acids from air pollution is called **acid precipitation.** When fossil fuels are burned, they can release sulfur dioxide and nitrogen oxide into the atmosphere. When these pollutants combine with water in the atmosphere, they form sulfuric acid and nitric acid. Precipitation is naturally acidic, but sulfuric acid and nitric acid can make it so acidic that it can negatively affect the environment. In most areas of the world, pollution controls have helped reduce acid precipitation.

Acid Precipitation and Plants

Plant communities have adapted over long periods of time to the natural acidity of the soil in which they grow. Acid precipitation can cause the acidity of soil to increase. This process, called *acidification*, changes the balance of a soil's chemistry in several ways. When the acidity of soil increases, some nutrients are dissolved. Nutrients that plants need for growth get washed away by rainwater. Increased acidity also causes aluminum and other toxic metals to be released. Some of these toxic metals are absorbed by the roots of plants.

✓ **Reading Check** How does acid precipitation affect plants?

The Effects of Acid Precipitation on Forests

Forest ecology is complex. Scientists are still trying to fully understand the long-term effects of acid precipitation on groups of plants and their habitats. In some areas of the world, however, acid precipitation has damaged large areas of forest. The effects of acid precipitation are most noticeable in Eastern Europe, as shown in **Figure 5.** Forests in the northeastern United States and in eastern Canada have also been affected by acid precipitation.

acid precipitation rain, sleet, or snow that contains a high concentration of acids

Testing for Particulates

1. Particulates are pollutants such as dust that are extremely small. In this lab, you will measure the amount of particulates in the air. Begin by covering **ten 5 in. × 7 in. index cards** with a thin coat of **petroleum jelly.**

2. Hang the cards in various locations inside and outside your school.

3. One day later, use a **magnifying lens** to count the number of particles on the cards. Which location had the fewest number of particulates? Which location had the highest number of particulates? Hypothesize why.

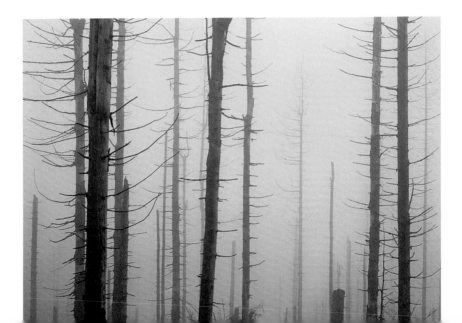

Figure 5 *This forest in Poland was damaged by acid precipitation.*

Acid Precipitation and Aquatic Ecosystems

Aquatic organisms have adapted to live in water with a particular range of acidity. If acid precipitation increases the acidity of a lake or stream, aquatic plants, fish, and other aquatic organisms may die. The effects of acid precipitation on lakes and rivers are worst in the spring, when the acidic snow that built up in the winter melts and acidic water flows into lakes and rivers. A rapid change in a body of water's acidity is called *acid shock*. Acid shock can cause large numbers of fish to die. Acid shock can also affect the delicate eggs of fish and amphibians.

To reduce the effects of acid precipitation on aquatic ecosystems, some communities spray powdered lime on acidified lakes in the spring, which reduces the acidity of the lakes. Lime, a base, neutralizes the acid in the water. Unfortunately, lime cannot be spread to offset all acid damage to lakes.

Reading Check Why is powdered lime sprayed on lakes in the spring instead of the fall?

The Ozone Hole

In 1985, scientists reported an alarming discovery about the Earth's protective ozone layer. Over the Antarctic regions, the ozone layer was thinning, particularly during the spring. This change was also noted over the Arctic. Chemicals called *CFCs* were causing ozone to break down into oxygen, which does not block the sun's harmful ultraviolet (UV) rays. The thinning of the ozone layer creates an ozone hole, shown in **Figure 6.** The ozone hole allows more UV radiation to reach the Earth's surface. UV radiation is dangerous to organisms because it damages genes and can cause skin cancer.

Cooperation to Reduce the Ozone Hole

In 1987, a group of nations met in Canada and agreed to take action against ozone depletion. Agreements were made to reduce and eventually ban CFC use, and CFC alternatives were quickly developed. Because many countries agreed to take swift action to control CFC use, and because a technological solution was quickly found, many people consider ozone protection an environmental success story. The battle to protect the ozone layer is not over, however. CFC molecules can remain active in the stratosphere for 60 to 120 years. So, CFCs released 30 years ago are still destroying ozone today. Thus, it will take many years for the ozone layer to completely recover.

Figure 6 *Polar weather conditions cause the size of the ozone hole (shown in blue) to vary. In the 2001 image, the ozone hole is larger than North America. One year later, it was 40% smaller.*

September 2001

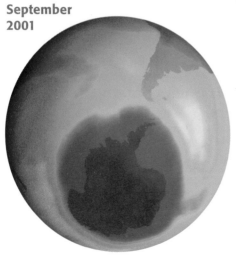

September 2002

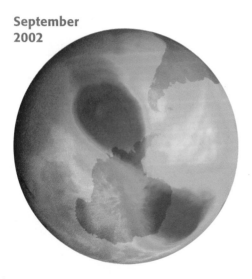

Air Pollution and Human Health

Daily exposure to small amounts of air pollution can cause serious health problems. Children, elderly people, and people with asthma, allergies, lung problems, and heart problems are especially vulnerable to the effects of air pollution. **Table 1** shows some of the effects of air pollution on the human body. The short-term effects of air pollution are immediately noticeable. Coughing, headaches, and increase in asthma-related problems are only a few short-term effects. The long-term effects of air pollution, such as lung cancer, are more dangerous because they may not be noticed until many years after an individual has been exposed to pollutants.

Table 1 Effects of Air Pollution on Human Health	
Short-term effects	headache; nausea; irritation of eyes, nose, and throat; coughing; upper respiratory infections; worsening of asthma and emphysema
Long-term effects	emphysema; lung cancer; permanent lung damage; heart disease

Cleaning Up Air Pollution

Much progress has been made in reducing air pollution. For example, in the United States the Clean Air Act was passed by Congress in 1970. The Clean Air Act is a law that gives the Environmental Protection Agency (EPA) the authority to control the amount of air pollutants that can be released from any source, such as cars and factories. The EPA also checks air quality. If air quality worsens, the EPA can set stricter standards. The Clean Air Act was strengthened in 1990.

Controlling Air Pollution from Industry

The Clean Air Act requires many industries to use pollution-control devices such as scrubbers. A *scrubber* is a device that is used to remove some pollutants before they are released by smokestacks. Scrubbers in coal-burning power plants remove particles such as ash from the smoke. Other industrial plants, such as the power plant shown in **Figure 7,** focus on burning fuel more efficiently so that fewer pollutants are released.

Figure 7 *This power plant in Florida is leading the way in clean-coal technology. The plant turns coal into a gas before it is burned, so fewer pollutants are released.*

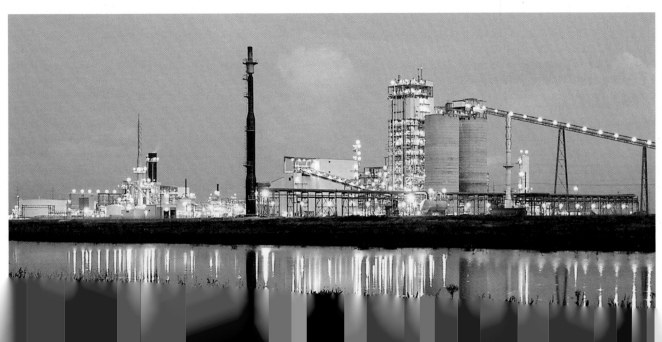

The Allowance Trading System

The Allowance Trading System is another initiative to reduce air pollution. In this program, the EPA establishes allowances for the amount of a pollutant that companies can release. If a company exceeds their allowance, they must pay a fine. A company that releases less than its allowance can sell some of its allowance to a company that releases more. Allowances are also available for the public to buy. So, organizations seeking to reduce air pollution can buy an allowance of 1,000 tons of sulfur dioxide, thus reducing the total amount of sulfur dioxide released by industries.

Reading Check How does the Allowance Trading System work?

Reducing Air Pollution from Vehicles

A large percentage of air pollution in the United States comes from the vehicles we drive. To reduce air pollution from vehicles, the EPA requires car makers to meet a certain standard for vehicle exhaust. Devices such as catalytic converters remove many pollutants from exhaust and help cars meet this standard. Cleaner fuels and more-effient engines have also helped reduce air pollution from vehicles. Car manufacturers are also making cars that run on fuels other than gasoline. Some of these cars run on hydrogen or natural gas. Hybrid cars, which are becoming more common, use gasoline and electric power to reduce emissions. Another way to reduce air pollution is to carpool, use public transportation, or bike or walk to your destination, as shown in **Figure 8.**

Figure 8 *In Copenhagen, Denmark, companies loan free bicycles in exchange for publicity. The program helps reduce air pollution and auto traffic.*

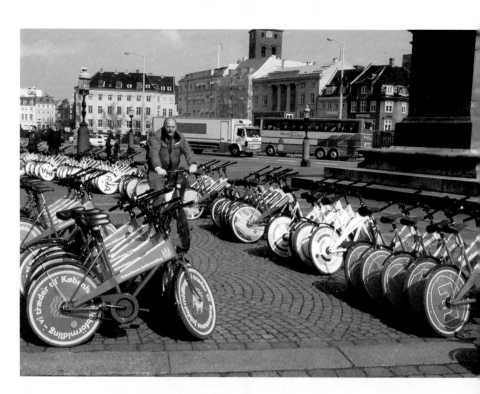

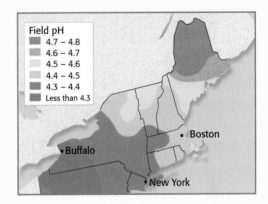

Summary

- Primary pollutants are pollutants that are put directly into the air by human or natural activity.

- Secondary pollutants are pollutants that form when primary pollutants react with other primary pollutants or with naturally occurring substances.

- Transportation, industry, and natural sources are the main sources of air pollution.

- Air pollution can be reduced by legislation, such as the Clean Air Act; by technology, such as scrubbers; and by changes in lifestyle.

Using Key Terms

The statements below are false. For each statement, replace the underlined term to make a true statement.

1. <u>Air pollution</u> is a sudden change in the acidity of a stream or lake.

2. <u>Smog</u> is rain, sleet, or snow that has a high concentration of acid.

Understanding Key Ideas

3. Which of the following results in the formation of smog?
 a. Acids in the air react with ozone.
 b. Ozone reacts with vehicle exhaust.
 c. Vehicle exhaust reacts with sunlight and ozone.
 d. Water vapor reacts with sunlight and ozone.

4. What is the difference between primary and secondary pollutants?

5. Describe five sources of indoor air pollution. Is all air pollution caused by humans? Explain.

6. What is the ozone hole, and why does it form?

7. Describe five effects of air pollution on human health. How can air pollution be reduced?

Critical Thinking

8. **Expressing Opinions** How do you think that nations should resolve air-pollution problems that cross national boundaries?

9. **Making Inferences** Why might establishing a direct link between air pollution and health problems be difficult?

Interpreting Graphics

The map below shows the pH of precipitation measured at field stations in the northeastern U.S. On the pH scale, lower numbers indicate solutions that are more acidic than solutions with higher numbers. Use the map to answer the questions below.

Field pH
- 4.7 – 4.8
- 4.6 – 4.7
- 4.5 – 4.6
- 4.4 – 4.5
- 4.3 – 4.4
- Less than 4.3

Boston
Buffalo
New York

10. Which areas have the most acidic precipitation? Hypothesize why.

11. Boston is a larger city than Buffalo is, but the precipitation measured in Buffalo is more acidic than the precipitation in Boston. Explain why.

SCiLINKS®

NSTA
Developed and maintained by the
National Science Teachers Association

For a variety of links related to this chapter, go to www.scilinks.org

Topic: Air Pollution
SciLinks code: HSM0033

Skills Practice Lab

OBJECTIVES

Predict how changes in air pressure affect a barometer.

Build a barometer to test your hypothesis.

MATERIALS

- balloon
- can, coffee, large, empty, 10 cm in diameter
- card, index
- scissors
- straw, drinking
- tape, masking, or rubber band

SAFETY

Under Pressure!

Imagine that you are planning a picnic with your friends, so you look in the newspaper for the weather forecast. The temperature this afternoon should be in the low 80s. This temperature sounds quite comfortable! But you notice that the newspaper's forecast also includes the barometer reading. What's a barometer? And what does the reading tell you? In this activity, you will build your own barometer and will discover what this tool can tell you.

Ask a Question

1 How can I use a barometer to detect changes in air pressure?

Form a Hypothesis

2 Write a few sentences that answer the question above.

Test the Hypothesis

3 Stretch the balloon a few times. Then, blow up the balloon, and let the air out. This step will make your barometer more sensitive to changes in atmospheric pressure.

4 Cut off the open end of the balloon. Next, stretch the balloon over the open end of the coffee can. Then, attach the balloon to the can with masking tape or a rubber band.

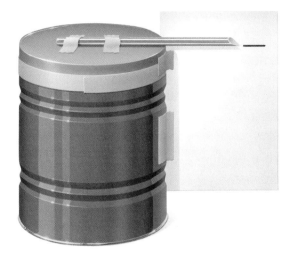

5 Cut one end of the straw at an angle to make a pointer.

6 Place the straw on the stretched balloon so that the pointer is directed away from the center of the balloon. Five centimeters of the end of the straw should hang over the edge of the can. Tape the straw to the balloon as shown in the illustration at right.

7 Tape the index card to the side of the can as shown in the illustration at right. Congratulations! You have just made a barometer!

8 Now, use your barometer to collect and record information about air pressure. Place the barometer outside for 3 or 4 days. On each day, mark on the index card where the tip of the straw points.

Analyze the Results

1 **Explaining Events** What atmospheric factors affect how your barometer works? Explain your answer.

2 **Recognizing Patterns** What does it mean when the straw moves up?

3 **Recognizing Patterns** What does it mean when the straw moves down?

Draw Conclusions

4 **Applying Conclusions** Compare your results with the barometric pressures listed in your local newspaper. What kind of weather is associated with high pressure? What kind of weather is associated with low pressure?

5 **Evaluating Results** Does the barometer you built support your hypothesis? Explain your answer.

Applying Your Data

Now, you can use your barometer to measure the actual air pressure! Get the weather section from your local newspaper for the same 3 or 4 days that you were testing your barometer. Find the barometer reading in the newspaper for each day, and record the reading beside that day's mark on your index card. Use these markings on your card to create a scale with marks at regular intervals. Transfer this scale to a new card and attach it to your barometer.

Chapter Review

USING KEY TERMS

For each pair of terms, explain how the meanings of the terms differ.

1 *air pressure* and *wind*

2 *troposphere* and *thermosphere*

3 *greenhouse effect* and *global warming*

4 *convection* and *thermal conduction*

5 *global wind* and *local wind*

6 *stratosphere* and *mesosphere*

UNDERSTANDING KEY IDEAS

Multiple Choice

7 What is the most abundant gas in the atmosphere?

a. oxygen
b. hydrogen
c. nitrogen
d. carbon dioxide

8 A major source of oxygen for the Earth's atmosphere is

a. sea water.
b. the sun.
c. plants.
d. animals.

9 The bottom layer of the atmosphere, where almost all weather occurs, is the

a. stratosphere.
b. troposphere.
c. thermosphere.
d. mesosphere.

10 What percentage of the solar energy that reaches the outer atmosphere is absorbed at the Earth's surface?

a. 20%
c. 50%
b. 30%
d. 70%

11 The ozone layer is located in the

a. stratosphere.
b. troposphere.
c. thermosphere.
d. mesosphere.

12 By which method does most thermal energy in the atmosphere circulate?

a. conduction
b. convection
c. advection
d. radiation

13 The balance between incoming and outgoing energy is called

a. the convection balance.
b. the conduction balance.
c. the greenhouse effect.
d. the radiation balance.

14 In which wind belt is most of the United States located?

a. westerlies
b. northeast trade winds
c. southeast trade winds
d. doldrums

15 Which of the following pollutants is NOT a primary pollutant?

a. car exhaust
b. acid precipitation
c. smoke from a factory
d. fumes from burning plastic

16 The Clean Air Act

 a. controls the amount of air pollutants that can be released from many sources.

 b. requires cars to run on fuels other than gasoline.

 c. requires many industries to use scrubbers.

 d. Both (a) and (c)

Short Answer

17 Why does the atmosphere become less dense as altitude increases?

18 Explain why air rises when it is heated.

19 What is the main cause of temperature changes in the atmosphere?

20 What are secondary pollutants, and how do they form? Give an example of a secondary pollutant.

CRITICAL THINKING

21 **Concept Mapping** Use the following terms to create a concept map: *mesosphere, stratosphere, layers, temperature, troposphere,* and *atmosphere.*

22 **Identifying Relationships** What is the relationship between the greenhouse effect and global warming?

23 **Applying Concepts** How do you think the Coriolis effect would change if the Earth rotated twice as fast as it does? Explain.

24 **Making Inferences** The atmosphere of Venus has a very high level of carbon dioxide. How might this fact influence the greenhouse effect on Venus?

INTERPRETING GRAPHICS

Use the diagram below to answer the questions that follow. When answering the questions that follow, assume that ocean currents do not affect the path of the boats.

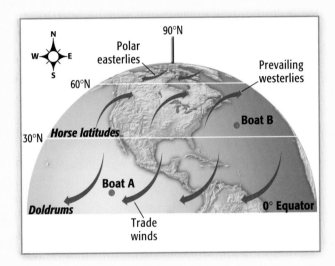

25 If Boat A traveled to 50°N, from which direction would the prevailing winds blow?

26 If Boat B sailed with the prevailing westerlies in the Northern Hemisphere, in which direction would the boat be traveling?

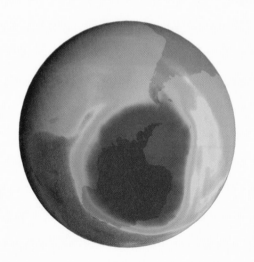

Standardized Test Preparation

Read each of the passages below. Then, answer the questions that follow each passage.

Passage 1 An important part of the EPA's Acid Rain Program is the allowance trading system, which is designed to reduce sulfur dioxide emissions. In this system, 1 ton of sulfur dioxide (SO_2) emission is equivalent to one <u>allowance</u>. A limited number of allowances are allocated for each year. Companies purchase the allowances from the EPA and are allowed to produce as many tons of SO_2 as they have allowances for the year. Companies can buy, sell, or trade allowances, but if they exceed their allowances, they must pay a fine. The system allows a company to determine the most cost-effective ways to comply with the Clean Air Act. A company can reduce emissions by using technology that conserves energy, using renewable energy sources, or updating its pollution-control devices and using low-sulfur fuels.

1. According to the passage, which of the following methods can a company use to reduce emissions?

 A preserving wildlife habitat
 B lobbying Congress
 C using high-sulfur fuels
 D using technology that conserves energy

2. In the passage, what does *allowance* mean?

 F an allotment for a pollutant
 G an allocation of money for reducing pollution
 H an alleviation of pollution
 I an allegation of pollution

Passage 2 The chinook, or "snow eater," is a dry wind that blows down the eastern side of the Rocky Mountains from New Mexico to Alaska. Arapaho Indians gave the chinook its name because of its ability to melt large amounts of snow very quickly. Chinooks form when moist air is forced over a mountain range. The air cools as it rises. As the air cools, it releases moisture by raining or snowing. As the dry air flows over the mountaintop, it compresses and heats the air below. The warm, dry wind that results is worthy of the name "snow eater" because it melts a half meter of snow in a few hours! The temperature change caused when a chinook rushes down a mountainside can also be dramatic. In 1943 in Spearfish, South Dakota, the temperature at 7:30 in the morning was −4°F. But two minutes later, a chinook caused the temperature to soar 49° to 45°F.

1. Which of the following descriptions best explains why the chinook is called "the snow eater"?

 A The chinook is so cold that it prevents the formation of snow in the atmosphere.
 B The chinook is so warm that it prevents the formation of snow in the atmosphere.
 C The chinook is a warm wind that has high humidity.
 D The chinook is a warm wind that has low humidity.

2. According to the passage, at what time did the temperature reach 45°F in Spearfish, South Dakota?

 F 7:30 P.M.
 G 7:32 P.M.
 H 7:30 A.M.
 I 7:32 A.M.

Use the illustration below to answer the questions that follow.

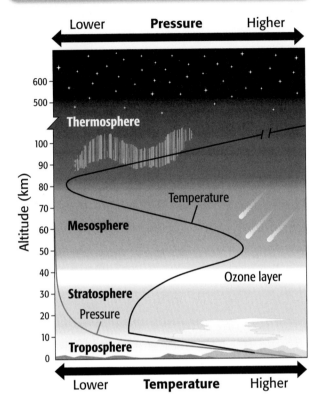

1. Which of the following statements describes how temperature changes in the mesosphere?

 A Temperature increases as altitude increases.

 B Temperature decreases as altitude increases.

 C Temperature decreases as pressure increases.

 D Temperature does not change as pressure increases.

2. In which layers does temperature decrease as pressure decreases?

 F the troposphere and the mesosphere

 G the troposphere and the stratosphere

 H the ozone layer and the troposphere

 I the ozone layer and the thermosphere

3. A research balloon took measurements at 23 km, 35 km, 52 km, 73 km, 86 km, 92 km, 101 km, and 110 km. Which measurements were taken in the mesosphere?

 A measurements at 23 km and 35 km

 B measurements at 52 km and 73 km

 C measurements at 86 km and 92 km

 D measurements at 101 km and 110 km

Read each question below, and choose the best answer.

1. An airplane is flying at a speed of 500 km/h when it encounters a jet stream moving in the same direction at 150 km/h. If the plane flies with the jet stream, how much farther will the plane travel in 1.5 h?

 A 950 km

 B 525 km

 C 225 km

 D 150 km

2. Today's wind speed was measured at 18 km/h. What was the wind speed in meters per hour?

 F 1.8 m/h

 G 180 m/h

 H 1,800 m/h

 I 18,000 m/h

3. Rockport received 24.1 cm of rain on Monday, 12.5 cm of rain on Tuesday, and 5.8 cm of rain on Thursday. The rest of the week, it did not rain. How much rain did Rockport receive during the week?

 A 18.3 cm

 B 36.6 cm

 C 42.4 cm

 D 45.7 cm

4. A weather station recorded the following temperatures during a 5 h period: 15°C, 18°C, 13°C, 15°C, and 20°C. What was the average temperature during this period?

 F 14.2°C

 G 15.2°C

 H 16.2°C

 I 20.2°C

5. The temperature in Waterford, Virginia, increased 1.3°C every hour for 5 h. If the temperature in the morning was –4°C, what was the temperature 4 h later?

 A 2.5°C

 B 2.3°C

 C 1.3°C

 D 1.2°C

Standardized Test Preparation

Science in Action

Science, Technology, and Society

The HyperSoar Jet

Imagine traveling from Chicago to Tokyo in 72 minutes. If the HyperSoar jet becomes a reality, you may be able to travel to the other side of the world in less time than it takes to watch a movie! To accomplish this amazing feat, the jet would "skip" across the upper stratosphere. To begin skipping, the jet would climb above the stratosphere, turn off its engines, and glide for about 60 km. Then, gravity would pull the jet down to where the air is denser. The denser air would cause the jet to soar upward. In this way, the jet would skip across a layer of dense air until it was ready to land. Each 2-minute skip would cover about 450 km, and the HyperSoar would be able to fly at Mach 10—a speed of 3 km/s!

Math ACTIVITY

A trip on the HyperSoar from Chicago to Tokyo would require about 18 "skips." Each skip is 450 km. If the trip is 10,123 km, how many kilometers will the jet travel when it is not skipping?

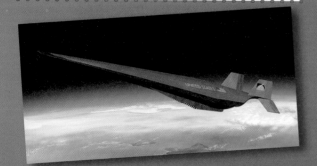

Weird Science

Radar Zoology

"For tonight's forecast, expect a light shower of mayflies. A wave of warblers will approach from the south. Tomorrow will be cloudy, and a band of free-tailed bats will move to the south in the early evening." Such a forecast may not make the evening news, but it is a familiar scenario for radar zoologists. Radar zoologists use a type of radar called *NEXRAD* to track migrating birds, bands of bats, and swarms of insects. NEXRAD tracks animals in the atmosphere in the same way that it tracks storms. The system sends out a microwave signal. If the signal hits an object, some of the energy reflects back to a receiver. NEXRAD has been especially useful to scientists who study bird migration. Birds tend to migrate at night, when the atmosphere is more stable, so until now, nighttime bird migration has been difficult to observe. NEXRAD has also helped identify important bird migration routes and critical stopovers. For example, scientists have discovered that many birds migrate over the Gulf of Mexico instead of around it.

Social Studies ACTIVITY

Geography plays an important role in bird migration. Many birds ride the "thermals" produced by mountain ranges. Find out what thermals are, and create a map of bird migration routes over North America.

Ellen Paneok

Bush Pilot For Ellen Paneok, understanding weather patterns is a matter of life and death. As a bush pilot, she flies mail, supplies, and people to remote villages in Alaska that can be reached only by plane. Bad weather is one of the most serious challenges Paneok faces. "It's beautiful up here," she says, "but it can also be harsh." One dangerous situation is landing a plane in mountainous regions. "On top of a mountain you can't tell which way the wind is blowing," Paneok says. In this case, she flies in a rectangular pattern to determine the wind direction. Landing a plane on the frozen Arctic Ocean is also dangerous. In white-out conditions, the horizon can't be seen because the sky and the ground are the same color. "It's like flying in a milk bottle full of milk," Paneok says. In these conditions, she fills black plastic garbage bags and drops them from the plane to help guide her landing.

Paneok had to overcome many challenges to become a pilot. As a child, she lived in seven foster homes before being placed in an all-girls' home at the age of 14. In the girls' home, she read a magazine about careers in aviation and decided then and there that she wanted to become a pilot. At first, she faced a lot of opposition from people telling her that she wouldn't be able to become a pilot. Now, she encourages young people to pursue their goals. "If you decide you want to go for it, go for it. There may be obstacles in your way, but you've just got to find a way to go over them, get around them, or dig under them," she says.

Language Arts ACTiViTY

Beryl Markham lived an exciting life as a bush pilot delivering mail and supplies to remote areas of Africa. Read about her life or the life of Bessie Coleman, one of the most famous African American women in the history of flying.

Ellen Paneok is shown at right with two of her Inupiat passengers.

To learn more about these Science in Action topics, visit go.hrw.com and type in the keyword **HZ5ATMF.**

Current Science

Check out Current Science® articles related to this chapter by visiting go.hrw.com. Just type in the keyword **HZ5CS15.**

Understanding Weather

About the PHOTO

Flamingos in the bathroom? This may look like someone's idea of a practical joke, but in fact, it's a practical idea! These flamingos reside at the Miami-Metro Zoo in Florida. They were put in the bathroom for protection against the incredibly dangerous winds of Hurricane Floyd in September of 1999.

PRE-READING ACTIVITY

FOLDNOTES **Four-Corner Fold**
Before you read the chapter, create the FoldNote entitled "Four-Corner Fold" described in the **Study Skills** section of the Appendix. Label the flaps of the four-corner fold with "Water in the air," "Air masses and fronts," "Severe weather," and "Forecasting the weather." Write what you know about each topic under the appropriate flap. As you read the chapter, add other information that you learn.

START-UP ACTIVITY

Meeting of the Masses

In this activity, you will model what happens when two air masses that have different temperature characteristics meet.

Procedure

1. Pour **500 mL of water** into a **beaker.** Pour **500 mL of cooking oil** into a **second beaker.** The water represents a dense cold air mass. The cooking oil represents a less dense warm air mass.

2. Predict what would happen to the two liquids if you tried to mix them.

3. Pour the contents of both beakers into a **clear, plastic, rectangular container** at the same time from opposite ends of the container.

4. Observe the interaction of the oil and water.

Analysis

1. What happens when the liquids meet?

2. Does the prediction that you made in step 2 of the Procedure match your results?

3. Using your results, hypothesize what would happen if a cold air mass met a warm air mass.

Water in the Air

What will the weather be this weekend? Depending on what you have planned, knowing the answer to this question could be important. A picnic in the rain can be a mess!

Have you ever wondered what weather is? **Weather** is the condition of the atmosphere at a certain time and place. The condition of the atmosphere is affected by the amount of water in the air. So, to understand weather, you need to understand how water cycles through Earth's atmosphere.

The Water Cycle

Water in liquid, solid, and gaseous states is constantly being recycled through the water cycle. The *water cycle* is the continuous movement of water from sources on Earth's surface—such as lakes, oceans, and plants—into the air, onto and over land, into the ground, and back to the surface. The movement of water through the water cycle is shown in **Figure 1.**

✓ **Reading Check** What is the water cycle? (*See the Appendix for answers to Reading Checks.*)

READING WARM-UP

Objectives

● Explain how water moves through the water cycle.

● Describe how relative humidity is affected by temperature and levels of water vapor.

● Describe the relationship between dew point and condensation.

● List three types of cloud forms.

● Identify four kinds of precipitation.

Terms to Learn

weather cloud
humidity precipitation
relative humidity
condensation

READING STRATEGY

Paired Summarizing Read this section silently. In pairs, take turns summarizing the material. Stop to discuss ideas that seem confusing.

Figure 1 The Water Cycle

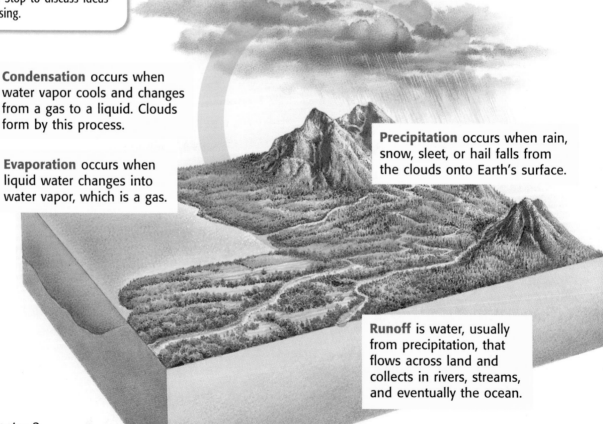

Condensation occurs when water vapor cools and changes from a gas to a liquid. Clouds form by this process.

Evaporation occurs when liquid water changes into water vapor, which is a gas.

Precipitation occurs when rain, snow, sleet, or hail falls from the clouds onto Earth's surface.

Runoff is water, usually from precipitation, that flows across land and collects in rivers, streams, and eventually the ocean.

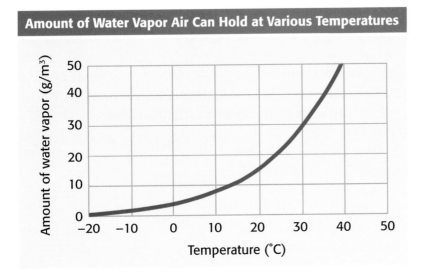

Amount of Water Vapor Air Can Hold at Various Temperatures

Figure 2 *This graph shows that as air gets warmer, the amount of water vapor that the air can hold increases.*

Humidity

As water evaporates from lakes, oceans, and plants, it becomes *water vapor,* or moisture in the air. Water vapor is invisible. The amount of water vapor in the air is called **humidity.** As water evaporates and becomes water vapor, the humidity of the air increases. The air's ability to hold water vapor changes as the temperature of the air changes. **Figure 2** shows that as the temperature of the air increases, the air's ability to hold water vapor also increases.

Relative Humidity

One way to express humidity is through relative humidity. **Relative humidity** is the amount of water vapor in the air compared with the maximum amount of water vapor that the air can hold at a certain temperature. So, relative humidity is given as a percentage. When air holds all of the water that it can at a given temperature, it is said to be *saturated.* Saturated air has a relative humidity of 100%. But how do you find the relative humidity of air that is not saturated? If you know the maximum amount of water vapor that air can hold at a given temperature and the actual amount of water vapor in the air, you can calculate the relative humidity.

Suppose that 1 m³ of air at a certain temperature can hold 24 g of water vapor. However, you know that the air actually contains 18 g of water vapor. You can calculate the relative humidity by using the following formula:

$$\frac{actual\ water\ vapor\ content\ (g/m^3)}{saturation\ water\ vapor\ content\ (g/m^3)} \times 100 = relative\ humidity\ (\%)$$

$$\frac{18\ g/m^3}{24\ g/m^3} = 75\%$$

weather the short-term state of the atmosphere, including temperature, humidity, precipitation, wind, and visibility

humidity the amount of water vapor in the air

relative humidity the ratio of the amount of water vapor in the air to the maximum amount of water vapor the air can hold at a set temperature

Relative Humidity
Assume that 1 m³ of air at 25°C contains 11 g of water vapor. At this temperature, the air can hold 24 g/m³ of water vapor. Calculate the relative humidity of the air.

Factors Affecting Relative Humidity

Two factors that affect relative humidity are amount of water vapor and temperature. At constant temperature and pressure, as the amount of water vapor in air changes, the relative humidity changes. The more water vapor there is in the air, the higher the relative humidity is. If the amount of water vapor in the air stays the same but the temperature changes, the relative humidity changes. The relative humidity decreases as the temperature rises and increases as the temperature drops.

Measuring Relative Humidity

A *psychrometer* (sie KRAHM uht uhr) is an instrument that is used to measure relative humidity. A psychrometer consists of two thermometers, one of which is a wet-bulb thermometer. The bulb of a wet-bulb thermometer is covered with a damp cloth. The other thermometer is a dry-bulb thermometer.

The difference in temperature readings between the thermometers indicates the amount of water vapor in the air. The larger the difference between the two readings is, the less water vapor the air contains and thus the lower the humidity is. **Figure 3** shows how to use a table of differences between wet-bulb and dry-bulb readings to determine relative humidity.

✓ **Reading Check** What tool is used to measure relative humidity?

Figure 3 Determining Relative Humidity

Find the relative humidity by locating the column head that is equal to the difference between the wet-bulb and dry-bulb readings. Then, locate the row head that equals the temperature reading on the dry-bulb thermometer. The value that lies where the column and row intersect equals the relative humidity. You can see a psychrometer below.

Relative Humidity (%)								
Dry-bulb reading (°C)	Difference between wet-bulb reading and dry-bulb reading (°C)							
	1	2	3	4	5	6	7	8
0	81	64	46	29	13			
2	84	68	52	37	22	7		
4	85	71	57	43	29	16		
6	86	73	60	48	35	24	11	
8	87	75	63	51	40	29	19	8
10	88	77	66	55	44	34	24	15
12	89	78	68	58	48	39	29	21
14	90	79	70	60	51	42	34	26
16	90	81	71	63	54	46	38	30
18	91	82	73	65	57	49	41	34
20	91	83	74	66	59	51	44	37

How a Wet-Bulb Thermometer Works

A wet-bulb thermometer works differently than a dry-bulb thermometer, which measures only air temperature. As air passes over the wet-bulb thermometer, the water in the cloth evaporates. As the water evaporates, the cloth cools. If the humidity is low, the water will evaporate more quickly and the temperature reading on the wet-bulb thermometer will drop. If the humidity is high, only a small amount of water will evaporate from the cloth of the wet-bulb thermometer and the change in temperature will be small.

✓ Reading Check Explain how a wet-bulb thermometer works.

Condensation

You have probably seen water droplets form on the outside of a glass of ice water, as shown in **Figure 4.** Where did those water drops come from? The water came from the surrounding air, and droplets formed as a result of condensation. **Condensation** is the process by which a gas, such as water vapor, becomes a liquid. Before condensation can occur, the air must be saturated, which means that the air must have a relative humidity of 100%. Condensation occurs when saturated air cools.

Dew Point

Air can become saturated when water vapor is added to the air through evaporation. Air can also become saturated when it cools to its dew point. The *dew point* is the temperature at which a gas condenses into a liquid. At its dew point, air is saturated. The ice in the glass of water causes the air surrounding the glass to cool to its dew point.

Before water vapor can condense, though, it must have a surface to condense on. In the case of the glass of ice water, water vapor condenses on the outside of the glass.

Figure 4 *Condensation occurred when the air next to the glass cooled to its dew point.*

condensation the change of state from a gas to a liquid

Out of Thin Air

1. Pour **room-temperature water** into a **plastic container,** such as a drinking cup, until the water level is near the top of the cup.
2. Observe the outside of the container, and record your observations.
3. Add **one or two ice cubes** to the container of water.
4. Watch the outside of the container for any changes.
5. What happened to the outside of the container?
6. What is the liquid on the container?
7. Where did the liquid come from? Explain your answer.

Figure 5 Three Forms of Clouds

Cumulus clouds look like piles of cotton balls.

Stratus clouds are not as tall as cumulus clouds, but they cover more area.

Cirrus clouds are made of ice crystals.

cloud a collection of small water droplets or ice crystals suspended in the air, which forms when the air is cooled and condensation occurs

CONNECTION TO
Language Arts

Cloud Clues Did you know that the name of a cloud actually describes the characteristics of the cloud? For example, the word *cumulus* comes from the Latin word meaning "heap." A cumulus cloud is a puffy, white cloud, which could be described as a "heap" of clouds. Use a dictionary or the Internet to find the word origins of the names of the other cloud types you learn about in this section.

Clouds

Have you ever wondered what clouds are and how they form? A **cloud** is a collection of millions of tiny water droplets or ice crystals. Clouds form as warm air rises and cools. As the rising air cools, it becomes saturated. When the air is saturated, the water vapor changes to a liquid or a solid, depending on the air temperature. At temperatures above freezing, water vapor condenses on small particles in the air and forms tiny water droplets. At temperatures below freezing, water vapor changes to a solid to form ice crystals. Clouds are classified by form, as shown in **Figure 5,** and by altitude.

Cumulus Clouds

Puffy, white clouds that tend to have flat bottoms are called *cumulus clouds* (KYOO myoo luhs KLOWDZ). Cumulus clouds form when warm air rises. These clouds generally indicate fair weather. However, when these clouds get larger, they produce thunderstorms. Thunderstorms come from a kind of cumulus cloud called a *cumulonimbus cloud* (KYOO myoo loh NIM buhs KLOWD). Clouds that have names that include *-nimbus* or *nimbo-* are likely to produce precipitation.

Stratus Clouds

Clouds called *stratus clouds* (STRAYT uhs KLOWDZ) are clouds that form in layers. Stratus clouds cover large areas of the sky and often block out the sun. These clouds can be caused by a gentle lifting of a large body of air into the atmosphere. *Nimbostratus clouds* (NIM boh STRAYT uhs KLOWDZ) are dark stratus clouds that usually produce light to heavy, continuous rain. *Fog* is a stratus cloud that has formed near the ground.

Cirrus Clouds

As you can see in **Figure 5,** *cirrus clouds* (SIR uhs KLOWDZ) are thin, feathery, white clouds found at high altitudes. Cirrus clouds form when the wind is strong. If they get thicker, cirrus clouds indicate that a change in the weather is coming.

Clouds and Altitude

Clouds are also classified by the altitude at which they form. **Figure 6** shows two altitude groups used to describe clouds and the altitudes at which they form in the middle latitudes. The prefix *cirro-* is used to describe clouds that form at high altitudes. For example, a cumulus cloud that forms high in the atmosphere is called a *cirrocumulus cloud.* The prefix *alto-* describes clouds that form at middle altitudes. Clouds that form at low altitudes do not have a specific prefix to describe them.

Reading Check At what altitude does an altostratus cloud form?

Figure 6 **Cloud Types Based on Form and Altitude**

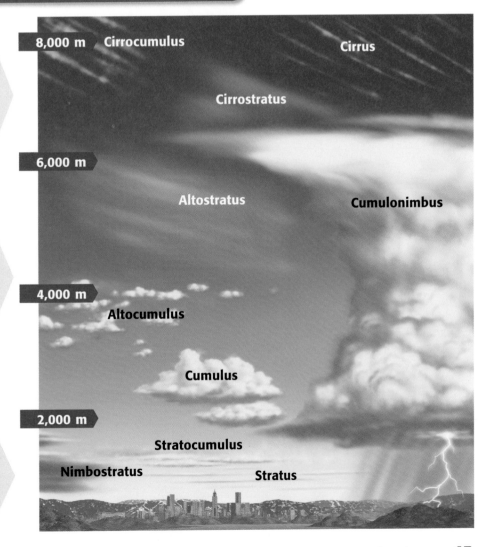

High Clouds Because of the cold temperatures at high altitude, high clouds are made up of ice crystals. The prefix *cirro-* is used to describe high clouds.

Middle Clouds Middle clouds can be made up of both water drops and ice crystals. The prefix *alto-* is used to describe middle clouds.

Low Clouds Low clouds are made up of water drops. There is no specific prefix used to describe low clouds.

8,000 m Cirrocumulus Cirrus

Cirrostratus

6,000 m

Altostratus Cumulonimbus

4,000 m

Altocumulus

Cumulus

2,000 m

Stratocumulus

Nimbostratus Stratus

Figure 7 *Snowflakes are six-sided ice crystals that can be several millimeters to several centimeters in size.*

precipitation any form of water that falls to the Earth's surface from the clouds

Precipitation

When water from the air returns to Earth's surface, it returns as precipitation. **Precipitation** is water, in solid or liquid form, that falls from the air to Earth. There are four major forms of precipitation—rain, snow, sleet, and hail.

Rain

The most common form of precipitation is *rain*. A cloud produces rain when the water drops in the cloud become large enough to fall. A water drop in a cloud begins as a droplet that is smaller than the period at the end of this sentence. Before such a water drop falls as rain, it must become about 100 times its original size.

Sleet and Snow

Sleet forms when rain falls through a layer of freezing air. The rain freezes in the air, which produces falling ice. *Snow* forms when temperatures are so cold that water vapor changes directly to a solid. Snow can fall as single ice crystals or can join to form snowflakes, as shown in **Figure 7.**

Hail

Balls or lumps of ice that fall from clouds are called *hail*. Hail forms in cumulonimbus clouds. When updrafts of air in the clouds carry raindrops high in the clouds, the raindrops freeze and hail forms. As hail falls, water drops coat it. Another updraft of air can send the hail up again. Here, the water drops collected on the hail freeze to form another layer of ice on the hail. This process can happen many times. Eventually, the hail becomes too heavy to be carried by the updrafts and so falls to Earth's surface, as shown in **Figure 8.**

Figure 8 *The impact of large hailstones can damage property and crops. The inset photograph shows layers inside of a hailstone, which reveal how it formed.*

Summary

- Weather is the condition of the atmosphere at a certain time and place. Weather is affected by the amount of water vapor in the air.

- The water cycle describes the movement of water above, on, and below Earth's surface.

- Humidity describes the amount of water vapor in the air. Relative humidity is a way to express humidity.

- When the temperature of the air cools to its dew point, the air has reached saturation and condensation occurs.

- Clouds form as air cools to its dew point. Clouds are classified by form and by the altitude at which they form.

- Precipitation occurs when the water vapor that condenses in the atmosphere falls back to Earth in solid or liquid form.

Using Key Terms

1. In your own words, write a definition for each of the following terms: *relative humidity, condensation, cloud,* and *precipitation*.

Understanding Key Ideas

2. Which of the following clouds is most likely to produce light to heavy, continuous rain?

 a. cumulus cloud

 b. cumulonimbus cloud

 c. nimbostratus cloud

 d. cirrus cloud

3. How is relative humidity affected by the amount of water vapor in the air?

4. What does a relative humidity of 75% mean?

5. Describe the path of water through the water cycle.

6. What are four types of precipitation?

Critical Thinking

7. **Applying Concepts** Why are some clouds formed from water droplets, while others are made up of ice crystals?

8. **Applying Concepts** How can rain and hail fall from the same cumulonimbus cloud?

9. **Identifying Relationships** What happens to relative humidity as the air temperature drops below the dew point?

Interpreting Graphics

Use the image below to answer the questions that follow.

10. What type of cloud is shown in the image?

11. How is this type of cloud formed?

12. What type of weather can you expect when you see this type of cloud? Explain.

Air Masses and Fronts

Have you ever wondered how the weather can change so quickly? For example, the weather may be warm and sunny in the morning and cold and rainy by afternoon.

Changes in weather are caused by the movement and interaction of air masses. An **air mass** is a large body of air where temperature and moisture content are similar throughout. In this section, you will learn about air masses and their effect on weather.

Air Masses

Air masses are characterized by their moisture content and temperature. The moisture content and temperature of an air mass are determined by the area over which the air mass forms. These areas are called *source regions*. An example of a source region is the Gulf of Mexico. An air mass that forms over the Gulf of Mexico is warm and wet because this area is warm and has a lot of water that evaporates. There are many types of air masses, each of which is associated with a particular source region. The characteristics of these air masses are represented on maps by a two-letter symbol, as shown in **Figure 1.** The first letter indicates the moisture content that is characteristic of the air mass. The second letter represents the temperature that is characteristic of the air mass.

Figure 1 Air Masses That Affect Weather in North America

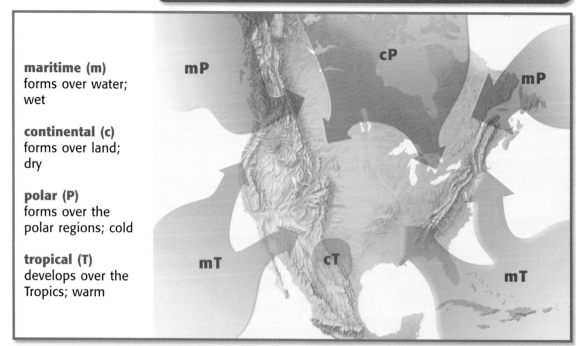

maritime (m) forms over water; wet

continental (c) forms over land; dry

polar (P) forms over the polar regions; cold

tropical (T) develops over the Tropics; warm

Figure 2 *Cold air masses that form over the North Atlantic Ocean can bring severe weather, such as blizzards, in the winter.*

Cold Air Masses

Most of the cold winter weather in the United States is influenced by three polar air masses. A continental polar (cP) air mass forms over northern Canada, which brings extremely cold winter weather to the United States. In the summer, a cP air mass generally brings cool, dry weather.

A maritime polar (mP) air mass that forms over the North Pacific Ocean is cool and very wet. This air mass brings rain and snow to the Pacific Coast in the winter and cool, foggy weather in the summer.

A maritime polar air mass that forms over the North Atlantic Ocean brings cool, cloudy weather and precipitation to New England in the winter, as shown in **Figure 2.** In the summer, the air mass brings cool weather and fog.

air mass a large body of air where temperature and moisture content are constant throughout

Warm Air Masses

Four warm air masses influence the weather in the United States. A maritime tropical (mT) air mass that develops over warm areas in the Pacific Ocean is milder than the maritime polar air mass that forms over the Pacific Ocean.

Other maritime tropical air masses develop over the warm waters of the Gulf of Mexico and the Atlantic Ocean. These air masses move north across the East Coast and into the Midwest. In the summer, they bring hot and humid weather, hurricanes, and thunderstorms, as shown in **Figure 3.** In the winter, they bring mild, often cloudy weather.

A continental tropical (cT) air mass forms over the deserts of northern Mexico and the southwestern United States. This air mass moves northward and brings clear, dry, and hot weather in the summer.

Figure 3 *Warm air masses that develop over the Gulf of Mexico bring thunderstorms in the summer.*

Reading Check What type of air mass contributes to the hot and humid summer weather in the midwestern United States? (*See the Appendix for answers to Reading Checks.*)

47

Figure 4 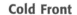 **Fronts That Affect Weather in North America**

Cold Front

Warm Front

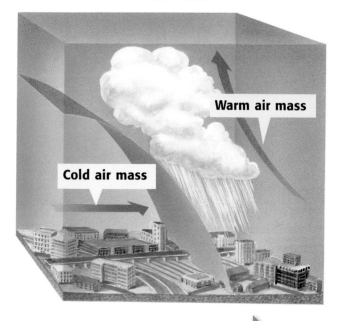

Warm air mass

Cold air mass

Direction of front

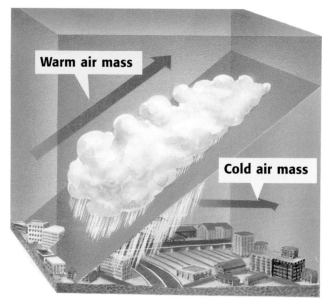

Warm air mass

Cold air mass

Direction of front

Fronts

front the boundary between air masses of different densities and usually different temperatures

Air masses that form from different areas often do not mix. The reason is that the air masses have different densities. For example, warm air is less dense than cold air. So, when two types of air masses meet, warm air generally rises. The area in which two types of air masses meet is called a **front.** The four kinds of fronts—cold fronts, warm fronts, occluded fronts, and stationary fronts—are shown in **Figure 4.** Fronts are associated with weather in the middle latitudes.

Cold Front

A cold front forms where cold air moves under warm air, which is less dense, and pushes the warm air up. Cold fronts can move quickly and bring thunderstorms, heavy rain, or snow. Cooler weather usually follows a cold front because the air mass behind the cold front is cooler and drier than the air mass that it is replacing.

Warm Front

A warm front forms where warm air moves over cold, denser air. In a warm front, the warm air gradually replaces the cold air. Warm fronts generally bring drizzly rain and are followed by clear and warm weather.

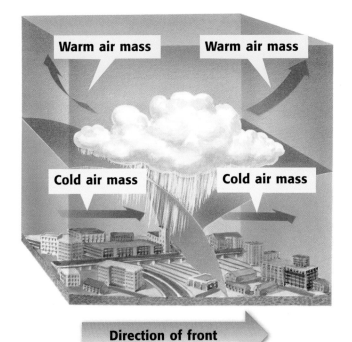

Occluded Front

Stationary Front

Direction of front

Occluded Front

An occluded front forms when a warm air mass is caught between two colder air masses. The coldest air mass moves under and pushes up the warm air mass. The coldest air mass then moves forward until it meets a cold air mass that is warmer and less dense. The colder of these two air masses moves under and pushes up the warmer air mass. Sometimes, though, the two colder air masses mix. An occluded front has cool temperatures and large amounts of rain and snow.

✓ Reading Check What type of weather would you expect an occluded front to produce?

Stationary Front

A stationary front forms when a cold air mass meets a warm air mass. In this case, however, both air masses do not have enough force to lift the warm air mass over the cold air mass. So, the two air masses remain separated. This may happen because there is not enough wind to keep the air masses pushing against each other. A stationary front often brings many days of cloudy, wet weather.

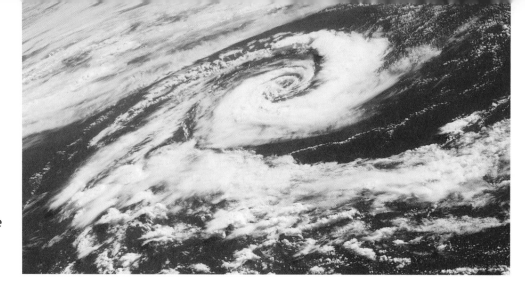

Figure 5 *This satellite image shows a cyclone system forming.*

Air Pressure and Weather

You may have heard a weather reporter on TV or radio talking about areas of low pressure and high pressure. These areas of different pressure affect the weather.

Cyclones

Areas that have lower pressure than the surrounding areas do are called **cyclones.** Cyclones are areas where air masses come together, or converge, and rise. **Figure 5** shows a satellite image of the formation of a cyclone system.

Anticyclones

Areas that have high pressure are called **anticyclones.** Anticyclones are areas where air moves apart, or diverges, and sinks. The sinking air is denser than the surrounding air, and the pressure is higher. Cooler, denser air moves out of the center of these high-pressure areas toward areas of lower pressure. **Figure 6** shows how wind can spiral out of an anticyclone and into a cyclone.

cyclone an area in the atmosphere that has lower pressure than the surrounding areas and has winds that spiral toward the center

anticyclone the rotation of air around a high-pressure center in the direction opposite to Earth's rotation

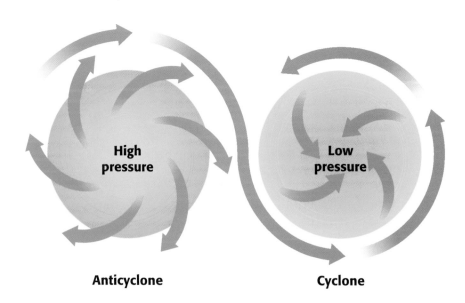

Figure 6 *As the colder, denser air spirals out of the anticyclone, it moves towards areas of low pressure, which sometimes forms a cyclone.*

Cyclones, Anticyclones, and Weather

You have learned what cyclones and anticyclones are. So, now you might be wondering how do cyclones and anticyclones affect the weather? As the air in the center of a cyclone rises, it cools and forms clouds and rain. The rising air in a cyclone causes stormy weather. In an anticyclone, the air sinks. As the air sinks, it gets warmer and absorbs moisture. The sinking air in an anticyclone brings dry, clear weather. By keeping track of cyclones and anticyclones, meteorologists can predict the weather.

✓ Reading Check Describe the different types of weather that a cyclone and an anticyclone can produce.

CONNECTION TO Astronomy

Storms on Jupiter Cyclones and anticyclones occur on Jupiter, too! Generally, cyclones on Jupiter appear as dark ovals, and anticyclones appear as bright ovals. Jupiter's Great Red Spot is an anticyclone that has existed for centuries. Research the existence of cyclones and anticyclones on other bodies in our solar system.

SECTION Review

Summary

- Air masses are characterized by moisture content and temperature.
- A front occurs where two air masses meet.
- Four major types of fronts are cold, warm, occluded, and stationary fronts.
- Differences in air pressure cause cyclones, which bring stormy weather, and anticyclones, which bring dry, clear weather.

Using Key Terms

For each pair of terms, explain how the meanings of the terms differ.

1. *front* and *air mass*

2. *cyclone* and *anticyclone*

Understanding Key Ideas

3. What kind of front forms when a cold air mass displaces a warm air mass?
 a. a cold front
 b. a warm front
 c. an occluded front
 d. a stationary front

4. What are the major air masses that influence the weather in the United States?

5. What is one source region of a maritime polar air mass?

6. What are the characteristics of an air mass whose two-letter symbol is cP?

7. What are the four major types of fronts?

8. How do fronts cause weather changes?

9. How do cyclones and anticyclones affect the weather?

Math Skills

10. A cold front is moving toward the town of La Porte at 35 km/h. The front is 200 km away from La Porte. How long will it take the front to get to La Porte?

Critical Thinking

11. **Applying Concepts** How do air masses that form over the land and ocean affect weather in the United States?

12. **Identifying Relationships** Why does the Pacific Coast have cool, wet winters and warm, dry summers? Explain.

13. **Applying Concepts** Which air masses influence the weather where you live? Explain.

SCiLINKS

NSTA Developed and maintained by the National Science Teachers Association

For a variety of links related to this chapter, go to www.scilinks.org

Topic: Air Masses and Fronts
SciLinks code: HSM0032

Severe Weather

CRAAAACK! BOOM! What made that noise? You didn't expect it, and it sure made you jump.

A big boom of thunder has probably surprised you at one time or another. And the thunder was probably followed by a thunderstorm. A thunderstorm is an example of severe weather. *Severe weather* is weather that can cause property damage and sometimes death.

Thunderstorms

Thunderstorms can be very loud and powerful. **Thunderstorms,** such as the one shown in **Figure 1,** are small, intense weather systems that produce strong winds, heavy rain, lightning, and thunder. Thunderstorms can occur along cold fronts. But thunderstorms can develop in other places, too. There are only two atmospheric conditions required to produce thunderstorms: warm and moist air near Earth's surface and an unstable atmosphere. The atmosphere is unstable when the surrounding air is colder than the rising air mass. The air mass will continue to rise as long as the surrounding air is colder than the air mass.

When the rising warm air reaches its dew point, the water vapor in the air condenses and forms cumulus clouds. If the atmosphere is extremely unstable, the warm air will continue to rise, which causes the cloud to grow into a dark, cumulonimbus cloud. Cumulonimbus clouds can reach heights of more than 15 km.

READING WARM-UP

Objectives

- Describe how lightning forms.
- Describe the formation of thunderstorms, tornadoes, and hurricanes.
- Describe the characteristics of thunderstorms, tornadoes, and hurricanes.
- Explain how to stay safe during severe weather.

Terms to Learn

thunderstorm tornado
lightning hurricane
thunder

READING STRATEGY

Reading Organizer As you read this section, create an outline of the section. Use the headings from the section in your outline.

thunderstorm a usually brief, heavy storm that consists of rain, strong winds, lightning, and thunder

Figure 1 *A typical thunderstorm, such as this one over Dallas, Texas, generates an enormous amount of electrical energy.*

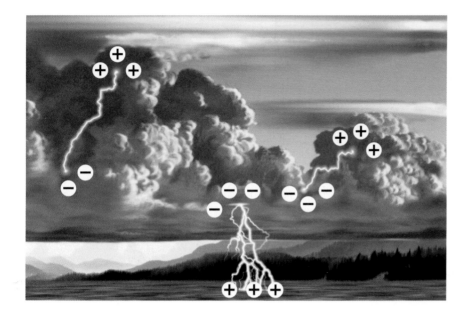

Figure 2 *The upper part of a cloud usually carries a positive electric charge, while the lower part of the cloud carries mainly negative charges.*

Lightning

Thunderstorms are very active electrically. **Lightning** is an electric discharge that occurs between a positively charged area and a negatively charged area, as shown in **Figure 2.** Lightning can happen between two clouds, between Earth and a cloud, or even between two parts of the same cloud. Have you ever touched someone after scuffing your feet on the carpet and received a mild shock? If so, you have experienced how lightning forms. While you walk around, friction between the floor and your shoes builds up an electric charge in your body. When you touch someone else, the charge is released.

When lightning strikes, energy is released. This energy is transferred to the air and causes the air to expand rapidly and send out sound waves. **Thunder** is the sound that results from the rapid expansion of air along the lightning strike.

lightning an electric discharge that takes place between two oppositely charged surfaces, such as between a cloud and the ground, between two clouds, or between two parts of the same cloud

thunder the sound caused by the rapid expansion of air along an electrical strike

Severe Thunderstorms

Severe thunderstorms can produce one or more of the following conditions: high winds, hail, flash floods, and tornadoes. Hailstorms damage crops, dent the metal on cars, and break windows. Flash flooding that results from heavy rains causes millions of dollars in property damage annually. And every year, flash flooding is a leading cause of weather-related deaths.

Lightning, as shown in **Figure 3,** happens during all thunderstorms and is very powerful. Lightning is responsible for starting thousands of forest fires each year and for killing or injuring hundreds of people a year in the United States.

✓ Reading Check What is a severe thunderstorm? (*See the Appendix for answers to Reading Checks.*)

Figure 3 *Lightning often strikes the tallest object in an area, such as the Eiffel Tower in Paris, France.*

Tornadoes

tornado a destructive, rotating column of air that has very high wind speeds, is visible as a funnel-shaped cloud, and touches the ground

Tornadoes happen in only 1% of all thunderstorms. A **tornado** is a small, spinning column of air that has high wind speeds and low central pressure and that touches the ground. A tornado starts out as a funnel cloud that pokes through the bottom of a cumulonimbus cloud and hangs in the air. The funnel cloud becomes a tornado when it makes contact with Earth's surface. **Figure 4** shows how a tornado forms.

Figure 4 **How a Tornado Forms**

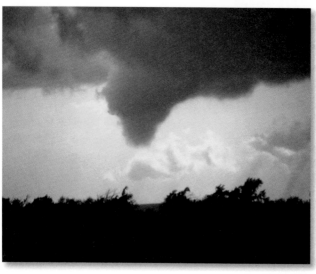

❶ Wind moving in two directions causes a layer of air in the middle to begin to spin like a roll of toilet paper.

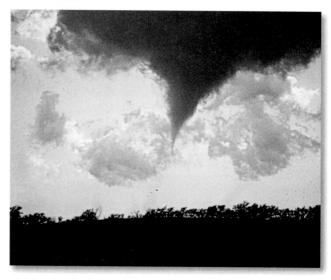

❷ The spinning column of air is turned to a vertical position by strong updrafts of air in the cumulonimbus cloud. The updrafts of air also begin to spin.

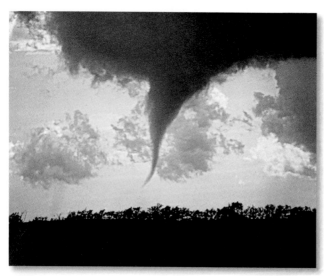

❸ The spinning column of air moves to the bottom of the cumulonimbus cloud and forms a funnel cloud.

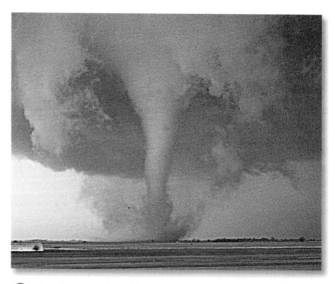

❹ The funnel cloud becomes a tornado when it touches the ground.

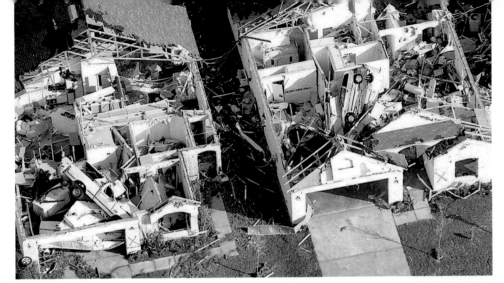

Figure 5 *The tornado that hit Kissimmee, Florida, in 1998 had wind speeds of up to 416 km/h.*

Twists of Terror

About 75% of the world's tornadoes occur in the United States. Most of these tornadoes happen in the spring and early summer when cold, dry air from Canada meets warm, moist air from the Tropics. The size of a tornado's path of destruction is usually about 8 km long and 10 to 60 m wide. Although most tornadoes last only a few minutes, they can cause a lot of damage. Their ability to cause damage is due to their strong spinning winds. The average tornado has wind speeds between 120 and 180 km/h, but rarer, more violent tornadoes can have spinning winds of up to 500 km/h. The winds of tornadoes have been known to uproot trees and destroy buildings, as shown in **Figure 5.** Tornadoes are capable of picking up heavy objects, such as mobile homes and cars, and hurling them through the air.

hurricane a severe storm that develops over tropical oceans and whose strong winds of more than 120 km/h spiral in toward the intensely low-pressure storm center

Hurricanes

A large, rotating tropical weather system that has wind speeds of at least 120 km/h is called a **hurricane,** shown in **Figure 6.** Hurricanes are the most powerful storms on Earth. Hurricanes have different names in different parts of the world. In the western Pacific Ocean, hurricanes are called *typhoons.* Hurricanes that form over the Indian Ocean are called *cyclones.*

Most hurricanes form in the areas between 5° and 20° north latitude and between 5° and 20° south latitude over warm, tropical oceans. At higher latitudes, the water is too cold for hurricanes to form. Hurricanes vary in size from 160 to 1,500 km in diameter and can travel for thousands of kilometers.

Reading Check What are some other names for hurricanes?

Figure 6 *This photograph of Hurricane Fran was taken from space.*

How a Hurricane Forms

A hurricane begins as a group of thunderstorms moving over tropical ocean waters. Winds traveling in two different directions meet and cause the storm to spin. Because of the Coriolis effect, the storm turns counterclockwise in the Northern Hemisphere and clockwise in the Southern Hemisphere.

A hurricane gets its energy from the condensation of water vapor. Once formed, the hurricane is fueled through contact with the warm ocean water. Moisture is added to the warm air by evaporation from the ocean. As the warm, moist air rises, the water vapor condenses and releases large amounts of energy. The hurricane continues to grow as long as it is over its source of warm, moist air. When the hurricane moves into colder waters or over land, it begins to die because it has lost its source of energy. **Figure 7** and **Figure 8** show two views of a hurricane.

Reading Check Where do hurricanes get their energy?

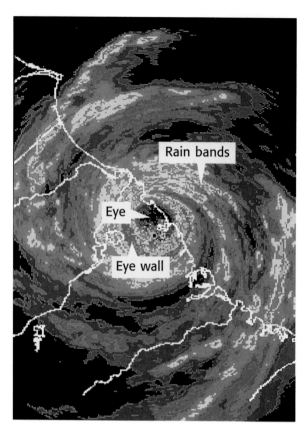

Figure 7 *The photo above gives you a bird's-eye view of a hurricane.*

Rain bands

Eye

Eye wall

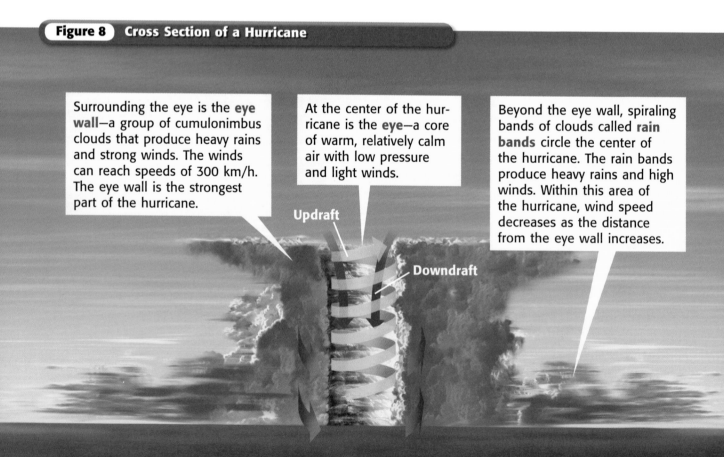

Figure 8 Cross Section of a Hurricane

Surrounding the eye is the **eye wall**—a group of cumulonimbus clouds that produce heavy rains and strong winds. The winds can reach speeds of 300 km/h. The eye wall is the strongest part of the hurricane.

At the center of the hurricane is the **eye**—a core of warm, relatively calm air with low pressure and light winds.

Beyond the eye wall, spiraling bands of clouds called **rain bands** circle the center of the hurricane. The rain bands produce heavy rains and high winds. Within this area of the hurricane, wind speed decreases as the distance from the eye wall increases.

Updraft

Downdraft

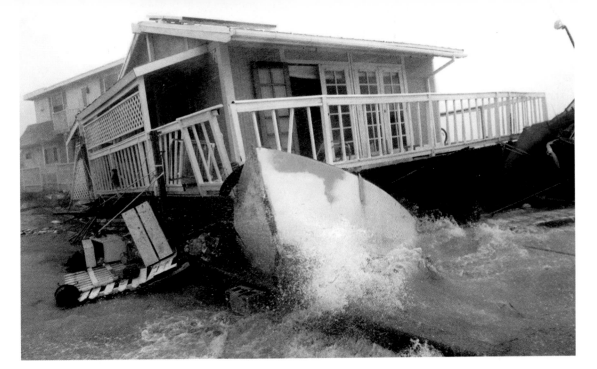

Figure 9 *A hurricane's storm surge can cause severe damage to homes near the shoreline.*

Damage Caused by Hurricanes

Hurricanes can cause a lot of damage when they move near or onto land. Wind speeds of most hurricanes range from 120 to 150 km/h. Some can reach speeds as high as 300 km/h. Hurricane winds can knock down trees and telephone poles and can damage and destroy buildings and homes.

While high winds cause a great deal of damage, most hurricane damage is caused by flooding associated with heavy rains and storm surges. A *storm surge* is a wall of water that builds up over the ocean because of the strong winds and low atmospheric pressure. The wall of water gets bigger as it nears the shore, and it reaches its greatest height when it crashes onto the shore. Depending on the hurricane's strength, a storm surge can be 1 to 8 m high and 65 to 160 km long. Flooding causes tremendous damage to property and lives when a storm surge moves onto shore, as shown in **Figure 9.**

Severe Weather Safety

Severe weather can be very dangerous, so it is important to keep yourself safe. One way to stay safe is to turn on the radio or TV during a storm. Your local radio and TV stations will let you know if a storm has gotten worse.

Thunderstorm Safety

Lightning is one of the most dangerous parts of a thunderstorm. Lightning is attracted to tall objects. If you are outside, stay away from trees, which can get struck down. If you are in the open, crouch down. Otherwise, you will be the tallest object in the area! Stay away from bodies of water. If lightning hits water while you are in it, you could be hurt or could even die.

SCHOOL to HOME

Natural Disaster Plan

WRITING SKILL Every family should have a plan to deal with weather emergencies. With a parent, discuss what your family should do in the event of severe weather. Together, write up a plan for your family to follow in case of a natural disaster. Also, make a disaster supply kit that includes enough food and water to last several days.

ACTIVITY

Figure 10 *During a tornado warning, it is best to protect yourself by crouching against a wall and covering the back of your head and neck with your hands or a book.*

Tornado Safety

Weather forecasters use watches and warnings to let people know about tornadoes. A *watch* is a weather alert that lets people know that a tornado may happen. A *warning* is a weather alert that lets people know that a tornado has been spotted.

If there is a tornado warning for your area, find shelter quickly. The best place to go is a basement or cellar. Or you can go to a windowless room in the center of the building, such as a bathroom, closet, or hallway, as **Figure 10** shows. If you are outside, lie down in a large, open field or a deep ditch.

Flood Safety

An area can get so much rain that it begins to flood. So, like tornadoes, floods have watches and warnings. However, little warning can usually be given. A flash flood is a flood that rises and falls very suddenly. The best thing to do during a flood is to find a high place to wait out the flood. You should always stay out of floodwaters. Even shallow water can be dangerous if it is moving fast.

Figure 11 *These store owners are boarding up their windows to protect the windows from strong winds during a hurricane.*

Hurricane Safety

If a hurricane is in your area, your local TV or radio station will keep you updated on its condition. People living on the shore may be asked to evacuate the area. If you live in an area where hurricanes strike, your family should have a disaster supply kit that includes enough water and food to last several days. To protect the windows in your home, you should cover them with plywood, as shown in **Figure 11.** Most important, you must stay indoors during the storm.

Summary

- Thunderstorms are intense weather systems that produce strong winds, heavy rain, lightning, and thunder.

- Lightning is a large electric discharge that occurs between two oppositely charged surfaces. Lightning releases a great deal of energy and can be very dangerous.

- Tornadoes are small, rotating columns of air that touch the ground and can cause severe damage.

- A hurricane is a large, rotating tropical weather system. Hurricanes cause strong winds and can cause severe property damage.

- In the event of severe weather, it is important to stay safe. Listening to your local TV or radio station for updates and remaining indoors and away from windows are good rules to follow.

Using Key Terms

Complete each of the following sentences by choosing the correct term from the word bank.

hurricane	storm surge
tornado	lightning

1. Thunderstorms are very active electrically and often cause ___.

2. A ___ forms when a funnel cloud pokes through the bottom of a cumulonimbus cloud and makes contact with the ground.

Understanding Key Ideas

3. The safest thing to do if you are caught outdoors during a tornado is to
 a. stay near buildings and roads.
 b. head for an open area.
 c. seek shelter near a large tree.
 d. None of the above

4. Describe how tornadoes form.

5. At what latitudes do hurricanes usually form?

6. What is lightning? What happens when lightning strikes?

Critical Thinking

7. **Applying Concepts** What items do you think you would need in a disaster kit? Explain.

8. **Identifying Relationships** What happens to a hurricane as it moves over land? Explain.

Interpreting Graphics

Use the diagram below to answer the questions that follow.

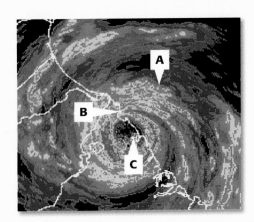

9. Describe what is happening at point C.

10. What is point B?

11. What kind of weather can you expect at point A?

Developed and maintained by the National Science Teachers Association

For a variety of links related to this chapter, go to www.scilinks.org

Topic: Severe Weather
SciLinks code: HSM1383

Forecasting the Weather

You watch the weather forecast on the evening news. The news is good—there's no rain in sight. But how can the weather forecasters tell that it won't rain?

Weather affects how you dress and how you plan your day, so it is important to get accurate weather forecasts. But where do weather reporters get their information? And how do they predict the weather? A *weather forecast* is a prediction of weather conditions over the next 3 to 5 days. A *meteorologist* is a person who observes and collects data on atmospheric conditions to make weather predictions. In this section, you will learn how weather data are collected and shown.

Weather-Forecasting Technology

To accurately forecast the weather, meteorologists need to measure various atmospheric conditions, such as air pressure, humidity, precipitation, temperature, wind speed, and wind direction. Meteorologists use special instruments to collect data on weather conditions both near and far above Earth's surface.

High in the Sky

Weather balloons carry electronic equipment that can measure weather conditions as high as 30 km above Earth's surface. Weather balloons, such as the one in **Figure 1,** carry equipment that measures temperature, air pressure, and relative humidity. By tracking the balloons, meteorologists can also measure wind speed and direction.

 Reading Check How do meteorologists gather data on atmospheric conditions above Earth's surface? (*See the Appendix for answers to Reading Check*.)

Figure 1 *Weather balloons carry radio transmitters that send measurements to stations on the ground.*

Windsock

Figure 2 *Meteorologists use these tools to collect atmospheric data.*

Thermometer

Anemometer

Measuring Air Temperature and Pressure

A tool used to measure air temperature is called a **thermometer.** Most thermometers use a liquid sealed in a narrow glass tube, as shown in **Figure 2.** When air temperature increases, the liquid expands and moves up the glass tube. As air temperature decreases, the liquid shrinks and moves down the tube.

A **barometer** is an instrument used to measure air pressure. A mercurial barometer consists of a glass tube that is sealed at one end and placed in a container full of mercury. As the air pressure pushes on the mercury inside the container, the mercury moves up the glass tube. The greater the air pressure is, the higher the mercury will rise.

Measuring Wind Direction

Wind direction can be measured by using a windsock or a wind vane. A windsock, shown in **Figure 2,** is a cone-shaped cloth bag open at both ends. The wind enters through the wide end and leaves through the narrow end. Therefore, the wide end points into the wind. A wind vane is shaped like an arrow with a large tail and is attached to a pole. As the wind pushes the tail of the wind vane, the wind vane spins on the pole until the arrow points into the wind.

thermometer an instrument that measures and indicates temperature

barometer an instrument that measures atmospheric pressure

anemometer an instrument used to measure wind speed

Measuring Wind Speed

An instrument used to measure wind speed is called an **anemometer.** An anemometer, as shown in **Figure 2,** consists of three or four cups connected by spokes to a pole. The wind pushes on the hollow sides of the cups and causes the cups to rotate on the pole. The motion sends a weak electric current that is measured and displayed on a dial.

Figure 3 *Using Doppler radar, meteorologists can predict a tornado up to 20 minutes before it touches the ground.*

Radar and Satellites

Radar is used to find the location, movement, and amount of precipitation. It can also detect what form of precipitation a weather system is carrying. You might have seen a kind of radar called *Doppler radar* used in a local TV weather report. **Figure 3** shows how Doppler radar is used to track precipitation. *Weather satellites* that orbit Earth provide the images of weather systems that you see on TV weather reports. Satellites can track storms and measure wind speeds, humidity, and temperatures at different altitudes.

Weather Maps

In the United States, the National Weather Service (NWS) and the National Oceanic and Atmospheric Administration (NOAA) collect and analyze weather data. The NWS produces weather maps based on information gathered from about 1,000 weather stations across the United States. On these maps, each station is represented by a station model. A *station model* is a small circle that shows the location of the weather station. As shown in **Figure 4,** surrounding the small circle is a set of symbols and numbers, which represent the weather data.

Figure 4 **A Station Model**

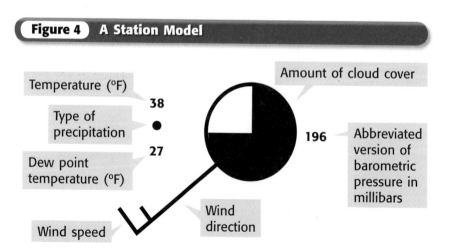

Reading a Weather Map

Weather maps that you see on TV include lines called *isobars*. Isobars are lines that connect points of equal air pressure. Isobars that form closed circles represent areas of high or low pressure. These areas are usually marked on a map with a capital *H* or *L*. Fronts are also labeled on weather maps, as you can see on the weather map in **Figure 5.**

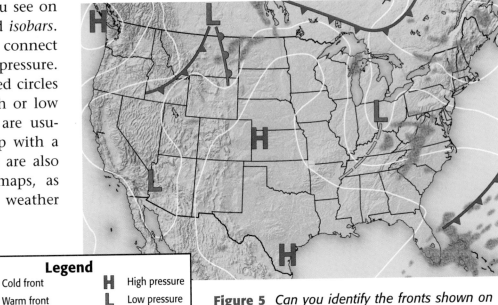

Legend

▼▼	Cold front	**H**	High pressure
⌒⌒	Warm front	**L**	Low pressure
━━	Low pressure trough	●	Rain
～～	Isobar	◯	Fog

Figure 5 *Can you identify the fronts shown on the weather map?*

SECTION Review

Summary

- Meteorologists use several instruments, such as weather balloons, thermometers, barometers, anemometers, windsocks, weather vanes, radar, and weather satellites, to forecast the weather.

- Station models show the weather conditions at various points across the United States.

- Weather maps show areas of high and low pressure as well as the location of fronts.

Using Key Terms

1. In your own words, write a definition for each of the following terms: *thermometer, barometer,* and *anemometer*.

Understanding Key Ideas

2. Which of the following instruments measures air pressure?

 a. thermometer

 b. barometer

 c. anemometer

 d. windsock

3. How does radar help meteorologists forecast the weather?

4. What does a station model represent?

Math Skills

5. If it is 75°F outside, what is the temperature in degrees Celsius? (Hint: °F = (°C × 9/5) + 32)

Critical Thinking

6. **Applying Concepts** Why would a meteorologist compare a new weather map with one that is 24 h old?

7. **Making Inferences** In the United States, why is weather data gathered from a large number of station models?

8. **Making Inferences** How might several station models from different regions plotted on a map help a meteorologist?

SCILINKS.

Developed and maintained by the National Science Teachers Association

For a variety of links related to this chapter, go to www.scilinks.org

Topic: Forecasting the Weather
SciLinks code: HSM0606

Inquiry Lab

Boiling Over!

Safety Industries, Inc., would like to produce and sell thermometers that are safer than mercury thermometers. The company would like your team of inventors to design a thermometer that uses water instead of mercury. The company will offer a contract to the team that creates the best design of a water thermometer. Good luck!

OBJECTIVES

Construct a device that uses water to measure temperature.

Calibrate the new device by using a mercury thermometer.

MATERIALS

- bottle, plastic
- can, aluminum soda
- card, index, 3 in. × 5 in.
- clay, modeling (1 lb)
- container, yogurt, with lid
- cup, plastic-foam, large (2)
- film canister
- food coloring, red (1 bottle)
- funnel, plastic or paper cone
- gloves, heat-resistant
- hot plate
- ice, cube (5 or 6)
- pan, aluminum pie
- pitcher
- plastic tubing, 5 mm diameter, 30 cm long
- ruler, metric
- straw, plastic, inflexible, clear (1)
- tape, transparent (1 roll)
- thermometer, Celsius
- water, tap

SAFETY

Ask a Question

1 What causes the liquid in a thermometer to rise? How can I use this information to make a thermometer?

Form a Hypothesis

2 Brainstorm with a classmate to design a thermometer that uses only water to measure temperature. Sketch your design. Write a one-sentence hypothesis that describes how your thermometer will work.

Test the Hypothesis

3 Following your design, build a thermometer by using only materials from the materials list. Like a mercury thermometer, your thermometer needs a bulb and a tube. However, the liquid in your thermometer will be water.

4 To test your design, place the aluminum pie pan on a hot plate. Use the pitcher to carefully pour water into the pan until the pan is half full. Turn on the hot plate, and heat the water.

5 Put on your safety goggles and heat-resistant gloves, and carefully place the "bulb" of your thermometer in the hot water. Observe the water level in the tube. Does the water level rise?

6 If the water level does not rise, change your design as necessary and repeat steps 3–5. When the water level in your thermometer does rise, sketch the design of this thermometer as your final design.

7 After you decide on your final design, you must calibrate your thermometer by using a laboratory thermometer. Tape an index card to your thermometer's tube so that the part of the tube that sticks out from the "bulb" of your thermometer touches the card.

8 Place the plastic funnel or the cone-shaped paper funnel into a plastic-foam cup. Carefully pour hot water from the pie pan into the funnel. Be sure that no water splashes or spills.

9 Place your thermometer and a laboratory thermometer in the hot water. As your thermometer's water level rises, mark the level on the index card. At the same time, observe and record the temperature of the laboratory thermometer, and write this value beside your mark on the card.

10 Repeat steps 8–9 using warm tap water.

11 Repeat steps 8–9 using ice water.

12 Draw evenly spaced scale markings between your temperature markings on the index card. Write the temperatures that correspond to the scale marks on the index card.

Analyze the Results

1 **Analyzing Results** How well does your thermometer measure temperature?

Draw Conclusions

2 **Drawing Conclusions** Compare your thermometer design with other students' designs. How would you change your design to make your thermometer measure temperature better?

3 **Applying Conclusions** Take a class vote to see which design should be used by Safety Industries. Why was this thermometer design chosen? How did it differ from other designs in the class?

Chapter Review

USING KEY TERMS

For each pair of terms, explain how the meanings of the terms differ.

1 *relative humidity* and *dew point*

2 *condensation* and *precipitation*

3 *air mass* and *front*

4 *lightning* and *thunder*

5 *tornado* and *hurricane*

6 *barometer* and *anemometer*

UNDERSTANDING KEY IDEAS

Multiple Choice

7 The process in which water changes from a liquid to gas is called

 a. precipitation.
 b. condensation.
 c. evaporation.
 d. water vapor.

8 What is the relative humidity of air at its dew point?

 a. 0% **c.** 75%
 b. 50% **d.** 100%

9 Which of the following is NOT a type of condensation?

 a. fog **c.** snow
 b. cloud **d.** dew

10 High clouds made of ice crystals are called ___ clouds.

 a. stratus **c.** nimbostratus
 b. cumulus **d.** cirrus

11 Large thunderhead clouds that produce precipitation are called ___ clouds.

 a. nimbostratus **c.** cumulus
 b. cumulonimbus **d.** stratus

12 Strong updrafts within a thunderhead can produce

 a. snow. **c.** sleet.
 b. rain. **d.** hail.

13 A maritime tropical air mass contains

 a. warm, wet air. **c.** warm, dry air.
 b. cold, moist air. **d.** cold, dry air.

14 A front that forms when a warm air mass is trapped between cold air masses and is forced to rise is a(n)

 a. stationary front. **c.** occluded front.
 b. warm front. **d.** cold front.

15 A severe storm that forms as a rapidly rotating funnel cloud is called a

 a. hurricane. **c.** typhoon.
 b. tornado. **d.** thunderstorm.

16 The lines connecting points of equal air pressure on a weather map are called

 a. contour lines. **c.** isobars.
 b. highs. **d.** lows.

Short Answer

17 Explain the relationship between condensation and dew point.

18 Describe the conditions along a stationary front.

19 What are the characteristics of an air mass that forms over the Gulf of Mexico?

20 Explain how a hurricane develops.

21 Describe the water cycle, and explain how it affects weather.

22 List the major similarities and differences between hurricanes and tornadoes.

23 Explain how a tornado forms.

24 Describe an interaction between weather and ocean systems.

25 What is a station model? What types of information do station models provide?

26 What type of technology is used to locate and measure the amount of precipitation in an area?

27 List two ways to keep yourself informed during severe weather.

28 Explain why staying away from flood-water is important even when the water is shallow.

CRITICAL THINKING

29 **Concept Mapping** Use the following terms to create a concept map: *evaporation*, *relative humidity*, *water vapor*, *dew*, *psychrometer*, *clouds*, and *fog*.

30 **Making Inferences** If both the air temperature and the amount of water vapor in the air change, is it possible for the relative humidity to stay the same? Explain.

31 **Applying Concepts** What can you assume about the amount of water vapor in the air if there is no difference between the wet- and dry-bulb readings of a psychrometer?

32 **Identifying Relationships** Explain why the concept of relative humidity is important to understanding weather.

INTERPRETING GRAPHICS

Use the weather map below to answer the questions that follow.

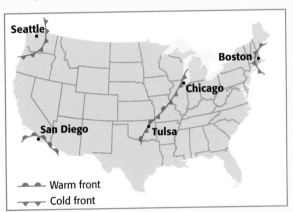

33 Where are thunderstorms most likely to occur? Explain your answer.

34 What are the weather conditions in Tulsa, Oklahoma? Explain your answer.

Standardized Test Preparation

Read each of the passages below. Then, answer the questions that follow each passage.

Passage 1 In May 1997, a springtime tornado <u>wreaked</u> havoc on Jarrell, Texas. The Jarrell tornado was a powerful tornado, whose wind speeds were estimated at more than 410 km/h. The winds of the twister were so strong that they peeled the asphalt from paved roads, stripped fields of corn bare, and destroyed an entire neighborhood. Some tornadoes, such as the one that struck the town of Jarrell, are classified as violent tornadoes. Only 2% of the tornadoes that occur in the United States are categorized as violent tornadoes. Despite the fact that these types of tornadoes do not occur often, 70% of all tornado-related deaths are a result of violent tornadoes.

1. In the passage, what does the word *wreaked* mean?

 A smelled

 B caused

 C prevented

 D removed

2. Which of the following can be concluded from the passage?

 F Tornadoes often hit Jarrell, Texas.

 G Most tornadoes fall into the violent category.

 H The tornado that hit Jarrell was a rare type of tornado.

 I Tornadoes always happen during the spring.

3. Which of the following **best** describes a characteristic of violent tornadoes?

 A Violent tornadoes destroy paved roads.

 B Violent tornadoes damage crops.

 C Violent tornadoes damage homes.

 D Violent tornadoes have extremely strong winds.

Passage 2 Water evaporates into the air from Earth's surface. This water returns to Earth's surface as <u>precipitation</u>. Precipitation is water, in solid or liquid form, that falls from the air to Earth. The four major types of precipitation are rain, snow, sleet, and hail. The most common form of precipitation is rain.

A cloud produces rain when the cloud's water drops become large enough to fall. A raindrop begins as a water droplet that is smaller than the period at the end of this sentence. Before a water drop falls as rain, it must become about 100 times this beginning size. Water drops get larger by joining with other water drops. When the water drops become too heavy, they fall as precipitation.

1. In this passage, what does *precipitation* mean?

 A acceleration

 B haste

 C water that falls from the atmosphere to Earth

 D separating a substance from a solution as a solid

2. What is the main idea of the second paragraph?

 F Rain occurs when the water droplets in clouds become large enough to fall.

 G Raindrops are very small at first.

 H Water droplets join with other water droplets to become larger.

 I Rain is a form of precipitation.

3. According to the passage, which step happens last in the formation of precipitation?

 A Water droplets join.

 B Water droplets fall to the ground.

 C Water droplets become heavy.

 D Water evaporates into the air.

Use each diagram below to answer the question that follows each diagram.

A B

1. During an experiment, the setup shown in the diagram above is maintained for 72 h. Which of the following is the most likely outcome?

A Beaker A will hold less water than beaker B will.

B The amount of water in beaker A and beaker B will stay the same.

C The amount of water in beaker A and beaker B will change by about the same amount.

D Beaker B will hold less water than beaker A will.

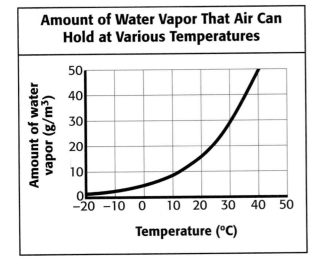

Amount of Water Vapor That Air Can Hold at Various Temperatures

2. Look at the line graph above. Which statement is consistent with the line graph?

F The ability of air to hold moisture increases as temperature increases.

G The ability of air to hold moisture decreases as temperature increases.

H The ability of air to hold moisture decreases and then increases as temperature increases.

I The ability of air to hold moisture stays the same regardless of temperature.

Read each question below, and choose the best answer.

1. The speed of light is 3.00×10^8 m/s. What is another way to express this measure?

A 3,000,000,000 m/s

B 300,000,000 m/s

C 3,000,000 m/s

D 300,000 m/s

2. A hurricane is moving 122 km/h. How long will it take to hit the coast, which is 549 km away?

F 4.2 h

G 4.5 h

H 4.8 h

I 5.2 h

3. A front is moving 15 km/h in an easterly direction. At that rate, how far will the front travel in 12 h?

A 0.8 km

B 1.25 km

C 27 km

D 180 km

4. On average, 2 out of every 100 tornadoes are classified as violent tornadoes. If there are 400 tornadoes in 1 year, which is the best prediction of the number of tornadoes that will be classified as violent tornadoes during that year?

F 2

G 4

H 8

I 16

5. The air temperature in the morning was 27°C. During the day, a front moved into the region and caused the temperature to drop to 18°C. By how many degrees did the temperature drop?

A 1°C

B 9°C

C 11°C

D 19°C

Standardized Test Preparation

Science in Action

Science Fiction

"All Summer in a Day" by Ray Bradbury

It is raining, just as it has been for seven long years. For the people who live on Venus, constant rain is a fact of life. But today is a special day—a day when the rain stops and the sun shines. This day comes once every seven years. At school, the students have been looking forward to this day for weeks. But Margot longs to see the sun even more than the others do. The reason for her longing makes the other kids jealous, and jealous kids can be cruel. What happens to Margot? Find out by reading Ray Bradbury's "All Summer in a Day" in the *Holt Anthology of Science Fiction*.

Language Arts ACTiViTY

WRITING SKILL What would living in a place where it rained all day and every day for seven years be like? Write a short story describing what your life would be like if you lived in such a place. In your story, describe what you and your friends would do for fun after school.

Weird Science

Can Animals Forecast the Weather?

Before ways of making sophisticated weather forecasts were developed, people observed animals and insects for evidence of changing weather. By observing the behavior of certain animals and insects, you, too, can detect changing weather! For example, did you know that birds fly higher when fair weather is coming? And a robin's song is high pitched in fair weather and low pitched as rain approaches. Ants travel in lines when rain is coming and scatter when the weather is clear. You can tell how hot the weather is by listening for the chirping of crickets—crickets chirp faster as the temperature rises!

Math ACTiViTY

To estimate the outdoor temperature in degrees Fahrenheit, count the number of times that a cricket chirps in 15 s and add 37. If you count 40 chirps in 15 s, what is the estimated temperature?

Cristy Mitchell

Meteorologist Predicting floods, observing a tornado develop inside a storm, watching the growth of a hurricane, and issuing flood warnings are all in a day's work for Cristy Mitchell. As a meteorologist for the National Weather Service, Mitchell spends each working day observing the powerful forces of nature. When asked what made her job interesting, Mitchell replied, "There's nothing like the adrenaline rush you get when you see a tornado coming!"

Perhaps the most familiar field of meteorology is weather forecasting. However, meteorology is also used in air-pollution control, weather control, agricultural planning, and even criminal and civil investigations. Meteorologists also study trends in Earth's climate.

Meteorologists such as Mitchell use high-tech tools—computers and satellites—to collect data. By analyzing such data, Mitchell is able to forecast the weather.

Social Studies ACTiViTY

An almanac is a type of calendar that contains various information, including weather forecasts and astronomical data, for every day of the year. Many people used almanacs before meteorologists started to forecast the weather on TV. Use an almanac from the library to find out what the weather was on the day that you were born.

To learn more about these Science in Action topics, visit go.hrw.com and type in the keyword HZ5WEAF.

Current Science

Check out Current Science® articles related to this chapter by visiting go.hrw.com. Just type in the keyword HZ5CS16.

3

Climate

About the PHOTO

Would you like to hang out on this ice with the penguins? You probably would not. You would be shivering, and your teeth would be chattering. However, these penguins feel comfortable. They have thick feathers and lots of body fat to keep them warm. Like other animals, penguins have adapted to their climate, which allows them to live comfortably in that climate. So, you will never see one of these penguins living comfortably on a hot, sunny beach in Florida!

PRE-READING ACTIVITY

FOLDNOTES **Pyramid** Before you read the chapter, create the FoldNote entitled "Pyramid" described in the **Study Skills** section of the Appendix. Label the sides of the pyramid with "Tropical climate," "Temperate climate," and "Polar climate." As you read the chapter, define each climate zone, and write characteristics of each climate zone on the appropriate pyramid side.

START-UP ACTIVITY

What's Your Angle?

Try this activity to see how the angle of the sun's solar rays influences temperatures on Earth.

Procedure

1. Place a **lamp** 30 cm from a **globe.**
2. Point the lamp so that the light shines directly on the globe's equator.
3. Using **adhesive putty,** attach a **thermometer** to the globe's equator in a vertical position. Attach **another thermometer** to the globe's North Pole so that the tip points toward the lamp.
4. Record the temperature reading of each thermometer.
5. Turn on the lamp, and let the light shine on the globe for 3 minutes.
6. After 3 minutes, turn off the lamp and record the temperature reading of each thermometer again.

Analysis

1. Was there a difference between the final temperature at the globe's North Pole and the final temperature at the globe's equator? If so, what was it?
2. Explain why the temperature readings at the North Pole and the equator may be different.

What Is Climate?

Suppose you receive a call from a friend who is coming to visit you tomorrow. To decide what clothing to bring, he asks about the current weather in your area.

You step outside to see if rain clouds are in the sky and to check the temperature. But what would you do if your friend asked you about the climate in your area? What is the difference between weather and climate?

READING WARM-UP

Objectives

- Explain the difference between weather and climate.
- Identify five factors that determine climates.
- Identify the three climate zones of the world.

Terms to Learn

weather elevation
climate surface current
latitude biome
prevailing winds

READING STRATEGY

Discussion Read this section silently. Write down questions that you have about this section. Discuss your questions in a small group.

Climate Vs. Weather

The main difference between weather and climate is the length of time over which both are measured. **Weather** is the condition of the atmosphere at a particular time. Weather conditions vary from day to day and include temperature, humidity, precipitation, wind, and visibility. **Climate,** on the other hand, is the average weather condition in an area over a long period of time. Climate is mostly determined by two factors—temperature and precipitation. Different parts of the world can have different climates, as shown in **Figure 1.** But why are climates so different? The answer is complicated. It includes factors in addition to temperature and precipitation, such as latitude, wind patterns, mountains, large bodies of water, and ocean currents.

Reading Check How is climate different from weather? (*See the Appendix for answers to Reading Checks.*)

Figure 1 *How does the climate in northern Africa differ from the climate where you live?*

North America

South America

Africa

Latitude

Think of the last time you looked at a globe. Do you recall the thin, horizontal lines that circle the globe? Those lines are called lines of latitude. **Latitude** is the distance north or south, measured in degrees, from the equator. In general, the temperature of an area depends on its latitude. The higher the latitude is, the colder the climate tends to be. One of the coldest places on Earth, the North Pole, is 90° north of the equator. However, the equator, at latitude 0°, is usually hot.

As shown in **Figure 2,** if you were to take a trip to different latitudes in the United States, you would experience different climates. For example, the climate in Washington, D.C., which is at a higher latitude, is different from the climate in Texas.

Solar Energy and Latitude

Solar energy, which is energy from the sun, heats the Earth. The amount of direct solar energy a particular area receives is determined by latitude. **Figure 3** shows how the curve of the Earth affects the amount of direct solar energy at different latitudes. Notice that the sun's rays hit the equator directly, at almost a 90° angle. At this angle, a small area of the Earth's surface receives more direct solar energy than at a lesser angle. As a result, that area has high temperatures. However, the sun's rays strike the poles at a lesser angle than they do the equator. At this angle, the same amount of direct solar energy that hits the area at the equator is spread over a larger area at the poles. The result is lower temperatures at the poles.

Figure 2 *Winter in south Texas (top) is different from winter in Washington D.C. (bottom).*

weather the short-term state of the atmosphere, including temperature, humidity, precipitation, wind, and visibility

climate the average weather condition in an area over a long period of time

latitude the distance north or south from the equator; expressed in degrees

Figure 3 The sun's rays strike the Earth's surface at different angles because the surface is curved.

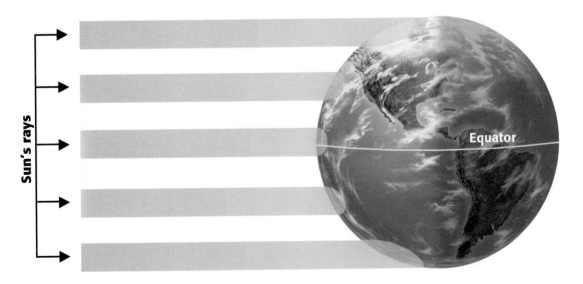

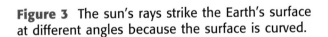

Seasons and Latitude

In most places in the United States, the year consists of four seasons. But there are places in the world that do not have such seasonal changes. For example, areas near the equator have approximately the same temperatures and same amount of daylight year-round. Seasons happen because the Earth is tilted on its axis at a 23.5° angle. This tilt affects how much solar energy an area receives as Earth moves around the sun. **Figure 4** shows how latitude and the tilt of the Earth determine the seasons and the length of the day in a particular area.

✓ *Reading Check* Why is there less seasonal change near the equator?

Figure 4 **The Seasons**

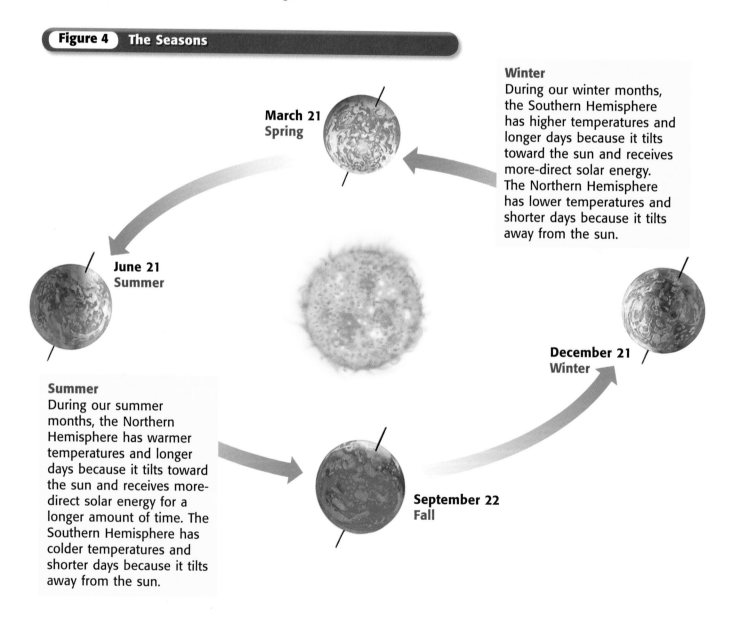

March 21
Spring

Winter
During our winter months, the Southern Hemisphere has higher temperatures and longer days because it tilts toward the sun and receives more-direct solar energy. The Northern Hemisphere has lower temperatures and shorter days because it tilts away from the sun.

June 21
Summer

December 21
Winter

Summer
During our summer months, the Northern Hemisphere has warmer temperatures and longer days because it tilts toward the sun and receives more-direct solar energy for a longer amount of time. The Southern Hemisphere has colder temperatures and shorter days because it tilts away from the sun.

September 22
Fall

Figure 5 The Circulation of Warm Air and Cold Air

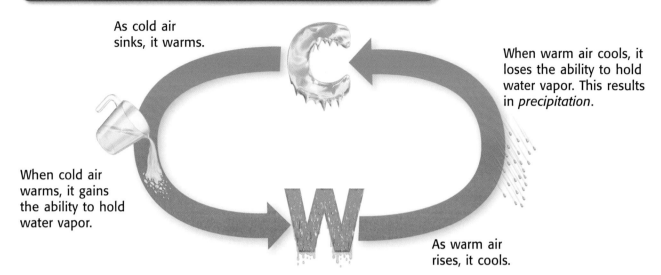

As cold air sinks, it warms.

When warm air cools, it loses the ability to hold water vapor. This results in *precipitation*.

When cold air warms, it gains the ability to hold water vapor.

As warm air rises, it cools.

Prevailing Winds

Winds that blow mainly from one direction are **prevailing winds**. Before you learn how the prevailing winds affect climate, take a look at **Figure 5** to learn about some of the basic properties of air.

Prevailing winds affect the amount of precipitation that a region receives. If the prevailing winds form from warm air, they may carry moisture. If the prevailing winds form from cold air, they will probably be dry.

The amount of moisture in prevailing winds is also affected by whether the winds blow across land or across a large body of water. Winds that travel across large bodies of water absorb moisture. Winds that travel across land tend to be dry. Even if a region borders the ocean, the area might be dry. **Figure 6** shows an example of how dry prevailing winds can cause the land to be dry though the land is near an ocean.

prevailing winds winds that blow mainly from one direction during a given period

A Cool Breeze

1. Hold a **thermometer** next to the top edge of a **cup** of **water** containing two **ice cubes.** Record the temperature next to the cup.

2. Have your lab partner fan the surface of the cup with a **paper fan.** Record the temperature again. Has the temperature changed? Why or why not?

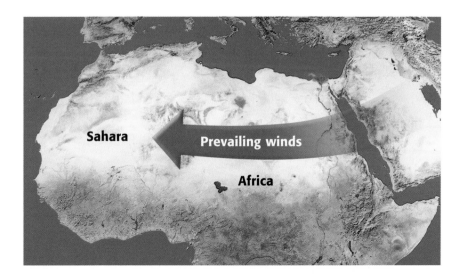

Figure 6 *The Sahara Desert, in northern Africa, is extremely dry because of the dry prevailing winds that blow across the continent.*

School to Home

Using a Map

With your parent, use a physical map to locate the mountain ranges in the United States. Does climate vary from one side of a mountain range to the other? If so, what does this tell you about the climatic conditions on either side of the mountain? From what direction are the prevailing winds blowing?

ACTIVITY

Mountains

Mountains can influence an area's climate by affecting both temperature and precipitation. Kilimanjaro is the tallest mountain in Africa. It has snow-covered peaks year-round, even though it is only about 3° (320 km) south of the equator. Temperatures on Kilimanjaro and in other mountainous areas are affected by elevation. **Elevation** is the height of surface landforms above sea level. As the elevation increases, the ability of air to transfer energy from the ground to the atmosphere decreases. Therefore, as elevation increases, temperature decreases.

Mountains also affect the climate of nearby areas by influencing the distribution of precipitation. **Figure 7** shows how the climates on two sides of a mountain can be very different.

✓ Reading Check Why does the atmosphere become cooler at higher elevations?

Figure 7 *Mountains block the prevailing winds and affect the climate on the other side.*

The Wet Side
Mountains force air to rise. The air cools as it rises, releasing moisture as snow or rain. The land on the windward side of the mountain is usually green and lush because the wind releases its moisture.

The Dry Side
After dry air crosses the mountain, the air begins to sink. As the air sinks, it is warmed and absorbs moisture. The dry conditions created by the sinking, warm air usually produce a desert. This side of the mountain is in a *rain shadow*.

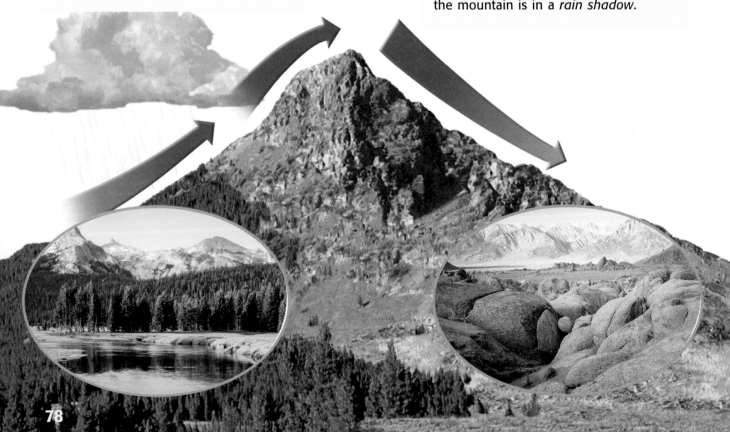

Large Bodies of Water

Large bodies of water can influence an area's climate. Water absorbs and releases heat slower than land does. Because of this quality, water helps to moderate the temperatures of the land around it. So, sudden or extreme temperature changes rarely take place on land near large bodies of water. For example, the state of Michigan, which is surrounded by the Great Lakes, has more-moderate temperatures than other places at the same latitude. The lakes also increase the moisture content of the air, which leads to heavy snowfall in the winter. This "lake effect" can cause 350 inches of snow to drop in one year!

Ocean Currents

The circulation of ocean surface currents has a large effect on an area's climate. **Surface currents** are streamlike movements of water that occur at or near the surface of the ocean. **Figure 8** shows the pattern of the major ocean surface currents.

As surface currents move, they carry warm or cool water to different locations. The surface temperature of the water affects the temperature of the air above it. Warm currents heat the surrounding air and cause warmer temperatures. Cool currents cool the surrounding air and cause cooler temperatures. The Gulf Stream current carries warm water northward off the east coast of North America and past Iceland. Iceland is an island country located just below the Arctic Circle. The warm water from the Gulf Stream heats the surrounding air and creates warmer temperatures in southern Iceland. Iceland experiences milder temperatures than Greenland, its neighboring island. Greenland's climate is cooler because Greenland is not influenced by the Gulf Stream.

Reading Check Why does Iceland experience milder temperatures than Greenland?

elevation the height of an object above sea level

surface current a horizontal movement of ocean water that is caused by wind and that occurs at or near the ocean's surface

Figure 8 *The red arrows represent the movement of warm surface currents. The blue arrows represent the movement of cold surface currents.*

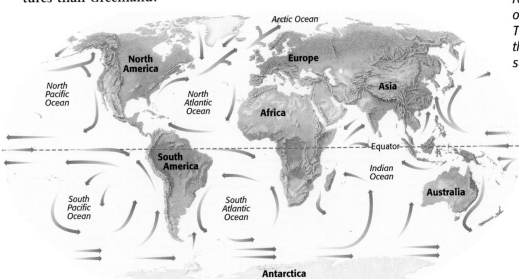

Figure 9 *The three major climate zones are determined by latitude.*

biome a large region characterized by a specific type of climate and certain types of plant and animal communities

Climates of the World

Have you seen any polar bears in your neighborhood lately? You probably have not. That's because polar bears live only in very cold arctic regions. Why are the animals in one part of the world so different from the animals in other parts? One of the differences has to do with climate. Plants and animals that have adapted to one climate may not be able to live in another climate. For example, frogs would not be able to survive at the North Pole.

Climate Zones

The Earth's three major climate zones—tropical, temperate, and polar—are shown in **Figure 9.** Each zone has a temperature range that relates to its latitude. However, in each of these zones, there are several types of climates because of differences in the geography and the amount of precipitation. Because of the various climates in each zone, there are different biomes in each zone. A **biome** is a large region characterized by a specific type of climate and certain types of plant and animal communities. **Figure 10** shows the distribution of the Earth's land biomes. In which biome do you live?

✓ **Reading Check** What factors distinguish one biome from another biome?

Figure 10 **The Earth's Land Biomes**

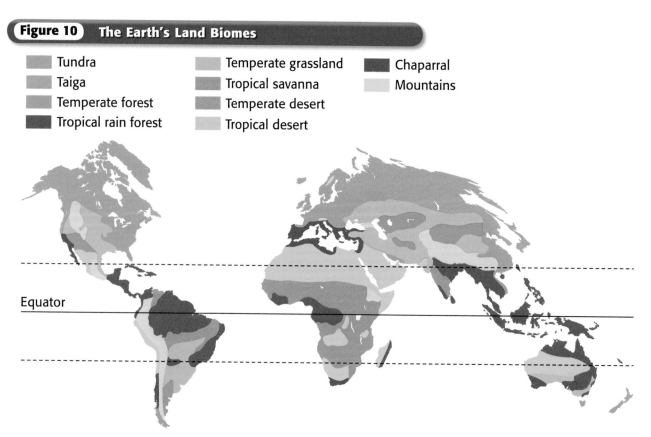

Tundra	Temperate grassland	Chaparral
Taiga	Tropical savanna	Mountains
Temperate forest	Temperate desert	
Tropical rain forest	Tropical desert	

Equator

Summary

- Weather is the condition of the atmosphere at a particular time. This condition includes temperature, humidity, precipitation, wind, and visibility.

- Climate is the average weather condition in an area over a long period of time.

- The higher the latitude, the cooler the climate.

- Prevailing winds affect the climate of an area by the amount of moisture they carry.

- Mountains influence an area's climate by affecting both temperature and precipitation.

- Large bodies of water and ocean currents influence the climate of an area by affecting the temperature of the air over the water.

- The three climate zones of the world are the tropical zone, the temperate zone, and the polar zone.

Using Key Terms

1. In your own words, write a definition for each of the following terms: *weather, climate, latitude, prevailing winds, elevation, surface currents,* and *biome.*

Understanding Key Ideas

2. Which of the following affects climate by causing the air to rise?

 a. mountains

 b. ocean currents

 c. large bodies of water

 d. latitude

3. What is the difference between weather and climate?

4. List five factors that determine climates.

5. Explain why there is a difference in climate between areas at 0° latitude and areas at 45° latitude.

6. List the three climate zones of the world.

Critical Thinking

7. **Analyzing Relationships** How would seasons be different if the Earth did not tilt on its axis?

8. **Applying Concepts** During what months does Australia have summer? Explain.

Interpreting Graphics

Use the map below to answer the questions that follow.

9. Would you expect the area that the arrow points to to be moist or dry? Explain your answer.

10. Describe how the climate of the same area would change if the prevailing winds traveled from the opposite direction. Explain how you came to this conclusion.

SCILINKS®

NSTA

Developed and maintained by the National Science Teachers Association

For a variety of links related to this chapter, go to www.scilinks.org

Topic: What Is Climate?
SciLinks code: HSM1659

The Tropics

Where in the world do you think you could find a flying dragon gliding above you from one treetop to the next?

Don't worry. This flying dragon, or tree lizard, is only about 20 cm long, and it eats only insects. With winglike skin flaps, the flying dragon can glide from one treetop to the next. But, you won't find this kind of animal in the United States. These flying dragons live in Southeast Asia, which is in the tropical zone.

The Tropical Zone

The region that surrounds the equator and that extends from about 23.5° north latitude to 23.5° south latitude is called the **tropical zone.** The tropical zone is also known as the Tropics. Latitudes in the tropical zone receive the most solar radiation. Temperatures are therefore usually hot, except at high elevations.

Within the tropical zone, there are three major types of biomes—tropical rain forest, tropical desert, and tropical savanna. These three biomes have high temperatures. But they differ in the amount of precipitation, soil characteristics, vegetation, and kinds of animals. **Figure 1** shows the distribution of these biomes.

✓ Reading Check At what latitudes would you find the tropical zone? (*See the Appendix for answers to Reading Checks.*)

Figure 1 Biomes of the Tropical Zone

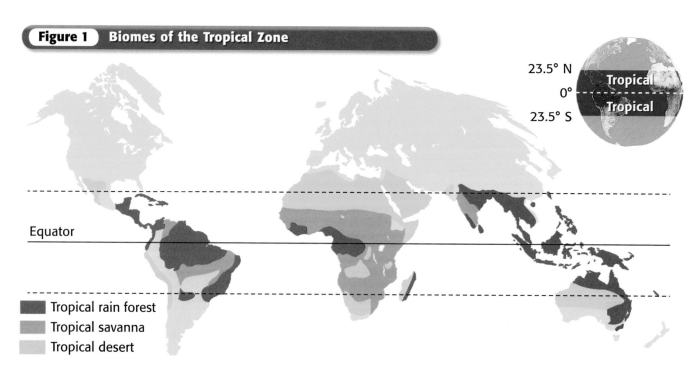

23.5° N
0°
23.5° S

Tropical
Tropical

Equator

■ Tropical rain forest
■ Tropical savanna
■ Tropical desert

Tropical Rain Forest

- **Average Temperature Range**
 25°C to 28°C (77°F to 82°F)
- **Average Yearly Precipitation**
 200 cm or more
- **Soil Characteristics**
 thin and nutrient poor

Tropical Rain Forests

Tropical rain forests are always warm and wet. Because they are located near the equator, they receive strong sunlight year-round. So, there is little difference between seasons in tropical rain forests.

Tropical rain forests contain the greatest number of animal and plant species of any biome. Animals found in tropical rain forests include monkeys, parrots, tree frogs, tigers, and leopards. Plants found in tropical rain forests include mahogany, vines, ferns, and bamboo. But in spite of the lush vegetation, shown in **Figure 2,** the soil in rain forests is poor. The rapid decay of plants and animals returns nutrients to the soil. But these nutrients are quickly absorbed and used by the plants. The nutrients that are not immediately used by the plants are washed away by the heavy rains. The soil is left thin and nutrient poor.

Figure 2 *In tropical rain forests, many of the trees form above-ground roots that provide extra support for the trees in the thin, nutrient-poor soil.*

tropical zone the region that surrounds the equator and that extends from about 23.5° north latitude to 23.5° south latitude

CONNECTION TO Social Studies

WRITING SKILL **Living in the Tropics** The tropical climate is very hot and humid. People who live in the Tropics have had to adapt to feel comfortable in that climate. For example, in the country of Samoa, some people live in homes that have no walls, which are called *fales.* Fales have only a roof, which provides shade. The openness of the home allows cool breezes to flow through the home. Research other countries in the Tropics. See how the climate influences the way the people live in those countries. Then, in your **science journal,** describe how the people's lifestyle helps them adapt to the climate.

Tropical Savanna

- **Average Temperature Range** 27°C to 32°C (80°F to 90°F)
- **Average Yearly Precipitation** 100 cm
- **Soil Characteristics** generally nutrient poor

Figure 3 *The grass of a tropical savanna can be as tall as 5 m.*

Tropical Savannas

Tropical savannas, or grasslands, are composed of tall grasses and a few scattered trees. The climate is usually very warm. Tropical savannas have a dry season that lasts four to eight months and that is followed by short periods of rain. Savanna soils are generally nutrient poor. However, grass fires, which are common during the dry season, leave the soils nutrient enriched. An African savanna is shown in **Figure 3.**

Many plants have adapted to fire and use it to promote development. For example, some species need fire to break open their seeds' outer skin. Only after this skin is broken can each seed grow. For other species, heat from the fire triggers the plants to drop their seeds into the newly enriched soil.

Animals that live in tropical savannas include giraffes, lions, crocodiles, and elephants. Plants include tall grasses, trees, and thorny shrubs.

CONNECTION TO Biology

WRITING SKILL **Animal and Plant Adaptations** Animals and plants adapt to the climate in which they live. These adaptations cause certain animals and plants to be unique to particular biomes. For example, the camel, which is unique to the desert, has adapted to going for long periods of time without water. Research other animals or plants that live in the Tropics. Then, in your **science journal,** describe the characteristics that help them survive in the Tropics.

Tropical Deserts

A desert is an area that receives less than 25 cm of rainfall per year. Because of this low yearly rainfall, deserts are the driest places on Earth. Desert plants, such as those shown in **Figure 4,** are adapted to survive in places that have little water. Animals such as rats, lizards, snakes, and scorpions have also adapted to survive in these deserts.

There are two kinds of deserts—hot deserts and cold deserts. Hot deserts are caused by cool, sinking air masses. Many hot deserts, such as the Sahara, in Africa, are tropical deserts. Daily temperatures in tropical deserts often vary from very hot daytime temperatures (50°C) to cool nighttime temperatures (20°C). Because of the dryness of deserts, the soil is poor in organic matter, which is needed for plants to grow.

✓ Reading Check What animals would you find in a tropical desert?

Tropical Desert

• **Average Temperature Range**
 16°C to 50°C (61°F to 120°F)
• **Average Yearly Precipitation**
 0–25 cm
• **Soil Characteristics**
 poor in organic matter

Figure 4 *Plants such as succulents have fleshy stems and leaves to store water.*

SECTION Review

Summary

- The tropical zone is located around the equator, between 23.5° north and 23.5° south latitude.

- Temperatures are usually hot in the tropical zone.

- Tropical rain forests are warm and wet. They have the greatest number of plant and animal species of any biome.

- Tropical savannas are grasslands that have a dry season.

- Tropical deserts are hot and receive little rain.

Using Key Terms

1. In your own words, write a definition for the term *tropical zone.*

Understanding Key Ideas

2. Which of the following tropical biomes has less than 50 cm of precipitation a year?
 a. rain forest **c.** grassland
 b. desert **d.** savanna

3. What are the soil characteristics of a tropical rain forest?

4. In what ways have savanna vegetation adapted to fire?

Math Skills

5. Suppose that in a tropical savanna, the temperature was recorded every hour for 4 h. The recorded temperatures were 27°C, 28°C, 29°C, and 29°C. Calculate the average temperature for this 4 h period.

Critical Thinking

6. **Analyzing Relationships** How do the tropical biomes differ?

7. **Making Inferences** How would you expect the adaptations of a plant in a tropical rain forest to differ from the adaptations of a tropical desert plant? Explain.

8. **Analyzing Data** An area has a temperature range of 30°C to 40°C and received 10 cm of rain this year. What biome is this area in?

Temperate and Polar Zones

Which season is your favorite? Do you like the change of colors in the fall, the flowers in the spring, or do you prefer the hot days of summer?

If you live in the continental United States, chances are you live in a biome that experiences seasonal change. Seasonal change is one characteristic of the temperate zone. Most of the continental United States is in the temperate zone, which is the climate zone between the Tropics and the polar zone.

The Temperate Zone

The climate zone between the Tropics and the polar zone is the **temperate zone.** Latitudes in the temperate zone receive less solar energy than latitudes in the Tropics do. Because of this, temperatures in the temperate zone tend to be lower than in the Tropics. Some biomes in the temperate zone have a mild change of seasons. Other biomes in the country can experience freezing temperatures in the winter and very hot temperatures in the summer. The temperate zone consists of the following four biomes—temperate forest, temperate grassland, chaparral, and temperate desert. Although these biomes have four distinct seasons, the biomes differ in temperature and precipitation and have different plants and animals. **Figure 1** shows the distribution of the biomes found in the temperate zone.

✓ **Reading Check** Where is the temperate zone? (*See the Appendix for answers to Reading Checks.*)

Figure 1 Biomes of the Temperate Zone

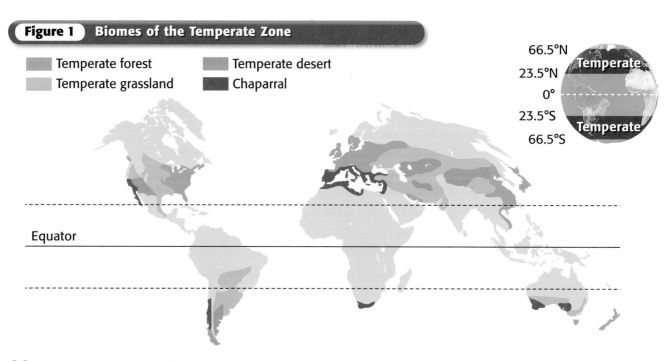

■ Temperate forest
■ Temperate grassland
■ Temperate desert
■ Chaparral

66.5°N
23.5°N
0°
23.5°S
66.5°S

Temperate
Temperate

Equator

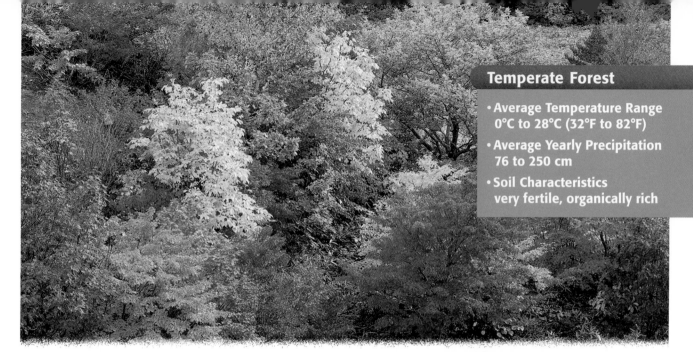

Figure 2 *Deciduous trees have leaves that change color and drop when temperatures become cold.*

Temperate Forests

The temperate forest biomes tend to have high amounts of rainfall and seasonal temperature differences. Summers are often warm, and winters are often cold. Animals such as deer, bears, and foxes live in temperate forests. **Figure 2** shows deciduous trees in a temperate forest. *Deciduous* describes trees that lose their leaves at the end of the growing season. The soils in deciduous forests are usually fertile because of the high organic content from decaying leaves that drop every winter. Another type of tree found in the temperate forest is the evergreen. *Evergreens* are trees that keep their leaves year-round.

temperate zone the climate zone between the Tropics and the polar zone

Temperate Grasslands

Temperate grasslands, such as those shown in **Figure 3,** are regions that receive too little rainfall for trees to grow. This biome has warm summers and cold winters. Examples of animals that are found in temperate grasslands include bison in North America and kangaroo in Australia. Grasses are the most common kind of plant found in this biome. Because grasslands have the most-fertile soils of all biomes, much of the grassland has been plowed to make room for croplands.

Figure 3 *At one time, the world's grasslands covered about 42% of Earth's total land surface. Today, they occupy only about 12% of the Earth's total land surface.*

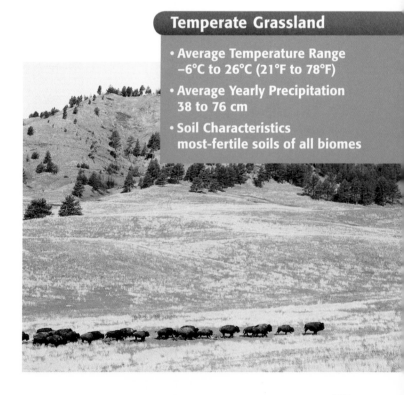

Chaparral

- Average Temperature Range 11°C to 26°C (51°F to 78°F)
- Average Yearly Precipitation 48 to 56 cm
- Soil Characteristics rocky, nutrient-poor soils

Chaparrals

Chaparral regions, as shown in **Figure 4,** have cool, wet winters and hot, dry summers. Animals, such as coyotes and mountain lions live in chaparrals. The vegetation is mainly evergreen shrubs. These shrubs are short, woody plants with thick, waxy leaves. The waxy leaves are adaptations that help prevent water loss in dry conditions. These shrubs grow in rocky, nutrient-poor soil. Like tropical-savanna vegetation, chaparral vegetation has adapted to fire. In fact, some plants, such as chamise, can grow back from their roots after a fire.

Temperate Deserts

The temperate desert biomes, like the one shown in **Figure 5,** tend to be cold deserts. Like all deserts, cold deserts receive less than 25 cm of precipitation yearly. Examples of animals that live in temperate deserts are lizards, snakes, bats, and toads. And the types of plants found in temperate deserts include cacti, shrubs, and thorny trees.

Temperate deserts can be very hot in the daytime. But, unlike hot deserts, they are often very cold at night. This large change in temperature between day and night is caused by low humidity and cloudless skies. These conditions allow for a large amount of energy to heat the Earth's surface during the day. However, these same characteristics allow the energy to escape at night. This causes temperatures to drop. You probably rarely think of snow and deserts together. But temperate deserts often receive light snow during the winter.

Reading Check Why are temperate deserts cold at night?

Figure 4 *Some plant species found in chaparral require fire to reproduce.*

Figure 5 *The Great Basin Desert is in the rain shadow of the Sierra Nevada.*

Temperate Desert

- Average Temperature Range 1°C to 50°C (34°F to 120°F)
- Average Yearly Precipitation 0 to 25 cm
- Soil Characteristics poor in organic matter

Figure 6 Biomes of the Polar Zone

Equator

Tundra

Taiga

Polar
66.5°N

0°

66.5°S
Polar

The Polar Zone

The climate zone located at the North or South Pole and its surrounding area is called the **polar zone.** Polar climates have the coldest average temperatures of all the climate zones. Temperatures in the winter stay below freezing. The temperatures during the summer remain cool. **Figure 6** shows the distribution of the biomes found in the polar zone.

polar zone the North or South Pole and its surrounding area

Tundra

The tundra biome, as shown in **Figure 7,** has long, cold winters with almost 24 hours of night. It also has short, cool summers with almost 24 hours of daylight. In the summer, only the top meter of soil thaws. Underneath the thawed soil lies a permanently frozen layer of soil, called *permafrost.* This frozen layer prevents the water in the thawed soil from draining. Because of the poor drainage, the upper soil layer is muddy. This muddy layer of soil makes a great breeding ground for insects, such as mosquitoes. Many birds migrate to the tundra during the summer to feed on the insects. Other animals that live in the tundra are caribou, reindeer, and polar bears. Plants in this biome include mosses and lichens.

Tundra

- **Average Temperature Range** −27°C to 5°C (−17°F to 41°F)
- **Average Yearly Precipitation** 0 to 25 cm
- **Soil Characteristics** frozen

Figure 7 *In the tundra, mosses and lichens cover rocks.*

Taiga
- **Average Temperature Range** −10°C to 15°C (14°F to 59°F)
- **Average Yearly Precipitation** 40 to 61 cm
- **Soil Characteristics** acidic

Figure 8 *The taiga, such as this one in Washington, have mostly evergreens for trees.*

microclimate the climate of a small area

Taiga (Northern Coniferous Forest)

Just south of the tundra lies the taiga biome. The taiga, as shown in **Figure 8,** has long, cold winters and short, warm summers. Animals commonly found here are moose, bears, and rabbits. The majority of the trees are evergreen needle-leaved trees called *conifers,* such as pine, spruce, and fir trees. The needles and flexible branches allow these trees to shed heavy snow before they can be damaged. Conifer needles are made of acidic substances. When the needles die and fall to the soil, they make the soil acidic. Most plants cannot grow in acidic soil. Because of the acidic soil, the forest floor is bare except for some mosses and lichens.

Microclimates

The climate and the biome of a particular place can also be influenced by local conditions. **Microclimate** is the climate of a small area. The alpine biome is a cold biome found on mountains all around the world. The alpine biome can even be found on mountains in the Tropics! How is this possible? The high elevation affects the area's climate and therefore its biome. As the elevation increases, the air's ability to transfer heat from the ground to the atmosphere by conduction decreases, which causes temperatures to decrease. In winter, the temperatures are below freezing. In summer, average temperatures range from 10°C to 15°C. Plants and animals have had to develop special adaptations to live in this severe climate.

SCHOOL to HOME

WRITING SKILL **Your Biome** With your parents, explore the biome in the area where you live. What kinds of animals and plants live in your area? Write a one-page paper that describes the biome and why the biome of your area has its particular climate.

ACTIVITY

Cities

Cities are also microclimates. In a city, temperatures can be 1°C to 2°C warmer than the surrounding rural areas. Have you ever walked barefoot on a black asphalt street on a hot summer day? Doing so burns your feet because buildings and pavement made of dark materials absorb solar radiation instead of reflecting it. There is also less vegetation in a city to take in the sun's rays. This absorption and re-radiation of heat by buildings and pavement heats the surrounding air. In turn, the temperatures rise.

✓ Reading Check Why do cities have higher temperatures than the surrounding rural areas?

CONNECTION TO Physics

Hot Roofs! Scientists studied roofs on a sunny day when the air temperature was 13°C. They recorded roof temperatures ranging from 18°C to 61°C depending on color and material of the roof. Place thermometers on outside objects that are made of different types of materials and that are different colors. Please stay off the roof! Is there a difference in temperatures?

ACTiViTY

SECTION Review

Summary

- The temperate zone is located between the Tropics and the polar zone. It has moderate temperatures.

- Temperate forests, temperate grasslands, and temperate deserts are biomes in the temperate zone.

- The polar zone includes the North or South Pole and its surrounding area. The polar zone has the coldest temperatures.

- The tundra and the taiga are biomes within the polar zone.

Using Key Terms

1. In your own words, write a definition for the term *microclimate*.

Complete each of the following sentences by choosing the correct term from the word bank.

temperate zone polar zone
microclimate

2. The coldest temperatures are found in the ___.

3. The ___ has moderate temperatures.

Understanding Key Ideas

4. Which of the following biomes has the driest climate?
 a. temperate forests
 b. temperate grasslands
 c. chaparrals
 d. temperate deserts

5. Explain why the temperate zone has lower temperatures than the Tropics.

6. Describe how the latitude of the polar zone affects the climate in that area.

7. Explain why the tundra can sometimes experience 24 hours of daylight or 24 hours of night.

8. How do conifers make the soil they grow in too acidic for other plants to grow?

Math Skills

9. Texas has an area of about 700,000 square kilometers. Grasslands compose about 20% of this area. About how many square kilometers of grassland are there in Texas?

Critical Thinking

10. **Identifying Relationships** Which biome would be more suitable for growing crops, temperate forest or taiga? Explain.

11. **Making Inferences** Describe the types of animals and vegetation you might find in the Alpine biome.

SCILINKS®

NSTA
Developed and maintained by the
National Science Teachers Association

For a variety of links related to this chapter, go to www.scilinks.org

Topic: Modeling Earth's Climate
SciLinks code: HSM0976

Changes in Climate

As you have probably noticed, the weather changes from day to day. Sometimes, the weather can change several times in one day! But have you ever noticed the climate change?

On Saturday, your morning baseball game was canceled because of rain, but by that afternoon the sun was shining. Now, think about the climate where you live. You probably haven't noticed a change in climate, because climates change slowly. What causes climatic change? Studies indicate that human activity may cause climatic change. However, natural factors also can influence changes in the climate.

Ice Ages

The geologic record indicates that the Earth's climate has been much colder than it is today. In fact, much of the Earth was covered by sheets of ice during certain periods. An **ice age** is a period during which ice collects in high latitudes and moves toward lower latitudes. Scientists have found evidence of many major ice ages throughout the Earth's geologic history. The most recent ice age began about 2 million years ago.

Glacial Periods

During an ice age, there are periods of cold and periods of warmth. These periods are called glacial and interglacial periods. During *glacial periods,* the enormous sheets of ice advance. As they advance, they get bigger and cover a larger area, as shown in **Figure 1.** Because a large amount of water is frozen during glacial periods, the sea level drops.

ice age a long period of climate cooling during which ice sheets cover large areas of Earth's surface; also known as a glacial period

Figure 1 *During glacial periods, ice sheets (as shown in light blue), cover a larger portion of the Earth.*

Interglacial Periods

Warmer times that happen between glacial periods are called *interglacial periods*. During an interglacial period, the ice begins to melt and the sea level rises again. The last interglacial period began 10,000 years ago and is still happening. Why do these periods occur? Will the Earth have another glacial period in the future? These questions have been debated by scientists for the past 200 years.

Motions of the Earth

There are many theories about the causes of ice ages. Each theory tries to explain the gradual cooling that begins an ice age. This cooling leads to the development of large ice sheets that periodically cover large areas of the Earth's surface.

The *Milankovitch theory* explains why an ice age isn't just one long cold spell. Instead, the ice age alternates between cold and warm periods. Milutin Milankovitch, a Yugoslavian scientist, proposed that changes in the Earth's orbit and in the tilt of the Earth's axis cause ice ages. His theory is shown in **Figure 2.** In a 100,000 year period, the Earth's orbit changes from elliptical to circular. This changes the Earth's distance from the sun. In turn, it changes the temperature on Earth. Changes in the tilt of the Earth also influence the climate. The more the Earth is tilted, the closer the poles are to the sun.

Reading Check What are the two things Milankovitch says causes ice ages? (*See the Appendix for answers to Reading Checks.*)

INTERNET ACTIVITY

For another activity related to this chapter, go to **go.hrw.com** and type in the keyword **HZ5CLMW.**

Figure 2 The Milankovitch Theory

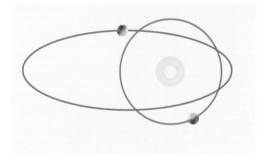

❶ Over a period of 100,000 years, the Earth's orbit slowly changes from a more circular shape to a more elliptical shape and back again. When Earth's orbit is elliptical, Earth receives more energy from the sun. When its orbit is more circular, Earth receives less energy from the sun.

❷ Over a period of 41,000 years, the tilt of the Earth's axis varies between 22.2° and 24.5°. When the tilt is at 24.5°, the poles receive more solar energy.

❸ The Earth's axis traces a complete circle every 26,000 years. The circular motion of the Earth's axis determines the time of year that the Earth is closest to the sun.

Figure 3 *Much of Pangaea—the part that is now Africa, South America, India, Antarctica, Australia, and Saudi Arabia—was covered by continental ice sheets.*

Plate Tectonics

The Earth's climate is further influenced by plate tectonics and continental drift. One theory proposes that ice ages happen when the continents are positioned closer to the polar regions. About 250 million years ago, all the continents were connected near the South Pole in one giant landmass called *Pangaea,* as shown in **Figure 3.** During this time, ice covered a large area of the Earth's surface. As Pangaea broke apart, the continents moved toward the equator, and the ice age ended. During the last ice age, many large landmasses were positioned in the polar zones. Antarctica, northern North America, Europe, and Asia were covered by large sheets of ice.

Volcanic Eruptions

Many natural factors can affect global climate. Catastrophic events, such as volcanic eruptions, can influence climate. Volcanic eruptions send large amounts of dust, ash, and smoke into the atmosphere. Once in the atmosphere, the dust, smoke, and ash particles act as a shield. This shield blocks the sun's rays, which causes the Earth to cool. **Figure 4** shows how dust particles from a volcanic eruption block the sun.

✓ *Reading Check* How can volcanoes change the climate?

| **Figure 4** | **Volcanic Dust in the Atmosphere** |

Volcanic eruptions, such as the 1980 eruption of Mount St. Helens, as shown at right, produce dust that reflects sunlight.

Sun's rays

Mount St. Helens

Dust layer

Atmosphere

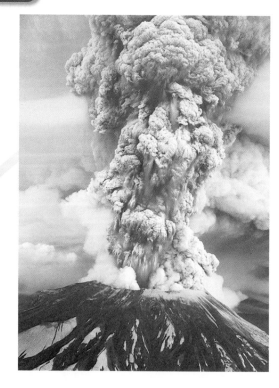

Figure 5 *Some scientists believe that a 10 km chunk of rock smashed into the Earth 65 million years ago, which caused the climatic change that resulted in the extinction of dinosaurs.*

Asteroid Impact

Imagine a rock the size of a car flying in from outer space and crashing in your neighborhood. This rock, like the one shown in **Figure 5,** is called an asteroid. An *asteroid* is a small, rocky object that orbits the sun. Sometimes, asteroids enter our atmosphere and crash into the Earth. What would happen if an asteroid 1 km wide, which is more than half a mile long, hit the Earth? Scientists believe that if an asteroid this big hit the Earth, it could change the climate of the entire world.

When a large piece of rock slams into the Earth, it causes debris to shoot into the atmosphere. *Debris* is dust and smaller rocks. This debris can block some of the sunlight and thermal energy. This would lower average temperatures, which would change the climate. Plants wouldn't get the sunlight they needed to grow, and animals would find surviving difficult. Scientists believe such an event is what caused dinosaurs to become extinct 65 million years ago when a 10 km asteroid slammed into the Earth and changed the Earth's climate.

The Sun's Cycle

Some changes in the climate can be linked to changes in the sun. You might think that the sun always stays the same. However, the sun follows an 11-year cycle. During this cycle, the sun changes from a solar maximum to a solar minimum. During a solar minimum, the sun produces a low percentage of high-energy radiation. But when the sun is at its solar maximum, it produces a large percentage of high-energy radiation. This increase in high-energy radiation warms the winds in the atmosphere. This change in turn affects climate patterns around the world.

CONNECTION TO Astronomy

Sunspots Sunspots are dark areas on the sun's surface. The number of sunspots changes with the sun's cycle. When the cycle is at a solar maximum, there are many sunspots. When the cycle is at a solar minimum, there are fewer sunspots. If the number of sunspots was low in 1997, in what year will the next low point in the cycle happen?

global warming a gradual increase in the average global temperature

greenhouse effect the warming of the surface and lower atmosphere of Earth that occurs when carbon dioxide, water vapor, and other gases in the air absorb and trap thermal energy

Global Warming

A gradual increase in the average global temperature that is due to a higher concentration of gases, such as carbon dioxide in the atmosphere, is called **global warming.** To understand how global warming works, you must first learn about the greenhouse effect.

Greenhouse Effect

The Earth's natural heating process, in which gases in the atmosphere trap thermal energy, is called the **greenhouse effect.** The car in **Figure 6** shows how the greenhouse effect works. The car's windows stop most of the thermal energy from escaping, and the inside of the car gets hot. On Earth, instead of glass stopping the thermal energy, atmospheric gases absorb the thermal energy. When this happens, the thermal energy stays in the atmosphere and keeps the Earth warm. Many scientists believe that the rise in global temperatures is due to an increase of carbon dioxide, an atmospheric gas. Most evidence shows that the increase in carbon dioxide is caused by the burning of fossil fuels.

Another factor that may add to global warming is the clearing of forests. In many countries, forests are being burned to clear land for farming. Burning of the forests releases more carbon dioxide. Because plants use carbon dioxide to make food, destroying the trees decreases a natural way of removing carbon dioxide from the atmosphere.

Figure 6 *Sunlight streams into the car through the clear, glass windows. The seats absorb the radiant energy and change it into thermal energy. The energy is then trapped in the car.*

Consequences of Global Warming

Many scientists think that if the global temperature continues to rise, the ice caps will melt and cause flooding. Melted ice-caps would raise the sea level and flood low-lying areas, such as the coasts.

Areas that receive little rainfall, such as deserts, might receive even less because of increased evaporation. Desert animals and plants would find surviving harder. Warmer and drier climates could harm crops in the Midwest of the United States. But farther north, such as in Canada, weather conditions for farming could improve.

Reading Check How would warmer temperatures affect deserts?

SECTION Review

Summary

- The Earth's climate experiences glacial and inter-glacial periods.
- The Milankovitch theory states that the Earth's climate changes as its orbit and the tilt of its axis change.
- Climate changes can be caused by volcanic eruptions, asteroid impact, the sun's cycle, and by global warming.
- Excess carbon dioxide is believed to contribute to global warming.

Using Key Terms

1. Use the following term in a sentence: *ice age*.

2. In your own words, write a definition for each of the following terms: *global warming* and *greenhouse effect*.

Understanding Key Ideas

3. Describe the possible causes of an ice age.

4. Which of the following can cause a change in the climate due to dust particles?
 a. volcanic eruptions
 b. plate tectonics
 c. solar cycles
 d. ice ages

5. How has the Earth's climate changed over time?

6. What might have caused the Earth's climate to change?

7. Which period of an ice age are we in currently? Explain.

8. Explain how the greenhouse effect warms the Earth.

Math Skills

9. After a volcanic eruption, the average temperature in a region dropped from 30° to 18°C. By how many degrees Celsius did the temperature drop?

Critical Thinking

10. **Analyzing Relationships** How will the warming of the Earth affect agriculture in different parts of the world? Explain.

11. **Predicting Consequences** How would deforestation (the cutting of trees) affect global warming?

Skills Practice Lab

Biome Business

You have just been hired as an assistant to a world-famous botanist. You have been provided with climatographs for three biomes. A *climatograph* is a graph that shows the monthly temperature and precipitation of an area in a year.

OBJECTIVES

Interpret data in a climatograph.

Identify the biome for each climatograph.

Tundra
Taiga
Temperate forest
Tropical rain forest
Temperate grassland
Tropical savanna
Temperate desert
Tropical desert
Chaparral
Mountains

You can use the information provided in the three graphs to determine what type of climate each biome has. Next to the climatograph for each biome is an unlabeled map of the biome. Using the maps and the information provided in the graphs, you must figure out what the environment is like in each biome. You can find the exact location of each biome by tracing the map of the biome and matching it to the map at the bottom of the page.

Procedure

1. Look at each climatograph. The shaded areas show the average precipitation for the biome. The red line shows the average temperature.

2. Use the climatographs to determine the climate patterns for each biome. Compare the map of each biome with the map below to find the exact location of each biome.

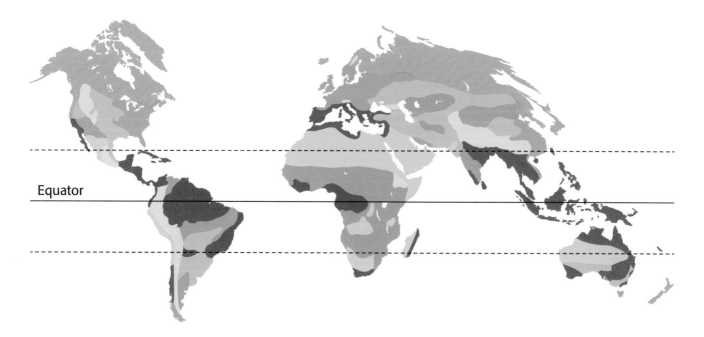

Equator

Analyze Results

1 **Analyzing Data** Describe the precipitation patterns of each biome by answering the following questions:

a. In which month does the biome receive the most precipitation?

b. Do you think that the biome is dry, or do you think that it is wet from frequent rains?

2 **Analyzing Data** Describe the temperature patterns of each biome by answering the following questions:

a. In the biome, which months are warmest?

b. Does the biome seem to have temperature cycles, like seasons, or is the temperature almost always the same?

c. Do you think that the biome is warm or cold? Explain.

Draw Conclusions

3 **Drawing Conclusions** Name each biome.

4 **Applying Conclusions** Where is each biome located?

Biome B

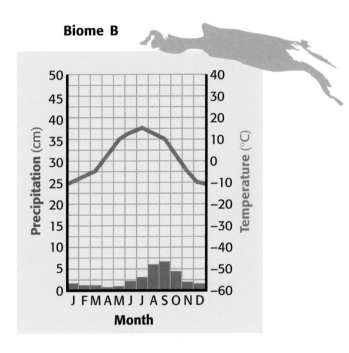

Biome A

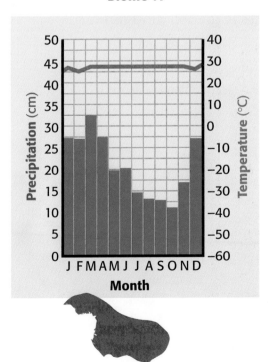

Biome C

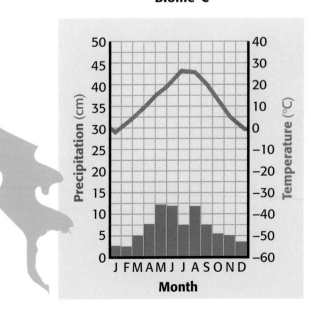

Chapter Review

USING KEY TERMS

For each pair of terms, explain how the meanings of the terms differ.

1 *biome* and *tropical zone*

2 *weather* and *climate*

3 *temperate zone* and *polar zone*

Complete each of the following sentences by choosing the correct term from the word bank.

biome microclimate
ice age global warming

4 One factor that could add to ___ is an increase in pollution.

5 A city is an example of a(n) ___.

UNDERSTANDING KEY IDEAS

Multiple Choice

6 Which of the following is a factor that affects climate?

 a. prevailing winds

 b. latitude

 c. ocean currents

 d. All of the above

7 The biome that has a temperature range of 28°C to 32°C and an average yearly precipitation of 100 cm is the

 a. tropical savanna.

 b. tropical desert.

 c. tropical rain forest.

 d. None of the above

8 Which of the following biomes is NOT found in the temperate zone?

 a. temperate forest

 b. taiga

 c. chaparral

 d. temperate grassland

9 In which of the following is the tilt of the Earth's axis considered to have an effect on climate?

 a. global warming

 b. the sun's cycle

 c. the Milankovitch theory

 d. asteroid impact

10 Which of the following substances contributes to the greenhouse effect?

 a. smoke

 b. smog

 c. carbon dioxide

 d. All of the above

11 In which of the following climate zones is the soil most fertile?

 a. the tropical climate zone

 b. the temperate climate zone

 c. the polar climate zone

 d. None of the above

Short Answer

12 Why do higher latitudes receive less solar radiation than lower latitudes do?

13 How does wind influence precipitation patterns?

14 Give an example of a microclimate. What causes the unique temperature and precipitation characteristics of this area?

15 How are tundras and deserts similar?

16 How does deforestation influence global warming?

CRITICAL THINKING

17 **Concept Mapping** Use the following terms to create a concept map: *global warming, deforestation, changes in climate, greenhouse effect, ice ages,* and *the Milankovitch theory.*

18 **Analyzing Processes** Explain how ocean surface currents cause milder climates.

19 **Identifying Relationships** Describe how the tilt of the Earth's axis affects seasonal changes in different latitudes.

20 **Evaluating Conclusions** Explain why the climate on the eastern side of the Rocky Mountains differs drastically from the climate on the western side.

21 **Applying Concepts** What are some steps you and your family can take to reduce the amount of carbon dioxide that is released into the atmosphere?

22 **Applying Concepts** If you wanted to live in a warm, dry area, which biome would you choose to live in?

23 **Evaluating Data** Explain why the vegetation in areas that have a tundra climate is sparse even though these areas receive precipitation that is adequate to support life.

INTERPRETING GRAPHICS

Use the diagram below to answer the questions that follow.

24 At what position—1, 2, 3, or 4—is it spring in the Southern Hemisphere?

25 At what position does the South Pole receive almost 24 hours of daylight?

26 Explain what is happening in each climate zone in both the Northern and Southern Hemispheres at position 4.

Standardized Test Preparation

Read each of the passages below. Then, answer the questions that follow each passage.

Passage 1 Earth's climate has gone through many changes. For example, 6,000 years ago today's desert in North Africa was grassland and shallow lakes. Hippopotamuses, crocodiles, and early Stone Age people shared the shallow lakes that covered the area. For many years, scientists have known that Earth's climate has changed. What they didn't know was why it changed. Today, scientists can use supercomputers and complex computer programs to help them find the answer. Now, scientists may be able to <u>decipher</u> why North Africa's lakes and grasslands became a desert. And that information may be useful for predicting future heat waves and ice ages.

1. In this passage, what does *decipher* mean?
 A to question
 B to cover up
 C to explain
 D to calculate

2. According to the passage, which of the following statements is true?
 F Scientists did not know that Earth's climate has changed.
 G Scientists have known that Earth's climate has changed.
 H Scientists have known why Earth's climate has changed.
 I Scientists know that North Africa was always desert.

3. Which of the following is a fact in the passage?
 A North African desert areas never had lakes.
 B North American desert areas never had lakes.
 C North African desert areas had shallow lakes.
 D North Africa is covered with shallow lakes.

Passage 2 El Niño, which is Spanish for "the child," is the name of a weather event that occurs in the Pacific Ocean. Every 2 to 12 years, the interaction between the ocean surface and atmospheric winds creates El Niño. This event influences weather patterns in many regions of the world. For example, in Indonesia and Malaysia, El Niño meant <u>drought</u> and forest fires in 1998. Thousands of people in these countries suffered respiratory ailments caused by breathing the smoke from these fires. Heavy rains in San Francisco created extremely high mold-spore counts. These spores caused problems for people who have allergies. In San Francisco, the spore count in February is usually between 0 and 100. In 1998, the count was often higher than 8,000.

1. In this passage, what does *drought* mean?
 A windy weather
 B stormy weather
 C long period of dry weather
 D rainy weather

2. What can you infer about mold spores from reading the passage?
 F Some people in San Francisco are allergic to mold spores.
 G Mold spores are only in San Francisco.
 H A higher mold-spore count helps people with allergies.
 I The mold-spore count was low in 1998.

3. According to the passage, which of the following statements is true?
 A El Niño causes droughts in Indonesia and Malaysia.
 B El Niño occurs every year.
 C El Niño causes fires in San Francisco.
 D El Niño last occurred in 1998.

The chart below shows types of organisms in an unknown biome. Use the chart below to answer the questions that follow.

Organisms in an Unknown Biome

1. *Biomass* is a term that means "the total mass of all living things in a certain area." The graph above shows the relative percentages of the total biomass for different plants and animals in a given area. What type of biome does the graph represent?

 A rain forest

 B chaparral

 C tundra

 D taiga

2. Approximately what percentage of biomass is made up of caribou?

 F 28%

 G 25%

 H 16%

 I 5%

3. Approximately what percentage of biomass is made up of lichens and mosses?

 A 45%

 B 35%

 C 25%

 D 16%

Read each question below, and choose the best answer.

1. In a certain area of the savanna that is 12 km long and 5 km wide, there are 180 giraffes. How many giraffes are there per square kilometer in this area?

 A 12

 B 6

 C 4

 D 3

2. If the air temperature near the shore of a lake measures 24°C and the temperature increases by 0.055°C every 10 m traveled away from the lake, what would the air temperature 1 km from the lake be?

 F 5°C

 G 25°C

 H 29.5°C

 I 35°C

3. In a temperate desert, the temperature dropped from 50°C at noon to 37°C by nightfall. By how many degrees Celsius did the noon temperature drop?

 A 13°C

 B 20°C

 C 26°C

 D 50°C

4. Earth is tilted on its axis at a 23.5° angle. What is the measure of the angle that is complementary to a 23.5° angle?

 F 66.5°

 G 67.5°

 H 156.5°

 I 336.5°

5. After a volcanic eruption, the average temperature in a region dropped from 30°C to 18°C. By what percentage did the temperature drop?

 A 30%

 B 25%

 C 40%

 D 15%

Standardized Test Preparation

Science in Action

Scientific Debate

Global Warming

Many scientists believe that pollution from burning fossil fuels is causing temperatures on Earth to rise. Higher average temperatures can cause significant changes in climate. These changes may make survival difficult for animals and plants that have adapted to a biome.

However, other scientists believe that there isn't enough evidence to prove that global warming exists. They argue that any increase in temperatures around the world can be caused by a number of factors other than pollution, such as the sun's cycle.

Language Arts ACTIVITY

WRITING SKILL Read articles that present a variety of viewpoints on global warming. Then, write your own article supporting your viewpoint on global warming.

Science, Technology, and Society

Ice Cores

How do scientists know what Earth's climate was like thousands of years ago? Scientists learn about Earth's past climates by studying ice cores. An ice core is collected by drilling a tube of ice from glaciers and polar ice sheets. Layers in the ice core contain substances that landed in the snow during a particular year or season, such as dust from desert storms, ash from volcanic eruptions, and carbon dioxide from pollution. By studying the layers of the ice cores, scientists can learn what factors influenced the past climates.

Math ACTIVITY

An area has an average yearly rainfall of 20 cm. In 1,000 years, if the average yearly rainfall decreases by 6%, what would the new average yearly rainfall be?

Mercedes Pascual

Climate Change and Disease Mercedes Pascual is a theoretical ecologist at the University of Michigan. Pascual has been able to help the people of Bangladesh save lives by using information about climate changes to predict outbreaks of the disease cholera. Cholera can be a deadly disease that people usually contract by drinking contaminated water. Pascual knew that in Bangladesh, outbreaks of cholera peak every 3.7 years. She noticed that this period matches the frequency of the El Niño Southern Oscillations, which is a weather event that occurs in the Pacific Ocean. El Niño affects weather patterns in many regions of the world, including Bangladesh. El Niño increases the temperatures of the sea off the coast of Bangladesh. Pascual found that increased sea temperatures lead to higher numbers of the bacteria that cause cholera. In turn, more people contract cholera. But because of the research conducted by Pascual and other scientists, the people of Bangladesh can better predict and prepare for outbreaks of cholera.

Social Studies ACTIVITY

WRITING SKILL Research the effects of El Niño. Write a report describing El Niño and its affect on a country other than Bangladesh.

To learn more about these Science in Action topics, visit go.hrw.com and type in the keyword HZ5CLMF.

Current Science

Check out Current Science® articles related to this chapter by visiting go.hrw.com. Just type in the keyword HZ5CS17.

Skills Practice Lab

Go Fly a Bike!

Your friend Daniel just invented a bicycle that can fly! Trouble is, the bike can fly only when the wind speed is between 3 m/s and 10 m/s. If the wind is not blowing hard enough, the bike won't get enough lift to rise into the air, and if the wind is blowing too hard, the bike is difficult to control. Daniel needs to know if he can fly his bike today. Can you build a device that can estimate how fast the wind is blowing?

Ask a Question

1 How can I construct a device to measure wind speed?

Form a Hypothesis

2 Write a possible answer for the question above. Explain your reasoning.

Test the Hypothesis

3 Cut off the rolled edges of all five paper cups. They will then be lighter so that they can spin more easily.

4 Measure and place four equally spaced markings 1 cm below the rim of one of the paper cups.

5 Use the hole punch to punch a hole at each mark so that the cup has four equally spaced holes. Use the sharp pencil to carefully punch a hole in the center of the bottom of the cup.

6 Push a straw through two opposite holes in the side of the cup.

7 Repeat step 5 for the other two holes. The straws should form an X.

8 Measure 3 cm from the bottom of the remaining paper cups, and mark each spot with a dot.

9 At each dot, punch a hole in the paper cups with the hole punch.

10 Color the outside of one of the four cups.

11 Slide a cup on one of the straws by pushing the straw through the punched hole. Rotate the cup so that the bottom faces to the right.

12 Fold the end of the straw, and staple it to the inside of the cup directly across from the hole.

13 Repeat steps 11–12 for each of the remaining cups.

14 Push the tack through the intersection of the two straws.

15 Push the eraser end of a pencil through the bottom hole in the center cup. Push the tack as far as it will go into the end of the eraser.

16 Push the sharpened end of the pencil into some modeling clay to form a base. The device will then be able to stand up without being knocked over, as shown at right.

17 Blow into the cups so that they spin. Adjust the tack so that the cups can freely spin without wobbling or falling apart. Congratulations! You have just constructed an anemometer.

18 Find a suitable area outside to place the anemometer vertically on a surface away from objects that would obstruct the wind, such as buildings and trees.

19 Mark the surface at the base of the anemometer with masking tape. Label the tape "starting point."

20 Hold the colored cup over the starting point while your partner holds the watch.

21 Release the colored cup. At the same time, your partner should look at the watch or clock. As the cups spin, count the number of times the colored cup crosses the starting point in 10 s.

Analyze the Results

1 How many times did the colored cup cross the starting point in 10 s?

2 Divide your answer in step 21 by 10 to get the number of revolutions in 1 s.

3 Measure the diameter of your anemometer (the distance between the outside edges of two opposite cups) in centimeters. Multiply this number by 3.14 to get the circumference of the circle made by the cups of your anemometer.

4 Multiply your answer from step 3 by the number of revolutions per second (step 2). Divide that answer by 100 to get wind speed in meters per second.

5 Compare your results with those of your classmates. Did you get the same results? What could account for any slight differences in your results?

Draw Conclusions

6 Could Daniel fly his bicycle today? Why or why not?

Skills Practice Lab

Watching the Weather

MATERIALS

• pencil

Imagine that you own a private consulting firm that helps people plan for big occasions, such as weddings, parties, and celebrity events. One of your duties is making sure the weather doesn't put a damper on your clients' plans. In order to provide the best service possible, you have taken a crash course in reading weather maps. Will the celebrity golf match have to be delayed on account of rain? Will the wedding ceremony have to be moved inside so the blushing bride doesn't get soaked? It is your job to say yea or nay.

Procedure

1 Study the station model and legend shown on the next page. You will use the legend to interpret the weather map on the final page of this activity.

2 Weather data is represented on a weather map by a station model. A station model is a small circle that shows the location of the weather station along with a set of symbols and numbers around the circle that represent the data collected at the weather station. Study the table below.

Weather-Map Symbols					
Weather conditions		**Cloud cover**		**Wind speed (mph)**	
••	Light rain	◐ No clouds	No clouds	◎	Calm
∴	Moderate rain	◐	One-tenth or less	╱	3–8
∴∴	Heavy rain	◕	Two- to three-tenths	╱	9–14
،	Drizzle	◑	Broken	⫽	15–20
✳ ✳	Light snow	◕	Nine-tenths	⫽	21–25
✳✳✳	Moderate snow	●	Overcast	⫻	32–37
℞	Thunderstorm	⊗	Sky obscured	⫻⫽	44–48
∽	Freezing rain	**Special Symbols**		◢	55–60
∞	Haze	▲▲▲▲	Cold front	◢◢	66–71
☰	Fog	●●●●	Warm front		
		H	High pressure		
		L	Low pressure		
		ৎ	Hurricane		

Station Model

Wind speed is represented by whole and half tails.

A line indicates the direction the wind is coming from.

Air temperature

A symbol represents the current weather conditions. If there is no symbol, there is no precipitation.

Dew point temperature

Shading indicates the cloud coverage.

234

77
73

Atmospheric pressure in millibars (mbar). This number has been shortened on the station model. To read the number properly you must follow a few simple rules.

- If the first number is greater than 5, place a 9 in front of the number and a decimal point between the last two digits.

- If the first number is less than or equal to 5, place a 10 in front of the number and a decimal point between the last two digits.

Interpreting Station Models

The station model below is for Boston, Massachusetts. The current temperature in Boston is 42°F, and the dew point is 39°F. The barometric pressure is 1011.0 mbar. The sky is overcast, and there is moderate rainfall. The wind is coming from the southwest at 15–20 mph.

110

42

39

Boston, Massachusetts

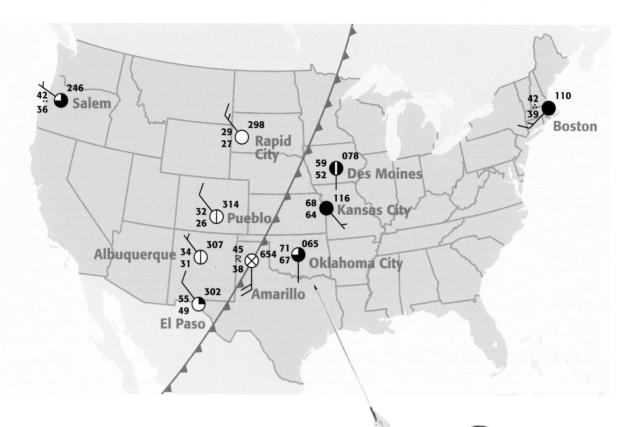

Analyze the Results

1. Based on the weather for the entire United States, what time of year is it? Explain your answer.

2. Interpret the station model for Salem, Oregon. What is the temperature, dew point, cloud coverage, wind direction, wind speed, and atmospheric pressure? Is there any precipitation? If so, what kind?

3. What is happening to wind direction, temperature, and pressure as the cold front approaches? as it passes?

Draw Conclusions

4. Interpret the station model for Amarillo, Texas.

Skills Practice Lab

Let It Snow!

Although an inch of rain might be good for your garden, 7 cm or 8 cm could cause an unwelcome flood. But what about snow? How much snow is too much? A blizzard might drop 40 cm of snow overnight. Sure it's up to your knees, but how does this much snow compare with rain? This activity will help you find out.

MATERIALS

- beaker, 100 mL
- gloves, heat-resistant
- graduated cylinder
- hot plate
- ice, shaved, 150 mL
- ruler, metric

SAFETY

Procedure

1. Pour 50 mL of shaved ice into your beaker. Do not pack the ice into the beaker. This ice will represent your snowfall.

2. Use the ruler to measure the height of the snow in the beaker.

3. Turn on the hot plate to a low setting. **Caution:** Wear heat-resistant gloves and goggles when working with the hot plate.

4. Place the beaker on the hot plate, and leave it there until all of the snow melts.

5. Pour the water into the graduated cylinder, and record the height and volume of the water.

6. Repeat steps 1–5 two more times.

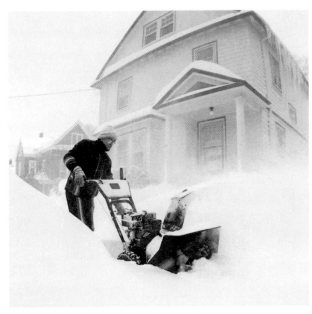

Analysis

1. What was the difference in height before and after the snow melted in each of your three trials? What was the average difference?

2. Why did the volume change after the ice melted?

3. What was the ratio of snow height to water height?

4. Use the ratio you found in step 3 of the Analysis to calculate how much water 50 cm of this snow would produce. Use the following equation to help.

$$\frac{\text{measured height of snow}}{\text{measured height of water}} = \frac{50 \text{ cm of snow}}{? \text{ cm of water}}$$

5. Why is it important to know the water content of a snowfall?

Applying Your Data

Shaved ice isn't really snow. Research to find out how much water real snow would produce. Does every snowfall produce the same ratio of snow height to water depth?

Model-Making Lab

Gone with the Wind

Pilots at the Fly Away Airport need your help—fast! Last night, lightning destroyed the orange windsock. This windsock helped pilots measure which direction the wind was blowing. But now the windsock is gone with the wind, and an incoming airplane needs to land. The pilot must know which direction the wind is blowing and is counting on you to make a device that can measure wind direction.

MATERIALS

- card, index
- compass, drawing
- compass, magnetic
- pencil, sharpened
- plate, paper
- protractor
- rock, small
- ruler, metric
- scissors
- stapler
- straw, straight plastic
- thumbtack (or pushpin)

SAFETY

Ask a Question

1 How can I measure wind direction?

Form a Hypothesis

2 Write a possible answer to the question above.

Test the Hypothesis

3 Find the center of the plate by tracing around its edge with a drawing compass. The pointed end of the compass should poke a small hole in the center of the plate.

4 Use a ruler to draw a line across the center of the plate.

5 Use a protractor to help you draw a second line through the center of the plate. This new line should be at a 90° angle to the line you drew in step 4.

6 Moving clockwise, label each line "N," "E," "S," and "W."

7 Use a protractor to help you draw two more lines through the center of the plate. These lines should be at a 45° angle to the lines you drew in steps 4 and 5.

8. Moving clockwise from *N,* label these new lines "NE," "SE," "SW," and "NW." The plate now resembles the face of a magnetic compass. The plate will be the base of your wind-direction indicator. It will help you read the direction of the wind at a glance.

9. Measure and mark a 5 cm × 5 cm square on an index card, and cut out the square. Fold the square in half to form a triangle.

10. Staple an open edge of the triangle to the straw so that one point of the triangle touches the end of the straw.

11. Hold the pencil at a 90° angle to the straw. The eraser should touch the balance point of the straw. Push a thumbtack or pushpin through the straw and into the eraser. The straw should spin without falling off.

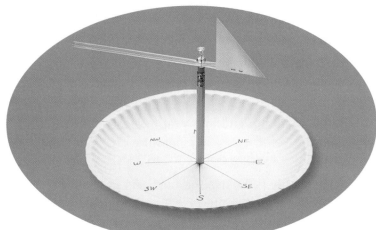

12. Find a suitable area outside to measure the wind direction. The area should be clear of trees and buildings.

13. Press the sharpened end of the pencil through the center hole of the plate and into the ground. The labels on your paper plate should be facing the sky, as shown on this page.

14. Use a compass to find magnetic north. Rotate the plate so that the *N* on the plate points north. Place a small rock on top of the plate so that the plate does not turn.

15. Watch the straw as it rotates. The triangle will point in the direction the wind is blowing.

Analyze the Results

1. From which direction is the wind coming?

2. In which direction is the wind blowing?

Draw Conclusions

3. Would this be an effective way for pilots to measure wind direction? Why or why not?

4. What improvements would you suggest to Fly Away Airport to measure wind direction more accurately?

Applying Your Data

Use this tool to measure and record wind direction for several days. What changes in wind direction occur as a front approaches? as a front passes?

Review magnetic declination in the chapter entitled "Maps as Models of the Earth." How might magnetic declination affect your design for a tool to measure wind direction?

Skills Practice Lab

Global Impact

For years, scientists have debated the topic of global warming. Is the temperature of the Earth actually getting warmer? In this activity, you will examine a table to determine if the data indicate any trends. Be sure to notice how much the trends seem to change as you analyze different sets of data.

MATERIALS

- pencils, colored (4)
- ruler, metric

Procedure

1. The table below shows average global temperatures recorded over the last 100 years.

2. Draw a graph. Label the horizontal axis "Time." Mark the grid in 5-year intervals. Label the vertical axis "Temperature (°C)," with values ranging from 13°C to 15°C.

3. Starting with 1900, use the numbers in red to plot the temperature in 20-year intervals. Connect the dots with straight lines.

4. Using a ruler, estimate the average slope for the temperatures. Draw a red line to represent the slope.

5. Using different colors, plot the temperatures at 10-year intervals and 5-year intervals on the same graph. Connect each set of dots, and draw the average slope for each set.

Analyze the Results

1. Examine your completed graph, and explain any trends you see in the graphed data. Was there an increase or a decrease in average temperature over the last 100 years?

2. What similarities and differences did you see between each set of graphed data?

Draw Conclusions

3. What conclusions can you draw from the data you graphed in this activity?

4. What would happen if your graph were plotted in 1-year intervals? Try it!

Average Global Temperatures											
Year	°C	Year	°C	Year	°C	Year	°C	Year	°C	Year	°C
1900	14.0	1917	13.6	1934	14.0	1951	14.0	1968	13.9	1985	14.1
1901	13.9	1918	13.6	1935	13.9	1952	14.0	1969	14.0	1986	14.2
1902	13.8	1919	13.8	1936	14.0	1953	14.1	1970	14.0	1987	14.3
1903	13.6	1920	13.8	1937	14.1	1954	13.9	1971	13.9	1988	14.4
1904	13.5	1921	13.9	1938	14.1	1955	13.9	1972	13.9	1989	14.2
1905	13.7	1922	13.9	1939	14.0	1956	13.8	1973	14.2	1990	14.5
1906	13.8	1923	13.8	1940	14.1	1957	14.1	1974	13.9	1991	14.4
1907	13.6	1924	13.8	1941	14.1	1958	14.1	1975	14.0	1992	14.1
1908	13.7	1925	13.8	1942	14.1	1959	14.0	1976	13.8	1993	14.2
1909	13.7	1926	14.1	1943	14.0	1960	14.0	1977	14.2	1994	14.3
1910	13.7	1927	14.0	1944	14.1	1961	14.1	1978	14.1	1995	14.5
1911	13.7	1928	14.0	1945	14.0	1962	14.0	1979	14.1	1996	14.4
1912	13.7	1929	13.8	1946	14.0	1963	14.0	1980	14.3	1997	14.4
1913	13.8	1930	13.9	1947	14.1	1964	13.7	1981	14.4	1998	14.5
1914	14.0	1931	14.0	1948	14.0	1965	13.8	1982	14.1	1999	14.5
1915	14.0	1932	14.0	1949	13.9	1966	13.9	1983	14.3	2000	14.5
1916	13.8	1933	13.9	1950	13.8	1967	14.0	1984	14.1	2001	14.5

Skills Practice Lab

For the Birds

You and a partner have a new business building birdhouses. But your first clients have told you that birds do not want to live in the birdhouses you have made. The clients want their money back unless you can solve the problem. You need to come up with a solution right away!

You remember reading an article about microclimates in a science magazine. Cities often heat up because the pavement and buildings absorb so much solar radiation. Maybe the houses are too warm! How can the houses be kept cooler?

You decide to investigate the roofs; after all, changing the roofs would be a lot easier than building new houses. In order to help your clients and the birds, you decide to test different roof colors and materials to see how these variables affect a roof's ability to absorb the sun's rays.

One partner will test the color, and the other partner will test the materials. You will then share your results and make a recommendation together.

MATERIALS

- cardboard (4 pieces)
- paint, black, white, and light blue tempera
- rubber, beige or tan
- thermometers, Celsius (4)
- watch (or clock)
- wood, beige or tan

SAFETY

Part A: Color Test

Ask a Question

1 What color would be the best choice for the roof of a birdhouse?

Form a Hypothesis

2 Write down the color you think will keep a birdhouse coolest.

Test the Hypothesis

3 Paint one piece of cardboard black, another piece white, and a third light blue.

4 After the paint has dried, take the three pieces of cardboard outside, and place a thermometer on each piece.

5 In an area where there is no shade, place each piece at the same height so that all three receive the same amount of sunlight. Leave the pieces in the sunlight for 15 min.

6 Leave a fourth thermometer outside in the shade to measure the temperature of the air.

7 Record the reading of the thermometer on each piece of cardboard. Also, record the outside temperature.

Analyze the Results

1. Did each of the three thermometers record the same temperature after 15 min? Explain.

2. Were the temperature readings on each of the three pieces of cardboard the same as the reading for the outside temperature? Explain.

Draw Conclusions

3. How do your observations compare with your hypothesis?

Part B: Material Test

Ask a Question

1. Which material would be the best choice for the roof of a birdhouse?

Form a Hypothesis

2. Write down the material you think will keep a birdhouse coolest.

Test the Hypothesis

3. Take the rubber, wood, and the fourth piece of cardboard outside, and place a thermometer on each.

4. In an area where there is no shade, place each material at the same height so that they all receive the same amount of sunlight. Leave the materials in the sunlight for 15 min.

5. Leave a fourth thermometer outside in the shade to measure the temperature of the air.

6. Record the temperature of each material. Also, record the outside temperature. After you and your partner have finished your investigations, take a few minutes to share your results.

Analyze the Results

1 Did each of the thermometers on the three materials record the same temperature after 15 min? Explain.

2 Were the temperature readings on the rubber, wood, and cardboard the same as the reading for the outside temperature? Explain.

Draw Conclusions

3 How do your observations compare with your hypothesis?

4 Which material would you use to build the roofs for your birdhouses? Why?

5 Which color would you use to paint the new roofs? Why?

Applying Your Data

Make three different-colored samples for each of the three materials. When you measure the temperatures for each sample, how do the colors compare for each material? Is the same color best for all three materials? How do your results compare with what you concluded in steps 4 and 5 under Draw Conclusions of this activity? What's more important, color or material?

✓ *Reading Check* Answers

Chapter 1 The Atmosphere

Section 1

Page 4: Water can be liquid (rain), solid (snow or ice), or gas (water vapor).

Page 6: The troposphere is the layer of turning or change. The stratosphere is the layer in which gases are layered and do not mix vertically. The mesosphere is the middle layer. The thermosphere is the layer in which temperatures are highest.

Page 8: The thermosphere does not feel hot because air molecules are spaced far apart and cannot collide to transfer much thermal energy.

Section 2

Page 11: Cold air is more dense than warm air, so cold air sinks and warm air rises. This produces convection currents.

Page 13: A greenhouse gas is a gas that absorbs thermal energy in the atmosphere.

Section 3

Page 15: Sinking air causes areas of high pressure because sinking air presses down on the air beneath it.

Page 16: the westerlies

Page 19: At night, the mountains cool faster than the valleys. The cold mountain air is denser than the warm valley air, so the mountain air blows down the valleys at night.

Section 4

Page 20: Sample answer: smoke, dust and sea salt

Page 23: Answers may vary. Acid precipitation may decrease the soil nutrients that are available to plants.

Page 24: Powdered lime is used to counteract the effects of acidic snowmelt from snow that accumulated during the winter.

Page 26: Allowance trading establishes allowances for a certain type of pollutant. Companies are permitted to release their allowance of the pollutant, but if they exceed the allowance, they must buy additional allowances or pay a fine.

Chapter 2 Understanding Weather

Section 1

Page 38: The water cycle is the continuous movement of water from Earth's oceans and rivers into the atmosphere, into the ground, and back into the oceans and rivers.

Page 40: A psychrometer is used to measure relative humidity.

Page 41: The bulb of a wet-bulb thermometer is covered with moistened material. The bulb cools as water evaporates from the material. If the air is dry, more water will evaporate from the material, and the temperature recorded by the thermometer will be low. If the air is humid, less water will evaporate from the material, and the temperature recorded by the thermometer will be higher.

Page 43: Altostratus clouds form at middle altitudes.

Section 2

Page 47: A maritime tropical air mass causes hot and humid summer weather in the midwestern United States.

Page 49: An occluded front produces cool temperatures and large amounts of rain.

Page 51: An anticyclone can produce dry, clear weather.

Section 3

Page 53: A severe thunderstorm is a thunderstorm that produces high winds, hail, flash floods, or tornadoes.

Page 55: Hurricanes are also called *typhoons* or *cyclones.*

Page 56: Hurricanes get their energy from the condensation of water vapor.

Section 4

Page 60: Meteorologists use weather balloons to collect atmospheric data above Earth's surface.

Chapter 3 Climate

Section 1

Page 74: Climate is the average weather condition in an area over a long period of time. Weather is the condition of the atmosphere at a particular time.

Page 76: Locations near the equator have less seasonal variation because the tilt of the Earth does not change the amount of energy these locations receive from the sun.

Page 78: The atmosphere becomes less dense and loses its ability to absorb and hold thermal energy, at higher elevations.

Page 79: The Gulf Stream current carries warm water past Iceland, which heats the air and causes milder temperatures.

Page 80: Each biome has a different climate and different plant and animals communities.

Section 2

Page 82: You would find the tropical zone from 23.5° north latitude to 23.5° south latitude.

Page 85: Answers may vary. Sample answer: rats, lizards, snakes, and scorpions.

Section 3

Page 86: The temperate zone is located between the Tropics and the polar zone.

Page 88: Temperate deserts are cold at night because low humidity and cloudless skies allow energy to escape.

Page 91: Cities have higher temperatures than the surrounding rural areas because buildings and pavement absorb solar radiation instead of reflecting it.

Section 4

Page 93: Changes in the Earth's orbit and the tilt of the Earth's axis are the two things that Milankovitch says cause ice ages.

Page 94: Dust, ash, and smoke from volcanic eruptions block the sun's rays, which causes the Earth to cool.

Page 97: The deserts would receive less rainfall, making it harder for plants and animals in the desert to survive.

Appendix

Study Skills

FoldNote Instructions

Have you ever tried to study for a test or quiz but didn't know where to start? Or have you read a chapter and found that you can remember only a few ideas? Well, FoldNotes are a fun and exciting way to help you learn and remember the ideas you encounter as you learn science!

FoldNotes are tools that you can use to organize concepts. By focusing on a few main concepts, FoldNotes help you learn and remember how the concepts fit together. They can help you see the "big picture." Below you will find instructions for building 10 different FoldNotes.

Pyramid

1. Place a sheet of paper in front of you. Fold the lower left-hand corner of the paper diagonally to the opposite edge of the paper.

2. Cut off the tab of paper created by the fold (at the top).

3. Open the paper so that it is a square. Fold the lower right-hand corner of the paper diagonally to the opposite corner to form a triangle.

4. Open the paper. The creases of the two folds will have created an X.

5. Using scissors, cut along one of the creases. Start from any corner, and stop at the center point to create two flaps. Use tape or glue to attach one of the flaps on top of the other flap.

Double Door

1. Fold a sheet of paper in half from the top to the bottom. Then, unfold the paper.

2. Fold the top and bottom edges of the paper to the crease.

Appendix

Booklet

1. Fold a sheet of paper in half from left to right. Then, unfold the paper.

2. Fold the sheet of paper in half again from the top to the bottom. Then, unfold the paper.

3. Refold the sheet of paper in half from left to right.

4. Fold the top and bottom edges to the center crease.

5. Completely unfold the paper.

6. Refold the paper from top to bottom.

7. Using scissors, cut a slit along the center crease of the sheet from the folded edge to the creases made in step 4. Do not cut the entire sheet in half.

8. Fold the sheet of paper in half from left to right. While holding the bottom and top edges of the paper, push the bottom and top edges together so that the center collapses at the center slit. Fold the four flaps to form a four-page book.

Layered Book

1. Lay one sheet of paper on top of another sheet. Slide the top sheet up so that 2 cm of the bottom sheet is showing.

2. Hold the two sheets together, fold down the top of the two sheets so that you see four 2 cm tabs along the bottom.

3. Using a stapler, staple the top of the FoldNote.

Key-Term Fold

1. Fold a sheet of lined notebook paper in half from left to right.

2. Using scissors, cut along every third line from the right edge of the paper to the center fold to make tabs.

Four-Corner Fold

1. Fold a sheet of paper in half from left to right. Then, unfold the paper.

2. Fold each side of the paper to the crease in the center of the paper.

3. Fold the paper in half from the top to the bottom. Then, unfold the paper.

4. Using scissors, cut the top flap creases made in step 3 to form four flaps.

Three-Panel Flip Chart

1. Fold a piece of paper in half from the top to the bottom.

2. Fold the paper in thirds from side to side. Then, unfold the paper so that you can see the three sections.

3. From the top of the paper, cut along each of the vertical fold lines to the fold in the middle of the paper. You will now have three flaps.

Appendix

Table Fold

1. Fold a piece of paper in half from the top to the bottom. Then, fold the paper in half again.

2. Fold the paper in thirds from side to side.

3. Unfold the paper completely. Carefully trace the fold lines by using a pen or pencil.

Two-Panel Flip Chart

1. Fold a piece of paper in half from the top to the bottom.

2. Fold the paper in half from side to side. Then, unfold the paper so that you can see the two sections.

3. From the top of the paper, cut along the vertical fold line to the fold in the middle of the paper. You will now have two flaps.

Tri-Fold

1. Fold a piece a paper in thirds from the top to the bottom.

2. Unfold the paper so that you can see the three sections. Then, turn the paper sideways so that the three sections form vertical columns.

3. Trace the fold lines by using a pen or pencil. Label the columns "Know," "Want," and "Learn."

Graphic Organizer Instructions

 Have you ever wished that you could "draw out" the many concepts you learn in your science class? Sometimes, being able to *see* how concepts are related really helps you remember what you've learned. Graphic Organizers do just that! They give you a way to draw or map out concepts.

All you need to make a Graphic Organizer is a piece of paper and a pencil. Below you will find instructions for four different Graphic Organizers designed to help you organize the concepts you'll learn in this book.

Spider Map

1. Draw a diagram like the one shown. In the circle, write the main topic.

2. From the circle, draw legs to represent different categories of the main topic. You can have as many categories as you want.

3. From the category legs, draw horizontal lines. As you read the chapter, write details about each category on the horizontal lines.

Comparison Table

1. Draw a chart like the one shown. Your chart can have as many columns and rows as you want.

2. In the top row, write the topics that you want to compare.

3. In the left column, write characteristics of the topics that you want to compare. As you read the chapter, fill in the characteristics for each topic in the appropriate boxes.

Appendix

Chain-of-Events-Chart

1. Draw a box. In the box, write the first step of a process or the first event of a timeline.

2. Under the box, draw another box, and use an arrow to connect the two boxes. In the second box, write the next step of the process or the next event in the timeline.

3. Continue adding boxes until the process or timeline is finished.

Concept Map

1. Draw a circle in the center of a piece of paper. Write the main idea of the chapter in the center of the circle.

2. From the circle, draw other circles. In those circles, write characteristics of the main idea. Draw arrows from the center circle to the circles that contain the characteristics.

3. From each circle that contains a characteristic, draw other circles. In those circles, write specific details about the characteristic. Draw arrows from each circle that contains a characteristic to the circles that contain specific details. You may draw as many circles as you want.

SI Measurement

The International System of Units, or SI, is the standard system of measurement used by many scientists. Using the same standards of measurement makes it easier for scientists to communicate with one another.

SI works by combining prefixes and base units. Each base unit can be used with different prefixes to define smaller and larger quantities. The table below lists common SI prefixes.

SI Prefixes

Prefix	Symbol	Factor	Example
kilo-	k	1,000	kilogram, 1 kg = 1,000 g
hecto-	h	100	hectoliter, 1 hL = 100 L
deka-	da	10	dekameter, 1 dam = 10 m
		1	meter, liter, gram
deci-	d	0.1	decigram, 1 dg = 0.1 g
centi-	c	0.01	centimeter, 1 cm = 0.01 m
milli-	m	0.001	milliliter, 1 mL = 0.001 L
micro-	μ	0.000 001	micrometer, 1 μm = 0.000 001 m

SI Conversion Table

SI units	From SI to English	From English to SI
Length		
kilometer (km) = 1,000 m	1 km = 0.621 mi	1 mi = 1.609 km
meter (m) = 100 cm	1 m = 3.281 ft	1 ft = 0.305 m
centimeter (cm) = 0.01 m	1 cm = 0.394 in.	1 in. = 2.540 cm
millimeter (mm) = 0.001 m	1 mm = 0.039 in.	
micrometer (μm) = 0.000 001 m		
nanometer (nm) = 0.000 000 001 m		
Area		
square kilometer (km^2) = 100 hectares	1 km^2 = 0.386 mi^2	1 mi^2 = 2.590 km^2
hectare (ha) = 10,000 m^2	1 ha = 2.471 acres	1 acre = 0.405 ha
square meter (m^2) = 10,000 cm^2	1 m^2 = 10.764 ft^2	1 ft^2 = 0.093 m^2
square centimeter (cm^2) = 100 mm^2	1 cm^2 = 0.155 in.2	1 in.2 = 6.452 cm^2
Volume		
liter (L) = 1,000 mL = 1 dm^3	1 L = 1.057 fl qt	1 fl qt = 0.946 L
milliliter (mL) = 0.001 L = 1 cm^3	1 mL = 0.034 fl oz	1 fl oz = 29.574 mL
microliter (μL) = 0.000 001 L		
Mass		
kilogram (kg) = 1,000 g	1 kg = 2.205 lb	1 lb = 0.454 kg
gram (g) = 1,000 mg	1 g = 0.035 oz	1 oz = 28.350 g
milligram (mg) = 0.001 g		
microgram (μg) = 0.000 001 g		

Temperature Scales

Temperature can be expressed by using three different scales: Fahrenheit, Celsius, and Kelvin. The SI unit for temperature is the kelvin (K).

Although 0 K is much colder than 0°C, a change of 1 K is equal to a change of 1°C.

Three Temperature Scales

	Fahrenheit	Celsius	Kelvin
Water boils	212°	100°	373
Body temperature	98.6°	37°	310
Room temperature	68°	20°	293
Water freezes	32°	0°	273

Temperature Conversions Table

To convert	Use this equation:	Example
Celsius to Fahrenheit °C → °F	$°F = \left(\dfrac{9}{5} \times °C\right) + 32$	Convert 45°C to °F. $°F = \left(\dfrac{9}{5} \times 45°C\right) + 32 = 113°F$
Fahrenheit to Celsius °F → °C	$°C = \dfrac{5}{9} \times (°F - 32)$	Convert 68°F to °C. $°C = \dfrac{5}{9} \times (68°F - 32) = 20°C$
Celsius to Kelvin °C → K	$K = °C + 273$	Convert 45°C to K. $K = 45°C + 273 = 318\ K$
Kelvin to Celsius K → °C	$°C = K - 273$	Convert 32 K to °C. $°C = 32K - 273 = -241°C$

Measuring Skills

Using a Graduated Cylinder

When using a graduated cylinder to measure volume, keep the following procedures in mind:

1. Place the cylinder on a flat, level surface before measuring liquid.

2. Move your head so that your eye is level with the surface of the liquid.

3. Read the mark closest to the liquid level. On glass graduated cylinders, read the mark closest to the center of the curve in the liquid's surface.

Using a Meterstick or Metric Ruler

When using a meterstick or metric ruler to measure length, keep the following procedures in mind:

1. Place the ruler firmly against the object that you are measuring.

2. Align one edge of the object exactly with the 0 end of the ruler.

3. Look at the other edge of the object to see which of the marks on the ruler is closest to that edge. (Note: Each small slash between the centimeters represents a millimeter, which is one-tenth of a centimeter.)

Using a Triple-Beam Balance

When using a triple-beam balance to measure mass, keep the following procedures in mind:

1. Make sure the balance is on a level surface.

2. Place all of the countermasses at 0. Adjust the balancing knob until the pointer rests at 0.

3. Place the object you wish to measure on the pan. **Caution:** Do not place hot objects or chemicals directly on the balance pan.

4. Move the largest countermass along the beam to the right until it is at the last notch that does not tip the balance. Follow the same procedure with the next-largest countermass. Then, move the smallest countermass until the pointer rests at 0.

5. Add the readings from the three beams together to determine the mass of the object.

6. When determining the mass of crystals or powders, first find the mass of a piece of filter paper. Then, add the crystals or powder to the paper, and remeasure. The actual mass of the crystals or powder is the total mass minus the mass of the paper. When finding the mass of liquids, first find the mass of the empty container. Then, find the combined mass of the liquid and container. The mass of the liquid is the total mass minus the mass of the container.

Scientific Methods

The ways in which scientists answer questions and solve problems are called **scientific methods.** The same steps are often used by scientists as they look for answers. However, there is more than one way to use these steps. Scientists may use all of the steps or just some of the steps during an investigation. They may even repeat some of the steps. The goal of using scientific methods is to come up with reliable answers and solutions.

Six Steps of Scientific Methods

 1 Ask a Question Good questions come from careful **observations.** You make observations by using your senses to gather information. Sometimes, you may use instruments, such as microscopes and telescopes, to extend the range of your senses. As you observe the natural world, you will discover that you have many more questions than answers. These questions drive investigations.

Questions beginning with *what, why, how,* and *when* are important in focusing an investigation. Here is an example of a question that could lead to an investigation.

Question: How does acid rain affect plant growth?

 2 Form a Hypothesis After you ask a question, you need to form a **hypothesis.** A hypothesis is a clear statement of what you expect the answer to your question to be. Your hypothesis will represent your best "educated guess" based on what you have observed and what you already know. A good hypothesis is testable. Otherwise, the investigation can go no further. Here is a hypothesis based on the question, "How does acid rain affect plant growth?"

Hypothesis: Acid rain slows plant growth.

The hypothesis can lead to predictions. A prediction is what you think the outcome of your experiment or data collection will be. Predictions are usually stated in an if-then format. Here is a sample prediction for the hypothesis that acid rain slows plant growth.

Prediction: If a plant is watered with only acid rain (which has a pH of 4), then the plant will grow at half its normal rate.

3 Test the Hypothesis After you have formed a hypothesis and made a prediction, your hypothesis should be tested. One way to test a hypothesis is with a controlled experiment. A **controlled experiment** tests only one factor at a time. In an experiment to test the effect of acid rain on plant growth, the **control group** would be watered with normal rain water. The **experimental group** would be watered with acid rain. All of the plants should receive the same amount of sunlight and water each day. The air temperature should be the same for all groups. However, the acidity of the water will be a variable. In fact, any factor that is different from one group to another is a **variable.** If your hypothesis is correct, then the acidity of the water and plant growth are *dependant variables.* The amount a plant grows is dependent on the acidity of the water. However, the amount of water each plant receives and the amount of sunlight each plant receives are *independent variables.* Either of these factors could change without affecting the other factor.

Sometimes, the nature of an investigation makes a controlled experiment impossible. For example, the Earth's core is surrounded by thousands of meters of rock. Under such circumstances, a hypothesis may be tested by making detailed observations.

 4 Analyze the Results After you have completed your experiments, made your observations, and collected your data, you must analyze all the information you have gathered. Tables and graphs are often used in this step to organize the data.

5 Draw Conclusions

After analyzing your data, you can determine if your results support your hypothesis. If your hypothesis is supported, you (or others) might want to repeat the observations or experiments to verify your results. If your hypothesis is not supported by the data, you may have to check your procedure for errors. You may even have to reject your hypothesis and make a new one. If you cannot draw a conclusion from your results, you may have to try the investigation again or carry out further observations or experiments.

6 Communicate Results

After any scientific investigation, you should report your results. By preparing a written or oral report, you let others know what you have learned. They may repeat your investigation to see if they get the same results. Your report may even lead to another question and then to another investigation.

Scientific Methods in Action

Scientific methods contain loops in which several steps may be repeated over and over again. In some cases, certain steps are unnecessary. Thus, there is not a "straight line" of steps. For example, sometimes scientists find that testing one hypothesis raises new questions and new hypotheses to be tested. And sometimes, testing the hypothesis leads directly to a conclusion. Furthermore, the steps in scientific methods are not always used in the same order. Follow the steps in the diagram, and see how many different directions scientific methods can take you.

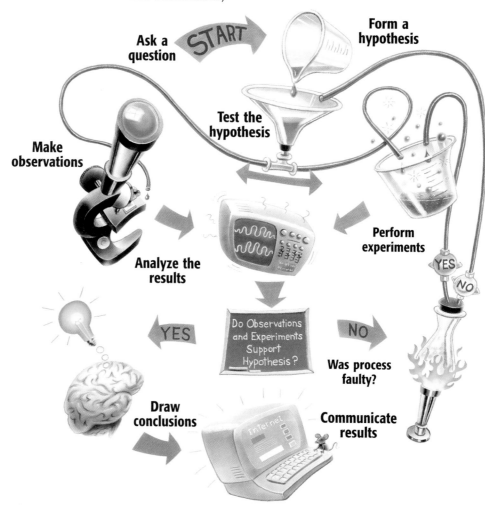

Appendix

Making Charts and Graphs

Pie Charts

A pie chart shows how each group of data relates to all of the data. Each part of the circle forming the chart represents a category of the data. The entire circle represents all of the data. For example, a biologist studying a hardwood forest in Wisconsin found that there were five different types of trees. The data table at right summarizes the biologist's findings.

Wisconsin Hardwood Trees	
Type of tree	Number found
Oak	600
Maple	750
Beech	300
Birch	1,200
Hickory	150
Total	3,000

How to Make a Pie Chart

1 To make a pie chart of these data, first find the percentage of each type of tree. Divide the number of trees of each type by the total number of trees, and multiply by 100.

$$\frac{600 \text{ oak}}{3,000 \text{ trees}} \times 100 = 20\%$$

$$\frac{750 \text{ maple}}{3,000 \text{ trees}} \times 100 = 25\%$$

$$\frac{300 \text{ beech}}{3,000 \text{ trees}} \times 100 = 10\%$$

$$\frac{1,200 \text{ birch}}{3,000 \text{ trees}} \times 100 = 40\%$$

$$\frac{150 \text{ hickory}}{3,000 \text{ trees}} \times 100 = 5\%$$

2 Now, determine the size of the wedges that make up the pie chart. Multiply each percentage by 360°. Remember that a circle contains 360°.

$20\% \times 360° = 72°$ $25\% \times 360° = 90°$

$10\% \times 360° = 36°$ $40\% \times 360° = 144°$

$5\% \times 360° = 18°$

3 Check that the sum of the percentages is 100 and the sum of the degrees is 360.

$20\% + 25\% + 10\% + 40\% + 5\% = 100\%$

$72° + 90° + 36° + 144° + 18° = 360°$

4 Use a compass to draw a circle and mark the center of the circle.

5 Then, use a protractor to draw angles of 72°, 90°, 36°, 144°, and 18° in the circle.

6 Finally, label each part of the chart, and choose an appropriate title.

A Community of Wisconsin Hardwood Trees

Line Graphs

Line graphs are most often used to demonstrate continuous change. For example, Mr. Smith's students analyzed the population records for their hometown, Appleton, between 1900 and 2000. Examine the data at right.

Because the year and the population change, they are the *variables*. The population is determined by, or dependent on, the year. Therefore, the population is called the **dependent variable,** and the year is called the **independent variable.** Each set of data is called a **data pair.** To prepare a line graph, you must first organize data pairs into a table like the one at right.

| Population of Appleton, 1900–2000 ||
Year	Population
1900	1,800
1920	2,500
1940	3,200
1960	3,900
1980	4,600
2000	5,300

How to Make a Line Graph

1. Place the independent variable along the horizontal (*x*) axis. Place the dependent variable along the vertical (*y*) axis.

2. Label the *x*-axis "Year" and the *y*-axis "Population." Look at your largest and smallest values for the population. For the *y*-axis, determine a scale that will provide enough space to show these values. You must use the same scale for the entire length of the axis. Next, find an appropriate scale for the *x*-axis.

3. Choose reasonable starting points for each axis.

4. Plot the data pairs as accurately as possible.

5. Choose a title that accurately represents the data.

How to Determine Slope

Slope is the ratio of the change in the *y*-value to the change in the *x*-value, or "rise over run."

1. Choose two points on the line graph. For example, the population of Appleton in 2000 was 5,300 people. Therefore, you can define point *a* as (2000, 5,300). In 1900, the population was 1,800 people. You can define point *b* as (1900, 1,800).

2. Find the change in the *y*-value. (*y* at point *a*) − (*y* at point *b*) = 5,300 people − 1,800 people = 3,500 people

3. Find the change in the *x*-value. (*x* at point *a*) − (*x* at point *b*) = 2000 − 1900 = 100 years

4. Calculate the slope of the graph by dividing the change in *y* by the change in *x*.

$$slope = \frac{change\ in\ y}{change\ in\ x}$$

$$slope = \frac{3,500\ people}{100\ years}$$

$$slope = 35\ people\ per\ year$$

In this example, the population in Appleton increased by a fixed amount each year. The graph of these data is a straight line. Therefore, the relationship is **linear.** When the graph of a set of data is not a straight line, the relationship is **nonlinear.**

Using Algebra to Determine Slope

The equation in step 4 may also be arranged to be

$$y = kx$$

where y represents the change in the y-value, k represents the slope, and x represents the change in the x-value.

$$slope = \frac{change\ in\ y}{change\ in\ x}$$

$$k = \frac{y}{x}$$

$$k \times x = \frac{y \times x}{x}$$

$$kx = y$$

Bar Graphs

Bar graphs are used to demonstrate change that is not continuous. These graphs can be used to indicate trends when the data cover a long period of time. A meteorologist gathered the precipitation data shown here for Hartford, Connecticut, for April 1–15, 1996, and used a bar graph to represent the data.

Precipitation in Hartford, Connecticut April 1–15, 1996			
Date	Precipitation (cm)	Date	Precipitation (cm)
April 1	0.5	April 9	0.25
April 2	1.25	April 10	0.0
April 3	0.0	April 11	1.0
April 4	0.0	April 12	0.0
April 5	0.0	April 13	0.25
April 6	0.0	April 14	0.0
April 7	0.0	April 15	6.50
April 8	1.75		

How to Make a Bar Graph

1 Use an appropriate scale and a reasonable starting point for each axis.

2 Label the axes, and plot the data.

3 Choose a title that accurately represents the data.

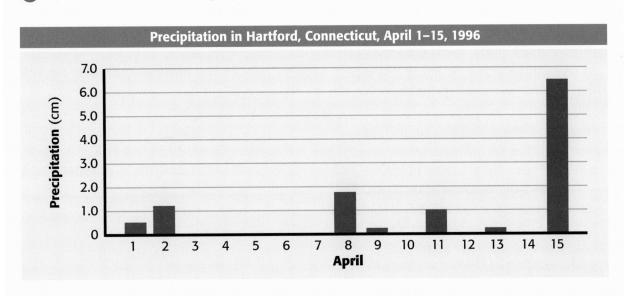

Precipitation in Hartford, Connecticut, April 1–15, 1996

Math Refresher

Science requires an understanding of many math concepts. The following pages will help you review some important math skills.

Averages

An **average,** or **mean,** simplifies a set of numbers into a single number that *approximates* the value of the set.

> **Example:** Find the average of the following set of numbers: 5, 4, 7, and 8.

Step 1: Find the sum.

$$5 + 4 + 7 + 8 = 24$$

Step 2: Divide the sum by the number of numbers in your set. Because there are four numbers in this example, divide the sum by 4.

$$\frac{24}{4} = 6$$

The average, or mean, is **6.**

Ratios

A **ratio** is a comparison between numbers, and it is usually written as a fraction.

> **Example:** Find the ratio of thermometers to students if you have 36 thermometers and 48 students in your class.

Step 1: Make the ratio.

$$\frac{36 \text{ thermometers}}{48 \text{ students}}$$

Step 2: Reduce the fraction to its simplest form.

$$\frac{36}{48} = \frac{36 \div 12}{48 \div 12} = \frac{3}{4}$$

The ratio of thermometers to students is **3 to 4,** or $\frac{3}{4}$. The ratio may also be written in the form 3:4.

Proportions

A **proportion** is an equation that states that two ratios are equal.

$$\frac{3}{1} = \frac{12}{4}$$

To solve a proportion, first multiply across the equal sign. This is called *cross-multiplication.* If you know three of the quantities in a proportion, you can use cross-multiplication to find the fourth.

> **Example:** Imagine that you are making a scale model of the solar system for your science project. The diameter of Jupiter is 11.2 times the diameter of the Earth. If you are using a plastic-foam ball that has a diameter of 2 cm to represent the Earth, what must the diameter of the ball representing Jupiter be?
>
> $$\frac{11.2}{1} = \frac{x}{2 \text{ cm}}$$

Step 1: Cross-multiply.

$$\frac{11.2}{1} \diagdown \frac{x}{2}$$

$$11.2 \times 2 = x \times 1$$

Step 2: Multiply.

$$22.4 = x \times 1$$

Step 3: Isolate the variable by dividing both sides by 1.

$$x = \frac{22.4}{1}$$
$$x = 22.4 \text{ cm}$$

You will need to use a ball that has a diameter of **22.4** cm to represent Jupiter.

Percentages

A **percentage** is a ratio of a given number to 100.

> **Example:** What is 85% of 40?

Step 1: Rewrite the percentage by moving the decimal point two places to the left.

0.85

Step 2: Multiply the decimal by the number that you are calculating the percentage of.

0.85 × 40 = 34

85% of 40 is **34.**

Decimals

To **add** or **subtract decimals,** line up the digits vertically so that the decimal points line up. Then, add or subtract the columns from right to left. Carry or borrow numbers as necessary.

> **Example:** Add the following numbers: 3.1415 and 2.96.

Step 1: Line up the digits vertically so that the decimal points line up.

```
  3.1415
+ 2.96
```

Step 2: Add the columns from right to left, and carry when necessary.

```
 1 1
  3.1415
+ 2.96
───────
  6.1015
```

The sum is **6.1015.**

Fractions

Numbers tell you how many; **fractions** tell you *how much of a whole.*

> **Example:** Your class has 24 plants. Your teacher instructs you to put 5 plants in a shady spot. What fraction of the plants in your class will you put in a shady spot?

Step 1: In the denominator, write the total number of parts in the whole.

$$\frac{?}{24}$$

Step 2: In the numerator, write the number of parts of the whole that are being considered.

$$\frac{5}{24}$$

So, $\frac{5}{24}$ of the plants will be in the shade.

Reducing Fractions

It is usually best to express a fraction in its simplest form. Expressing a fraction in its simplest form is called *reducing* a fraction.

> **Example:** Reduce the fraction $\frac{30}{45}$ to its simplest form.

Step 1: Find the largest whole number that will divide evenly into both the numerator and denominator. This number is called the *greatest common factor* (GCF).

Factors of the numerator 30:

1, 2, 3, 5, 6, 10, **15,** 30

Factors of the denominator 45:

1, 3, 5, 9, **15,** 45

Step 2: Divide both the numerator and the denominator by the GCF, which in this case is 15.

$$\frac{30}{45} = \frac{30 \div 15}{45 \div 15} = \frac{2}{3}$$

Thus, $\frac{30}{45}$ reduced to its simplest form is $\frac{2}{3}$.

Adding and Subtracting Fractions

To **add** or **subtract fractions** that have the **same denominator,** simply add or subtract the numerators.

Examples:

$$\frac{3}{5} + \frac{1}{5} = ? \quad \text{and} \quad \frac{3}{4} - \frac{1}{4} = ?$$

Step 1: Add or subtract the numerators.

$$\frac{3}{5} + \frac{1}{5} = \frac{4}{} \quad \text{and} \quad \frac{3}{4} - \frac{1}{4} = \frac{2}{}$$

Step 2: Write the sum or difference over the denominator.

$$\frac{3}{5} + \frac{1}{5} = \frac{4}{5} \quad \text{and} \quad \frac{3}{4} - \frac{1}{4} = \frac{2}{4}$$

Step 3: If necessary, reduce the fraction to its simplest form.

$\frac{4}{5}$ cannot be reduced, and $\frac{2}{4} = \frac{1}{2}$.

To **add** or **subtract fractions** that have **different denominators,** first find the least common denominator (LCD).

Examples:

$$\frac{1}{2} + \frac{1}{6} = ? \quad \text{and} \quad \frac{3}{4} - \frac{2}{3} = ?$$

Step 1: Write the equivalent fractions that have a common denominator.

$$\frac{3}{6} + \frac{1}{6} = ? \quad \text{and} \quad \frac{9}{12} - \frac{8}{12} = ?$$

Step 2: Add or subtract the fractions.

$$\frac{3}{6} + \frac{1}{6} = \frac{4}{6} \quad \text{and} \quad \frac{9}{12} - \frac{8}{12} = \frac{1}{12}$$

Step 3: If necessary, reduce the fraction to its simplest form.

The fraction $\frac{4}{6} = \frac{2}{3}$, and $\frac{1}{12}$ cannot be reduced.

Multiplying Fractions

To **multiply fractions,** multiply the numerators and the denominators together, and then reduce the fraction to its simplest form.

Example:

$$\frac{5}{9} \times \frac{7}{10} = ?$$

Step 1: Multiply the numerators and denominators.

$$\frac{5}{9} \times \frac{7}{10} = \frac{5 \times 7}{9 \times 10} = \frac{35}{90}$$

Step 2: Reduce the fraction.

$$\frac{35}{90} = \frac{35 \div 5}{90 \div 5} = \frac{7}{18}$$

Dividing Fractions

To **divide fractions,** first rewrite the divisor (the number you divide by) upside down. This number is called the *reciprocal* of the divisor. Then multiply and reduce if necessary.

Example:

$$\frac{5}{8} \div \frac{3}{2} = ?$$

Step 1: Rewrite the divisor as its reciprocal.

$$\frac{3}{2} \rightarrow \frac{2}{3}$$

Step 2: Multiply the fractions.

$$\frac{5}{8} \times \frac{2}{3} = \frac{5 \times 2}{8 \times 3} = \frac{10}{24}$$

Step 3: Reduce the fraction.

$$\frac{10}{24} = \frac{10 \div 2}{24 \div 2} = \frac{5}{12}$$

Scientific Notation

Scientific notation is a short way of representing very large and very small numbers without writing all of the place-holding zeros.

> **Example:** Write 653,000,000 in scientific notation.

Step 1: Write the number without the place-holding zeros.

653

Step 2: Place the decimal point after the first digit.

6.53

Step 3: Find the exponent by counting the number of places that you moved the decimal point.

6.53000000

The decimal point was moved eight places to the left. Therefore, the exponent of 10 is positive 8. If you had moved the decimal point to the right, the exponent would be negative.

Step 4: Write the number in scientific notation.

6.53×10^8

Area

Area is the number of square units needed to cover the surface of an object.

> **Formulas:**
>
> $area\ of\ a\ square = side \times side$
> $area\ of\ a\ rectangle = length \times width$
> $area\ of\ a\ triangle = \frac{1}{2} \times base \times height$
>
> **Examples:** Find the areas.

Triangle

$area = \frac{1}{2} \times base \times height$

$area = \frac{1}{2} \times 3\ cm \times 4\ cm$

$area = \textbf{6 cm}^2$

4 cm

3 cm

3 cm

6 cm

Rectangle

$area = length \times width$

$area = 6\ cm \times 3\ cm$

$area = \textbf{18 cm}^2$

3 cm

3 cm

Square

$area = side \times side$

$area = 3\ cm \times 3\ cm$

$area = \textbf{9 cm}^2$

Volume

Volume is the amount of space that something occupies.

> **Formulas:**
>
> $volume\ of\ a\ cube =$
> $side \times side \times side$
>
> $volume\ of\ a\ prism =$
> $area\ of\ base \times height$
>
> **Examples:**
>
> Find the volume of the solids.

Cube

$volume = side \times side \times side$

$volume = 4\ cm \times 4\ cm \times 4\ cm$

$volume = \textbf{64 cm}^3$

4 cm

4 cm

4 cm

4 cm

3 cm

5 cm

Prism

$volume = area\ of\ base \times height$

$volume = (area\ of\ triangle) \times height$

$volume = (\frac{1}{2} \times 3\ cm \times 4\ cm) \times 5\ cm$

$volume = 6\ cm^2 \times 5\ cm$

$volume = \textbf{30 cm}^3$

Glossary

A

acid precipitation rain, sleet, or snow that contains a high concentration of acids (23)

air mass a large body of air where temperature and moisture content are similar throughout (46)

air pollution the contamination of the atmosphere by the introduction of pollutants from human and natural sources (20)

air pressure the measure of the force with which air molecules push on a surface (5)

anemometer an instrument used to measure wind speed (61)

anticyclone the rotation of air around a high-pressure center in the direction opposite to Earth's rotation (50)

atmosphere a mixture of gases that surrounds a planet or moon (4)

B

barometer an instrument that measures atmospheric pressure (61)

biome a large region characterized by a specific type of climate and certain types of plant and animal communities (79)

C

climate the average weather conditions in an area over a long period of time (74)

cloud a collection of small water droplets or ice crystals suspended in the air, which forms when the air is cooled and condensation occurs (42)

condensation the change of state from a gas to a liquid (41)

convection the transfer of thermal energy by the circulation or movement of a liquid or gas (11)

Coriolis effect the apparent curving of the path of a moving object from an otherwise straight path due to the Earth's rotation (16)

cyclone an area in the atmosphere that has lower pressure than the surrounding areas and has winds that spiral toward the center (50)

E

elevation the height of an object above sea level (78)

F

front the boundary between air masses of different densities and usually different temperatures (48)

G

global warming a gradual increase in average global temperature (12, 96)

greenhouse effect the warming of the surface and lower atmosphere of Earth that occurs when water vapor, carbon dioxide, and other gases absorb and reradiate thermal energy (12, 96)

H

humidity the amount of water vapor in the air (39)

hurricane a severe storm that develops over tropical oceans and whose strong winds of more than 120 km/h spiral in toward the intensely low-pressure storm center (55)

I

ice age a long period of climate cooling during which ice sheets cover large areas of Earth's surface; also known as a *glacial period* (92)

J

jet stream a narrow belt of strong winds that blow in the upper troposphere (18)

L

latitude the distance north or south from the equator; expressed in degrees (75)

lightning an electric discharge that takes place between two oppositely charged surfaces, such as between a cloud and the ground, between two clouds, or between two parts of the same cloud (53)

M

mesosphere the layer of the atmosphere between the stratosphere and the thermosphere and in which temperature decreases as altitude increases (7)

microclimate the climate of a small area (90)

P

polar easterlies prevailing winds that blow from east to west between 60° and 90° latitude in both hemispheres (16)

polar zone the North or South Pole and the surrounding region (89)

precipitation any form of water that falls to the Earth's surface from the clouds (44)

prevailing winds winds that blow mainly from one direction during a given period (76)

R

radiation the transfer of energy as electromagnetic waves (10)

relative humidity the ratio of the amount of water vapor in the air to the maximum amount of water vapor the air can hold at a set temperature (39)

S

stratosphere the layer of the atmosphere that is above the troposphere and in which temperature increases as altitude increases (7)

surface current a horizontal movement of ocean water that is caused by wind and that occurs at or near the ocean's surface (79)

T

temperate zone the climate zone between the Tropics and the polar zone (86)

thermal conduction the transfer of energy as heat through a material (11)

thermometer an instrument that measures and indicates temperature (61)

thermosphere the uppermost layer of the atmosphere, in which temperature increases as altitude increases (8)

thunder the sound caused by the rapid expansion of air along an electrical strike (53)

thunderstorm a usually brief, heavy storm that consists of rain, strong winds, lightning, and thunder (52)

tornado a destructive, rotating column of air that has very high wind speeds, is visible as a funnel-shaped cloud, and touches the ground (54)

trade winds prevailing winds that blow northeast from 30° north latitude to the equator and that blow southeast from 30° south latitude to the equator (16)

tropical zone the region that surrounds the equator and that extends from about 23° north latitude to 23° south latitude (82)

troposphere the lowest layer of the atmosphere, in which temperature decreases at a constant rate as altitude increases (7)

W

weather the short-term state of the atmosphere, including temperature, humidity, precipitation, wind, and visibility (38, 74)

westerlies prevailing winds that blow from west to east between 30° and 60° latitude in both hemispheres (16)

wind the movement of air caused by differences in air pressure (14)

Spanish Glossary

A

acid precipitation/precipitación ácida lluvia, agua-nieve o nieve que contiene una alta concentración de ácidos (23)

air mass/masa de aire un gran volumen de aire que tiene una temperatura y contenido de humedad similar en toda su extensión (46)

air pollution/contaminación del aire la contaminación de la atmósfera debido a la introducción de contaminantes provenientes de fuentes humanas y naturales (20)

air pressure/presión del aire la medida de la fuerza con la que las moléculas del aire empujan contra una superficie (5)

anemometer/anemómetro un instrumento que se usa para medir la rapidez del viento (61)

anticyclone/anticiclón la rotación del aire alrededor de un centro de alta presión en dirección opuesta a la rotación de la Tierra (50)

atmosphere/atmósfera una mezcla de gases que rodea un planeta o una luna (4)

B

barometer/barómetro un instrumento que mide la presión atmosférica (61)

biome/bioma una región extensa caracterizada por un tipo de clima específico y ciertos tipos de comunidades de plantas y animales (79)

C

climate/clima las condiciones promedio del tiempo en un área durante un largo período de tiempo (74)

cloud/nube un conjunto de pequeñas gotitas de agua o cristales de hielo suspendidos en el aire, que se forma cuando el aire se enfría y ocurre condensación (42)

condensation/condensación el cambio de estado de gas a líquido (41)

convection/convección la transferencia de energía térmica mediante la circulación o el movimiento de un líquido o gas (11)

Coriolis effect/efecto de Coriolis la desviación aparente de la trayectoria recta que experimentan los objetos en movimiento debido a la rotación de la Tierra (16)

cyclone/ciclón un área de la atmósfera que tiene una presión menor que la de las áreas circundantes y que tiene vientos que giran en espiral hacia el centro (50)

E

elevation/elevación la altura de un objeto sobre el nivel del mar (78)

F

front/frente el límite entre masas de aire de diferentes desidades y, normalmente, diferentes temperaturas (48)

G

global warming/calentamiento global un aumento gradual de la temperatura global promedio (12, 96)

greenhouse effect/efecto de invernadero el calentamiento de la superficie y de la parte más baja de la atmósfera, el cual se produce cuando el vapor de agua, el dióxido de carbono y otros gases absorben y vuelven a irradiar la energía térmica (12, 96)

H

humidity/humedad la cantidad de vapor de agua que hay en el aire (39)

hurricane/huracán tormenta severa que se desarrolla sobre océanos tropicales, con vientos fuertes que soplan a más de 120 km/h y que se mueven en espiral hacia el centro de presión extremadamente baja de la tormenta (55)

I

ice age/edad de hielo un largo período de tiempo frío durante el cual grandes áreas de la superficie terrestre están cubiertas por capas de hielo; también conocido como período glacial (92)

J

jet stream/corriente en chorro un cinturón delgado de vientos fuertes que soplan en la parte superior de la troposfera (18)

L

latitude/latitud la distancia hacia el norte o hacia el sur del ecuador; se expresa en grados (75)

lightning/relámpago una descarga eléctrica que ocurre entre dos superficies que tienen carga opuesta, como por ejemplo, entre una nube y el suelo, entre dos nubes o entres dos partes de la misma nube (53)

M

mesosphere/mesosfera la capa de la atmósfera que se encuentra entre la estratosfera y la termosfera, en la cual la temperatura disminuye al aumentar la altitud (7)

microclimate/microclima el clima de un área pequeña (90)

P

polar easterlies/vientos polares del este vientos preponderantes que soplan de este a oeste entre los 60° y los 90° de latitud en ambos hemisferios (16)

polar zone/zona polar el Polo Norte y el Polo Sur y la región circundante (89)

precipitation/precipitación cualquier forma de agua que cae de las nubes a la superficie de la Tierra (44)

prevailing winds/vientos prevalecientes vientos que soplan principalmente de una dirección durante un período de tiempo determinado (76)

R

radiation/radiación la transferencia de energía en forma de ondas electromagnéticas (10)

relative humidity/humedad relativa la proporción de la cantidad de vapor de agua que hay en el aire respecto a la cantidad máxima de vapor de agua que el aire puede contener a una temperatura dada (39)

S

stratosphere/estratosfera la capa de la atmósfera que se encuentra encima de la troposfera y en la que la temperatura aumenta al aumentar la altitud (7)

surface current/corriente superficial un movimiento horizontal del agua del océano que es producido por el viento y que ocurre en la superficie del océano o cerca de ella (79)

T

temperate zone/zona templada la zona climática ubicada entre los trópicos y la zona polar (86)

thermal conduction/conducción térmica la transferencia de energía en forma de calor a través de un material (11)

thermometer/termómetro un instrumento que mide e indica la temperatura (61)

thermosphere/termosfera la capa más alta de la atmósfera, en la cual la temperatura aumenta a medida que la altitud aumenta (8)

thunder/trueno el sonido producido por la expansión rápida del aire a lo largo de una descarga eléctrica (53)

thunderstorm/tormenta eléctrica una tormenta fuerte y normalmente breve que consiste en lluvia, vientos fuertes, relámpagos y truenos (52)

tornado/tornado una columna destructiva de aire en rotación cuyos vientos se mueven a velocidades muy altas; se ve como una nube con forma de embudo y toca el suelo (54)

trade winds/vientos alisios vientos preponderantes que soplan hacia el noreste a partir de los 30° de latitud norte hacia el ecuador y que soplan hacia el sureste a partir de los 30° de latitud sur hacia el ecuador (16)

tropical zone/zona tropical la región que rodea el ecuador y se extiende desde aproximadamente 23° de latitud norte hasta 23° de latitud sur (82)

troposphere/troposfera la capa inferior de la atmósfera, en la que la temperatura disminuye a una tasa constante a medida que la altitud aumenta (7)

W

weather/tiempo el estado de la atmósfera a corto plazo que incluye la temperatura, la humedad, la precipitación, el viento y la visibilidad (38, 74)

westerlies/vientos del oeste vientos preponderantes que soplan de oeste a este entre 30° y 60° de latitud en ambos hemisferios (16)

wind/viento el movimiento de aire producido por diferencias en la presión barométrica (14)

Index

Index

Index

Index

Index

Z

Credits

Abbreviations used: (t) top, (c) center, (b) bottom, (l) left, (r) right, (bkgd) background

PHOTOGRAPHY

Front Cover Douglas E. Walker/Masterfile

Skills Practice Lab Teens Sam Dudgeon/HRW

Connection to Astrology Corbis Images; **Connection to Biology** David M. Phillips/Visuals Unlimited; **Connection to Chemistry** Digital Image copyright © 2005 PhotoDisc; **Connection to Environment** Digital Image copyright © 2005 PhotoDisc; **Connection to Geology** Letraset Phototone; **Connection to Language Arts** Digital Image copyright © 2005 PhotoDisc; **Connection to Meteorology** Digital Image copyright © 2005 PhotoDisc; **Connection to Oceanography** © ICONOTEC; **Connection to Physics** Digital Image copyright © 2005 PhotoDisc

Chapter One 2–3, Robert Holmes/CORBIS; 5, Peter Van Steen/HRW; 7 (t), SuperStock; 7 (b), NASA; 8, Image Copyright ©2005 PhotoDisc, Inc.; 9, Patrick J. Endres/Alaskaphotographics.com; 14, Terry Renna/AP/Wide World Photos; 15 (b), Moredun Animal Health Ltd./Science Photo Library/Photo Researchers, Inc.; 18 (t), NASA/Science Photo Library/Photo Researchers, Inc.; 20 (c), Argus Fotoarchiv/Peter Arnold, Inc.; 464 (r), David Weintraub/Photo Researchers, Inc; 464 (l), Digital Image copyright © 2005 PhotoDisc/Getty Images; 21 (bl), Steve Starr/CORBIS; 21 (r), Corbis Images; 23, Simon Fraser/SPL/Photo Researchers, Inc.; 24 (t), Goddard Space Flight Center Scientific Visualization Studio/NASA; 24 (b), Goddard Space Flight Center Scientific Visualization Studio/NASA; 25, Tampa Electric; 26, Francis Dean/The Image Works; 27, Tampa Electric; 28, 29, Sam Dudgeon/HRW; 31 (t), Goddard Space Flight Center Scientific Visualization Studio/NASA; 34 (b), James McInnis/Los Alamos National Laboratories; 34 (t), Jonathan Blair/CORBIS; 35 (r), Fred Hirschmann; 35 (bl), Fred Hirschmann

Chapter Two 36–37, Tim Chapman/Miami Herald/NewsCom; 40, Sam Dudgeon/HRW; 41, Victoria Smith/HRW; 42 (tc), NOAA; 42 (tr), Joyce Photographics/Photo Researchers, Inc.; 42 (tl), Corbis Images; 44, Gene E. Moore; 44 (tl), Gerben Oppermans/Getty Images/Stone; 45 (c), Corbis Images; 45 (t), Victoria Smith/HRW; 47, Image Copyright ©2005 PhotoDisc, Inc.; 47 (t), Reuters/Gary Wiepert/NewsCom; 50, NASA; 52, William H. Edwards/Getty Images/The Image Bank; 53 (br), Jean–Loup Charmet/Science Photo Library/Photo Researchers, Inc.; 54 (all), Howard B. Bluestein/Photo Researchers, Inc.; 55 (t), Red Huber/Orlando Sentinel/SYGMA/CORBIS; 55 (b), NASA; 500 (tl), NASA/Science Photo Library/Photo Researchers, Inc.; 57, Dave Martin/AP/Wide World Photos; 58 (b), Joe Raedle/NewsCom; 58 (t), Will Chandler/Anderson Independent–Mail/AP/Wide World Photos; 59 (t), Jean–Loup Charmet/Science Photo Library/Photo Researchers, Inc.; 59 (c), NASA/Science Photo Library/Photo Researchers, Inc.; 60, Graham Neden/Ecoscene/CORBIS; 61, Sam Dudgeon/HRW; 61 (br), G.R. Roberts Photo Library; 61 (t), Guido Alberto Rossi/Getty Images/The Image Bank; 62, National Weather Service/NOAA; 66, Sam Dudgeon/HRW; 67 (tl), Corbis Images; 70 (tr), Lightscapes Photography, Inc./CORBIS; 67 (b), Joyce Photographics/Photo Researchers, Inc.; 71 (t), Michael Lyon; 71 (bl), Corbis Images

Chapter Three 72–73, Steve Bloom Images; 74 (bkgd), Tom Van Sant, Geosphere Project/Planetary Visions/Science Photo Library/Photo Researchers, Inc.; 74 (tl), G.R. Roberts Photo Library; 74 (tr), Index Stock; 74 (c), Yva Momatiuk & John Eastcott; 74 (bl), Gary Retherford/Photo Researchers, Inc.; 74 (br), SuperStock; 75 (tr), CALLER–TIMES/AP/Wide World Photos; 75 (tc), Doug Mills/AP/Wide World Photos; 77 (b), Tom Van Sant, Geosphere Project/Planetary Visions/Science Photo Library/Photo Researchers, Inc.; 78 (bl), Larry Ulrich Photography; 78 (br), Paul Wakefield/Getty Images/Stone; 81, Index Stock; 82 (br), Tom Van Sant/Geosphere Project, Santa Monica/Science Photo Library/Photo Researchers, Inc.; 83 (tl), Carlos Navajas/Getty Images/The Image Bank; 83 (tr), Michael Fogden/Bruce Coleman, Inc.; 84, Nadine Zuber/Photo Researchers, Inc.; 85, Larry Ulrich Photography; 86 (tr), Tom Van Sant/Geosphere Project, Santa Monica/Science Photo Library/Photo Researchers, Inc.; 87 (b), Tom Bean/Getty Images/Stone; 87 (t), CORBIS Images/HRW; 88 (b), Steven Simpson/Getty Images/FPG International; 88 (t), Fred Hirschmann; 89 (b), Harry Walker/Alaska Stock; 89 (tr), Tom Van Sant/Geosphere Project, Santa Monica/Science Photo Library/Photo Researchers, Inc.; 90, SuperStock; 94 (br), Roger Werth/Woodfin Camp & Associates; 95, D. Van Ravenswaay/Photo Researchers, Inc.; 100, Gunter Ziesler/Peter Arnold, Inc.; 101, SuperStock; 104, Roger Ressmeyer/CORBIS; 104 (b), Terry Brandt/Grant Heilman Photography, Inc.; 105 (t), Courtesy of The University of Michigan

Lab Book/Appendix 106, Sam Dudgeon/HRW; 109, Kuni Stringer/AP/Wide World Photos; 110, Victoria Smith/HRW; 111, Jay Malonson/AP/Wide World Photos; 113, 116, Sam Dudgeon/HRW; 117, Andy Christiansen/HRW